The World's Family

The World's Family

Photographs by

Ken Heyman

Designed by Albert Squillace

A Pound Press Book G. P. Putnam's Sons/New York

Editor and Publisher: JERRY MASON
Art Director: ALBERT SQUILLACE
Editorial Director: MICHAEL MASON
Quotations: SYLVIA COLE

Acknowledgements

Conrad Aiken. From *Collected Poems* by Conrad Aiken. Copyright © 1953,
1970 by Conrad Aiken; renewed 1981 by Mary Aiken. Reprinted by permission
of Oxford University Press, Inc.

Paul Fort. From "La Ronde." Translated by Kenneth F. Canfield in *Selections
from French Poetry*. © 1965 by Harvey House, Inc. Reprinted by permission
of Harvey House Publishers.

Anne Morrow Lindbergh. From the poem "Bare Tree" from *The Unicorn and
Other Poems*. Copyright © 1956 by Anne Morrow Lindbergh. Reprinted by
permission of Pantheon Books, a division of Random House, Inc.

Minamota No Sanetomo. From *The Seasons of Time: Tanka Poetry of Ancient
Japan*. Edited by Virginia Olsen Baron. © Dial Press, Inc. Reprinted by
permission of Doubleday & Company, Inc.

Marianne Moore. From *Collected Poems* by Marianne Moore. Copyright © 1944,
and renewed 1972 by Marianne Moore. Reprinted by permission of Macmillan
Publishing Co., Inc.

Okot P'Bitek. From "Song of Lawino: An African Lament" from *Poems of Africa*,
selected by Samuel Allen. Copyright © 1973 by East African Publishing House.

Wilfred Owen. *The Collected Poems of Wilfred Owen*. Copyright © Chatto &
Windus Ltd., 1963. Reprinted by permission of New Directions Publishing
Corporation.

Theodore Roethke. Excerpts from "Dolor" and "Meditations of an Old Woman"
from *The Collected Poems of Theodore Roethke*. Copyright 1943 by
Modern Poetry Association, Inc. Copyright © 1958 by Theodore Roethke.
Reprinted by permission of Doubleday & Company, Inc.

Dylan Thomas. From *Poems of Dylan Thomas*. Copyright 1939 by New Directions
Publishing Corporation, 1945 by the Trustees for the Copyrights of Dylan
Thomas. Reprinted by permission of New Directions Publishing Corporation.

William Butler Yeats. From "Easter 1916," "A Dialogue of Self and Soul"
and "A Prayer for My Daughter." From *Collected Poems* by William Butler
Yeats. Copyright 1924, 1933 by Macmillan Publishing Company, renewed 1952,
1961 by Bertha Georgie Yeats. Reprinted by permission of Macmillan
Publishing Co., Inc.

Zenrin poem. From *The Way of Zen* by Alan Watts. Copyright © 1957 by Pantheon
Books, Inc. Reprinted by permission of Pantheon Books, a division of Random
House, Inc.

Library of Congress Cataloging in Publication Data

Heyman, Ken.
 The world's family.

 "A Pound Press book."
 1. Family—Pictorial works. I. Title.
HQ518.H49 1983 779'.2'0924 83-4476
ISBN 0-399-12833-6

COVER PHOTOGRAPH: JAPAN

For Margaret Mead, teacher,
collaborator, friend.

It was on a trip with Margaret
many years ago that I learned
that humanity is indeed a family.
I hope that people all over the
world, when they look at these
photographs, will realize they
share similar experiences. Then
they might think, "This is our
world, we better take care of it."

Ken Heyman

In 1952, Edward J. Steichen, the great photographer and head of the photography department of New York's Museum of Modern Art, began to work on a huge exhibition, the most important event in the history of photography. He had a name—The Family of Man, a phrase from one of Abraham Lincoln's speeches. In his autobiography, *A Life in Photography*, published in 1963, Steichen explained why he undertook the project:

"Although I had presented war in all its grimness in three exhibitions, I had failed to accomplish my mission. I had not incited people into taking open and united action against war itself. This failure made me take stock of my fundamental idea. What was wrong? I came to the conclusion that I had been working from a negative approach, that what was needed was a positive statement on what a wonderful thing life was, how marvelous people were, and, above all, how alike people were in all parts of the world."

In those early days of 1952, I was running a magazine publishing company. I commuted to New York on the train from Stamford, Connecticut. Steichen commuted to the museum from farther up the line. He would save a seat beside him for me. That experience, the rides to New York listening to him, learning from him, being challenged by him, remains the high point of my life.

Steichen was seventy-three years old in 1952, but he vibrated like a teenager when he confided his dream to me. My reaction was: "Will you let me do the book of your exhibit?" He shook his head. No, he was sorry, but the museum had a publishing agreement with one of the major publishers and, in any event, all the other book publishing giants would be standing in line for *The Family of Man*.

We continued our regular encounters on the plush seats of the New Haven Railroad. Steichen gave me steady progress reports. He went to Europe to begin his search for photographs. He assembled a staff, headed by Wayne Miller. The quest to create the world's greatest photographic exhibition had begun.

The months passed. Tens of thousands of photographs poured into the museum. Steichen and his staff began eliminating. A loft above a strip-tease joint on Fifty-second Street in New York was rented as a work place. In early 1954, Steichen had miniatures of the selected pictures pinned up in sequence on panels in the loft. And regularly, on the train, I'd ask how he was doing with the book publisher.

One morning, a few months before The Family of Man exhibition was to open at the museum, he was not himself. He had been on a high, but no longer. Not only had the museum's publisher rejected the idea of a book created from the exhibition, but so had every other potential publisher. They had all said the same thing: "A picture book won't sell."

We got off the train in New York and I followed Steichen to the loft. I looked at the mock-up of the exhibition. Steichen needed little persuasion to take me around the corner to see the museum's Director of Publications. Calculations were quick. Steichen wanted to reach out to as great an

audience as possible with a large-sized paper covered edition to sell for one dollar. I proposed that my partner Fred Sammis and I would publish 135,000 copies of a one-dollar edition—the first of the so-called trade paperbacks—and I would produce a specially printed hardcover edition and arrange distribution for it. Steichen's reaction was, "Jerry you're crazy. We can't let you do that. You'll lose your shirt." Then, realizing he'd joined all the other doubting publishers, he grinned ruefully.

As editor of *The Family of Man* book, I worked with Steichen to attempt to capture in two-dimensional form the spirit and immense impact of the exhibition. I persuaded the museum's own publisher to distribute our deluxe hardcover edition. Our company would distribute the paperbound edition. The exhibition opened on January 24, 1955. It was a smashing, record-breaking success. Publication followed several months later. The deluxe edition sold out quickly. The paperback started more slowly, then, suddenly, we had to go back to press. Today more than six million copies of *The Family of Man* have been sold. And the book is still alive, still being reprinted in both editions.

The exhibition toured the United States and the world. It is now gone. So is Steichen.

The world has changed in the intervening thirty years. When the exhibition was created, Ken Heyman was too young to submit a photograph. He became a photographer of the sixties, seventies, and eighties. He was sent to me by Steichen not long before the great man died. From Heyman's early days as a photographer, I have followed his work and published a great deal of it.

Recently I had a rich, unique experience: I went through the entire body of his work. Thousands of photographs by a man who has roamed the world, has worked with Margaret Mead, has been moved by a vision of humanity.

Dare we, thirty years later, take a look at this different world through the eyes and senses of one photographer? A world in 1983 when one begins to feel the Orwellian predictions for 1984 multiplying themselves beyond imagination?

Some communities of families sense themselves hurtling into obliteration and oblivion. Human control becomes doubtful. Even reproduction of the human species is controversial and contradictory.

Yet, for so many, everywhere in the world, nothing is changed. The seeded womb sets out the child who matures and seeks to mate. The broad range of ancestry and forbears and heirs and offspring persists and persists with or without census or computing.

Ken Heyman, a photographer stirred by his own very human convictions, has thoughtfully committed himself to search out and record images that show our human family persisting everywhere. The brilliant designer Albert Squillace has made all these images come together.

Indeed, contemporary life needs this special viewing and re-viewing to help us feel and know the world's family today.

—Jerry Mason

Whence come we? What are we? Whither go we? Paul Gauguin

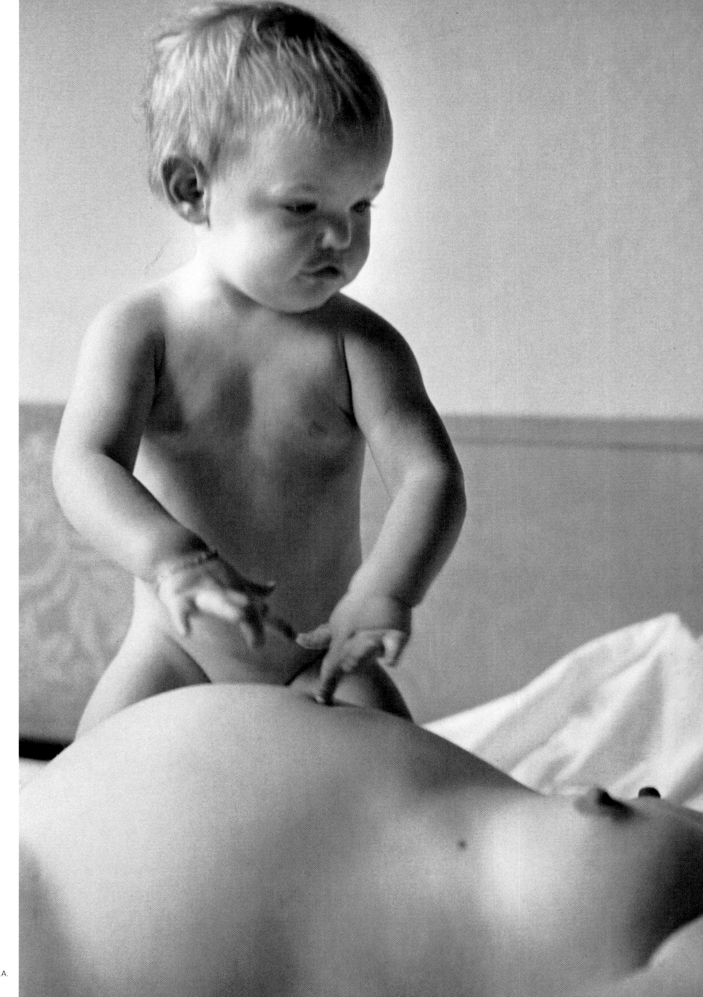

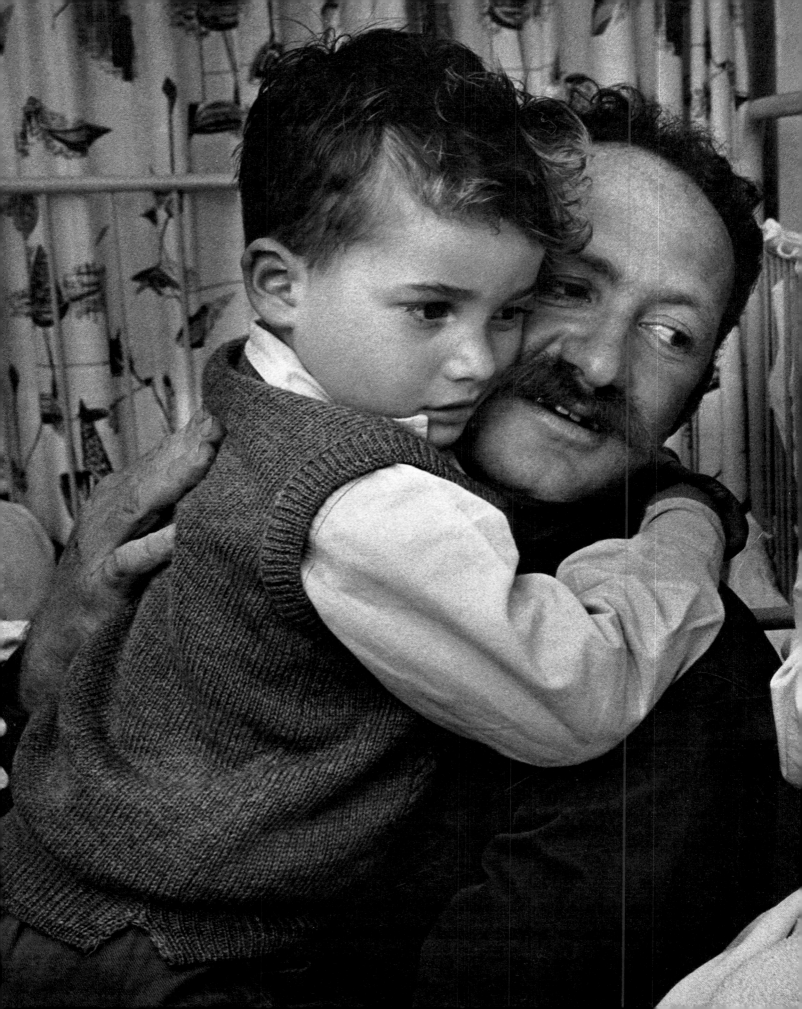

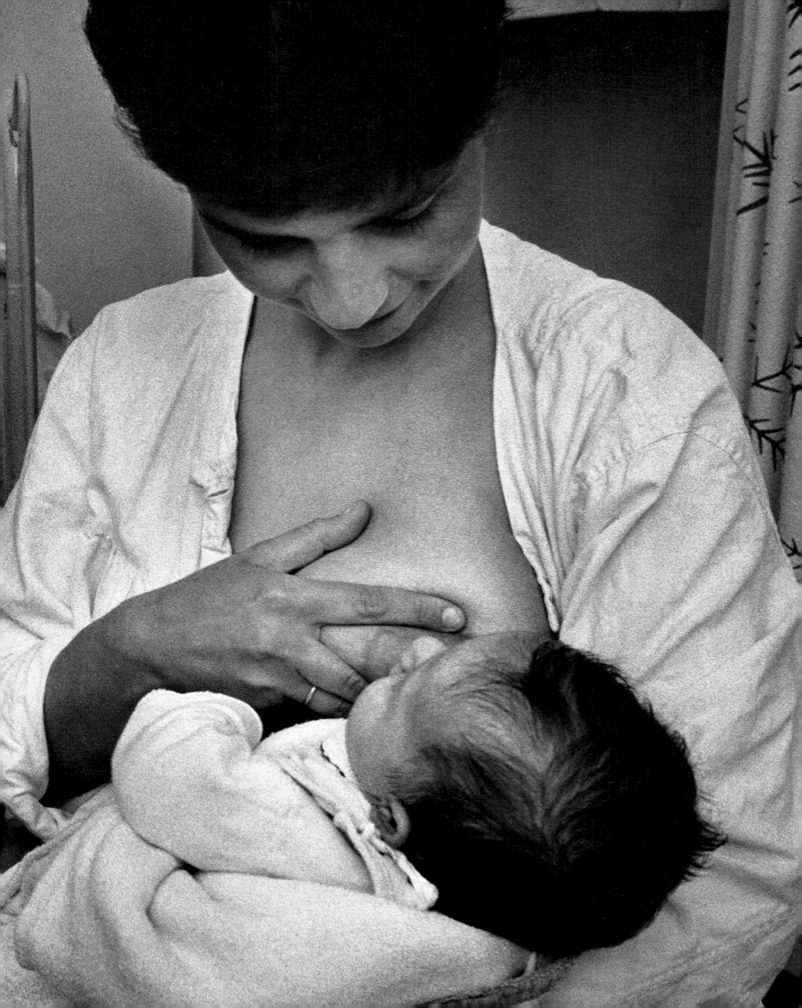

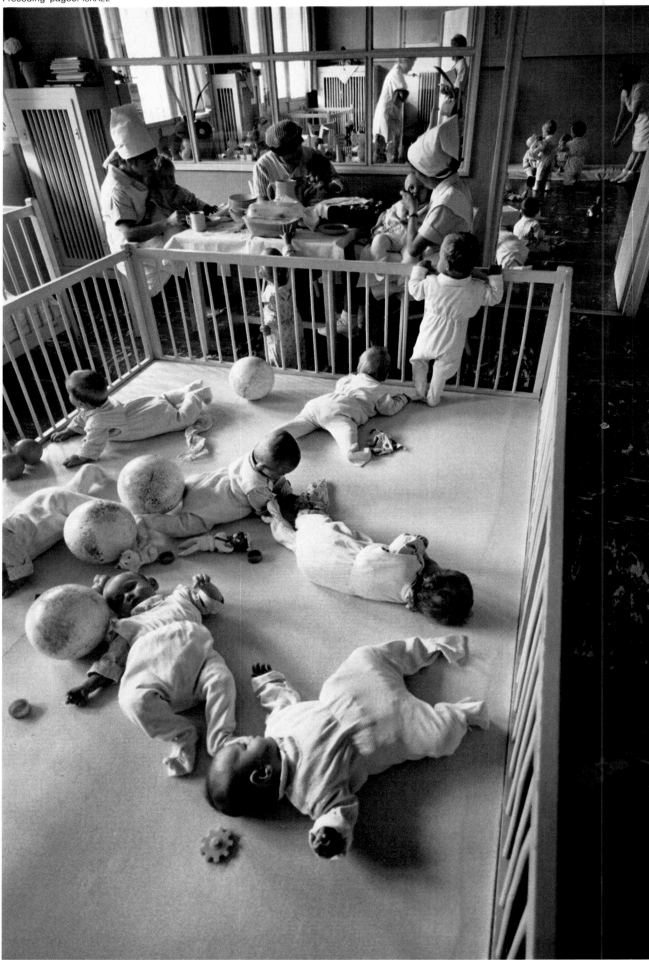

Some are born to
sweet delight
Some are born to
endless night.

William Blake

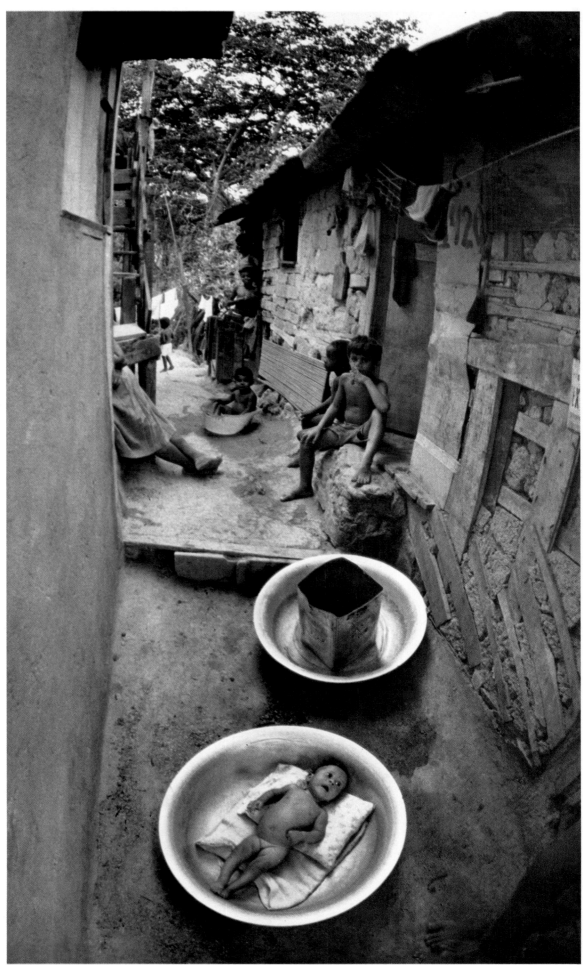

BRAZIL

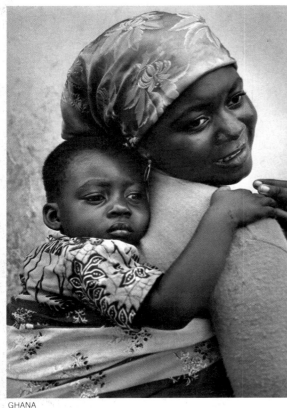

GHANA

You were born to the joy of all:
the blue sky,
birds,
your mother's eyes. Rabindranath Tagore

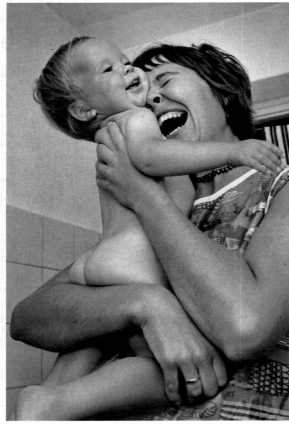

DENMARK

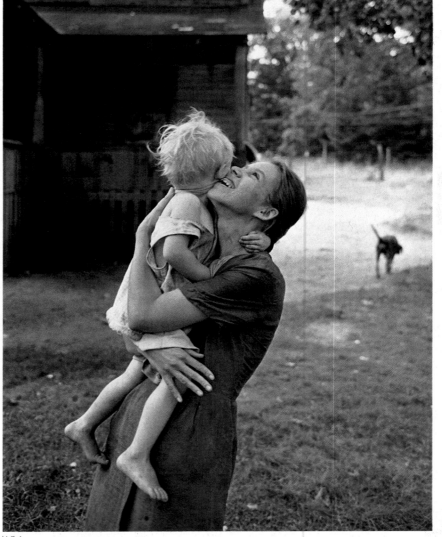

U.S.A.

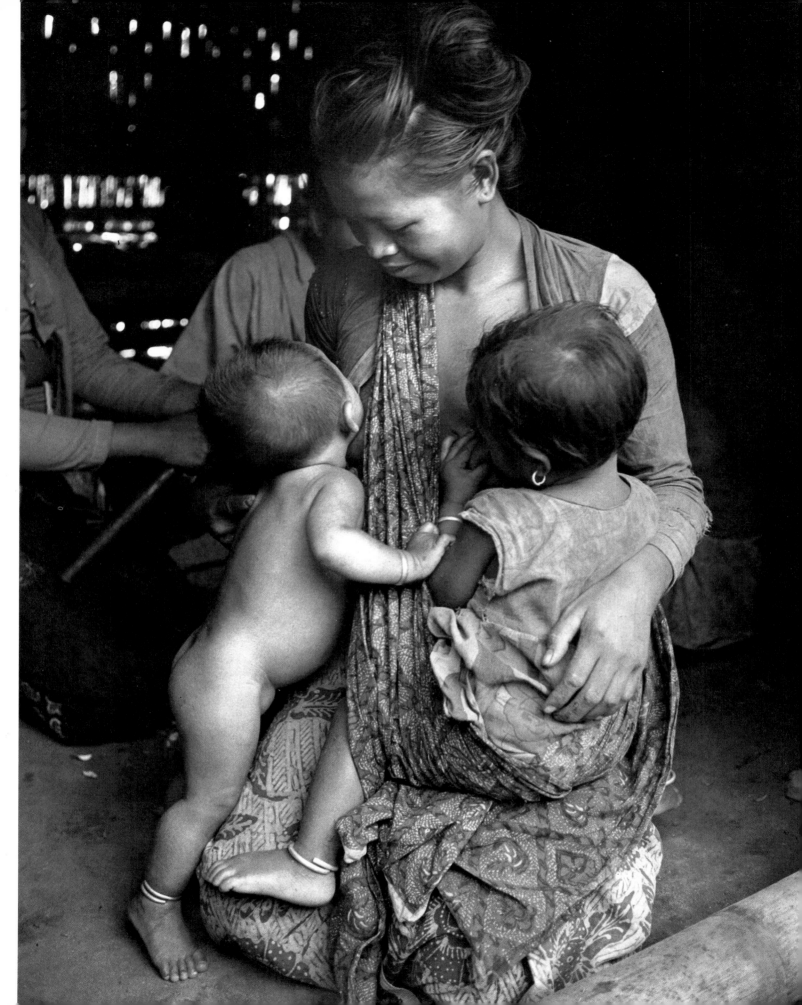

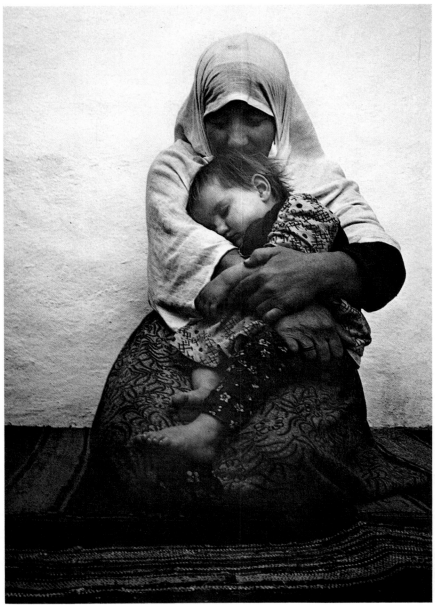

TURKEY

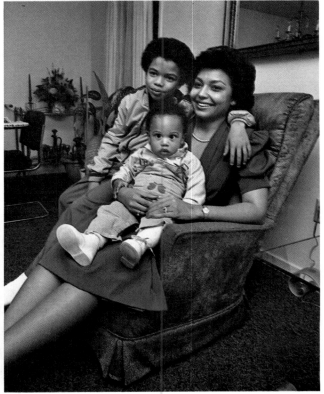

U.S.A.

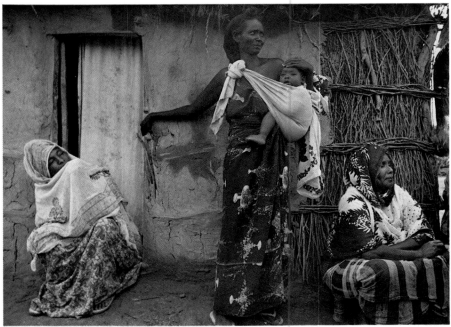

SOMALIA

16

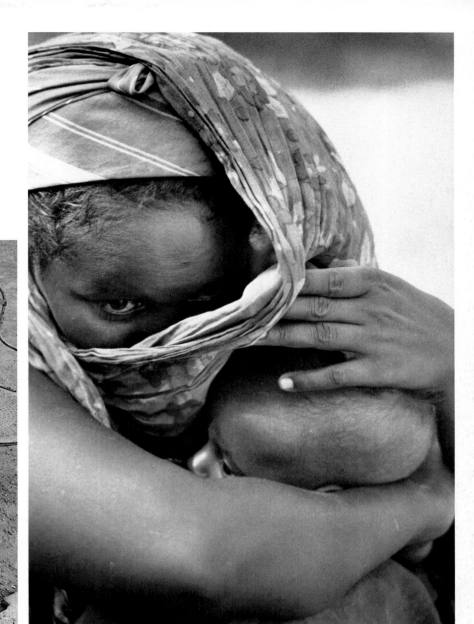

SOMALIA

FRANCE

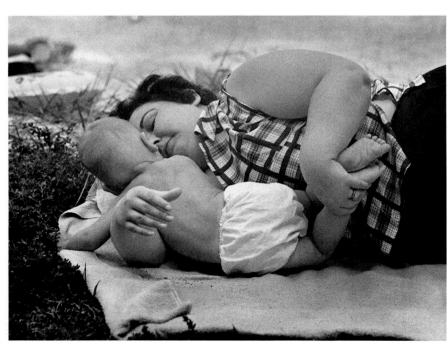

U.S.A.

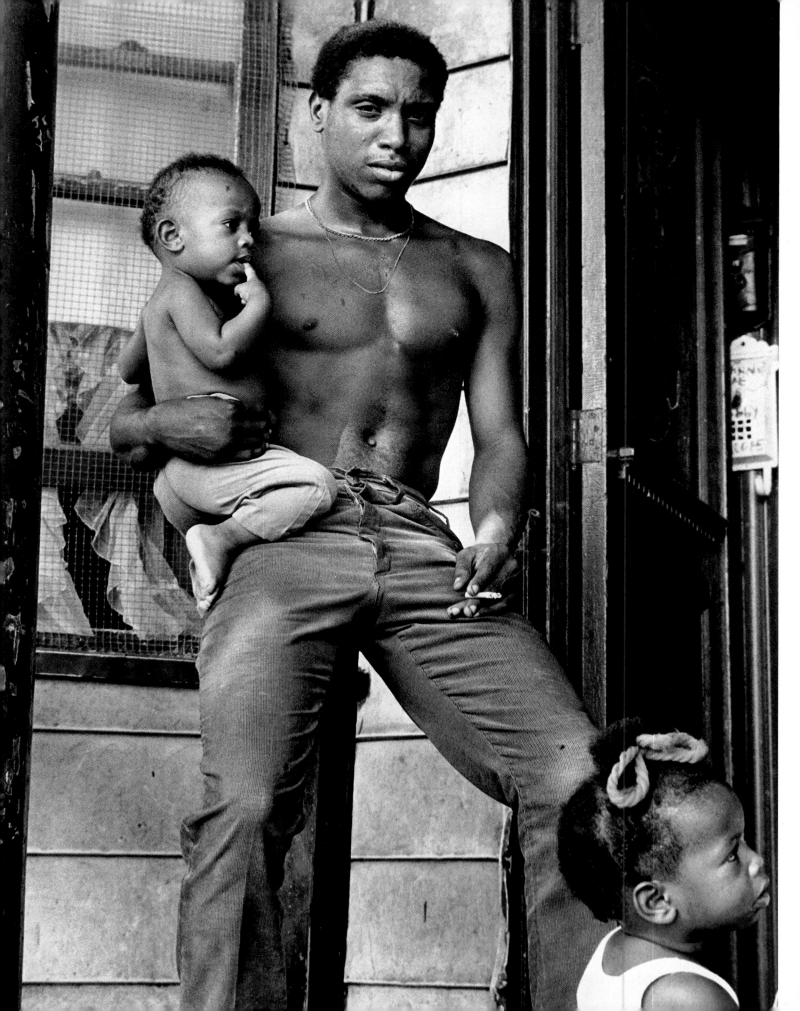

...the child grows toward the father.

Margaret Mead

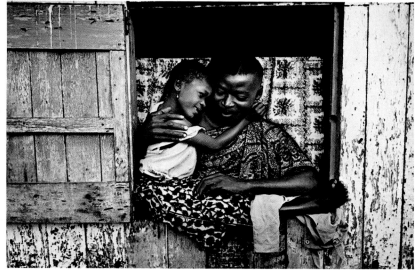

GHANA

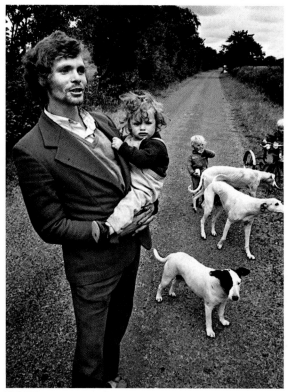

IRELAND

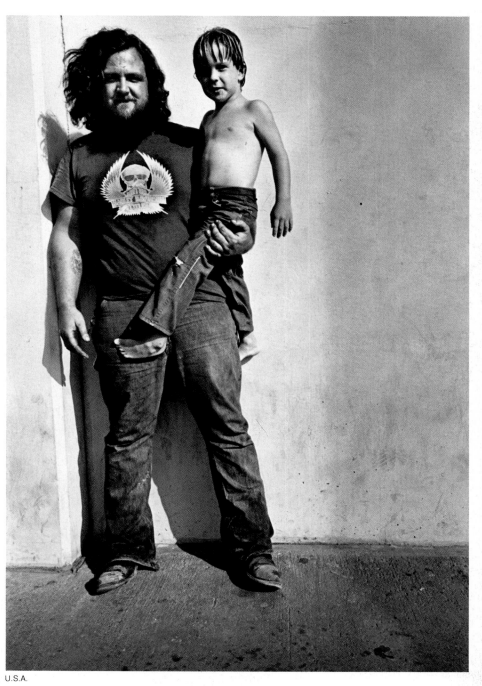

U.S.A.

U.S.A.

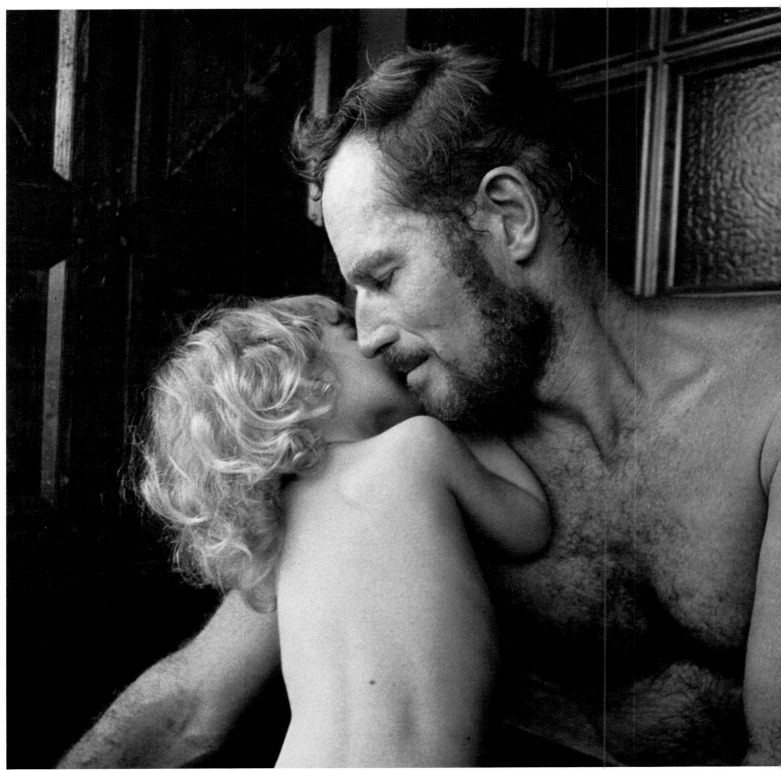

U.S.A.

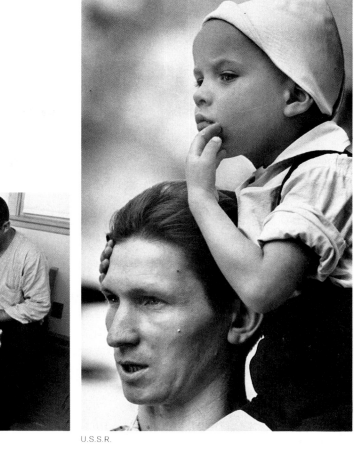

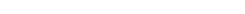

U.S.A.

U.S.S.R.

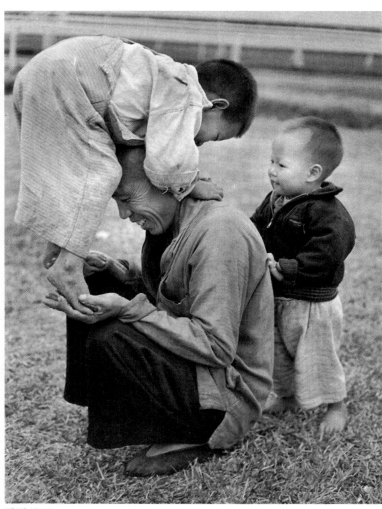

HONG KONG

21

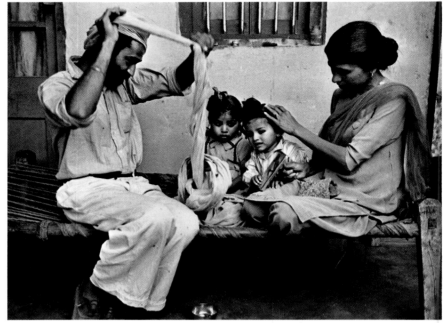

INDIA

GHANA

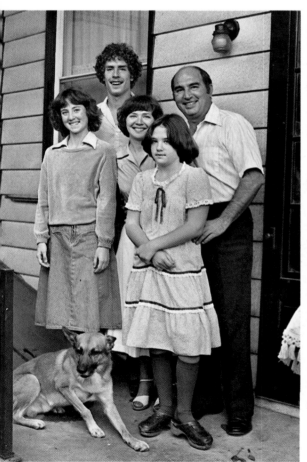

U.S.A.

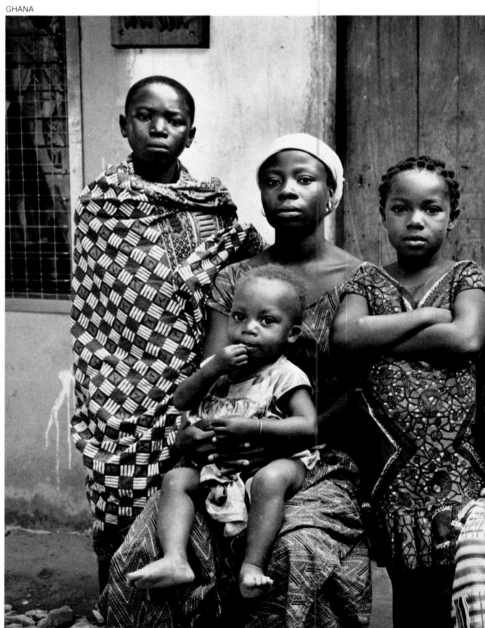

22

Happy families are all alike. Leo Tolstoy

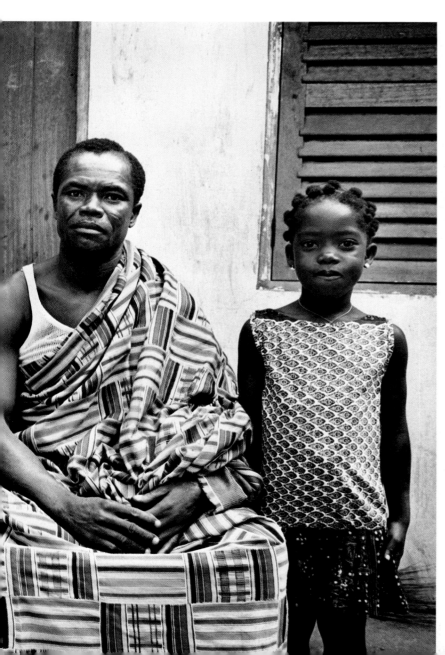

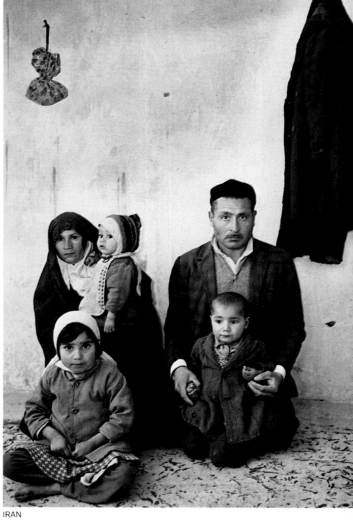

IRAN

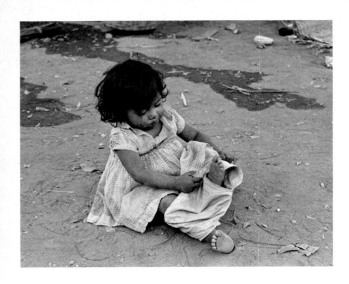

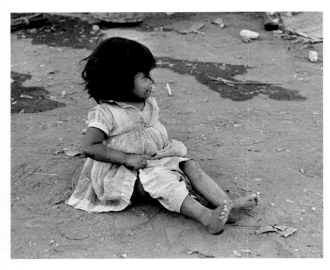

Oh, sacrament of summer days...
Permit a child to join. Emily Dickinson

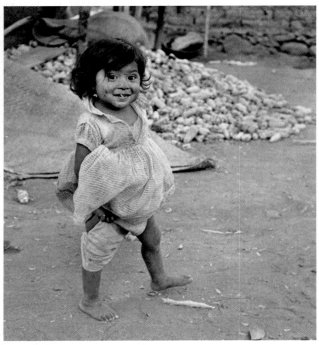

MEXICO

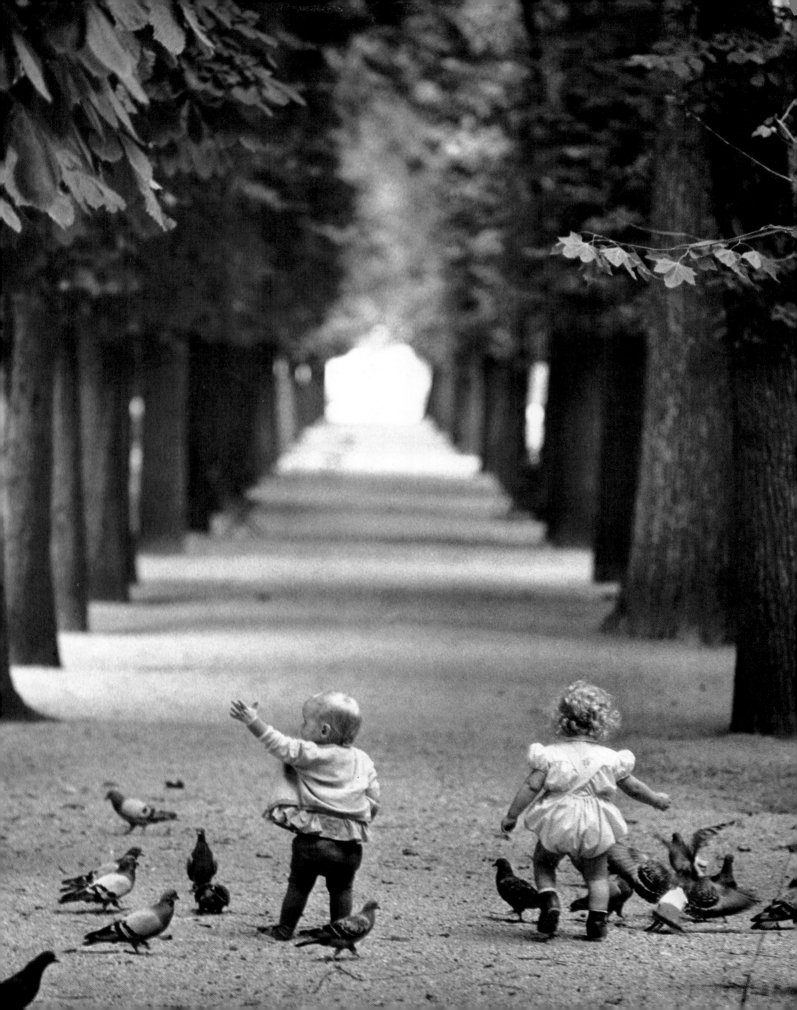

Such is life—
Seven times down
Eight times up! Zenrin poem

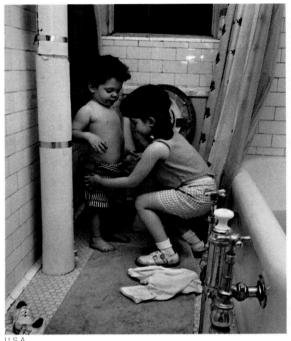
U.S.A.

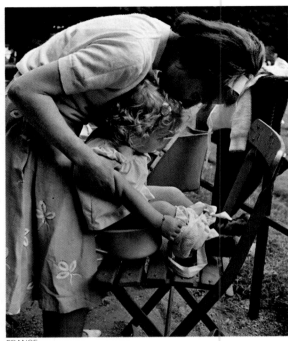
FRANCE

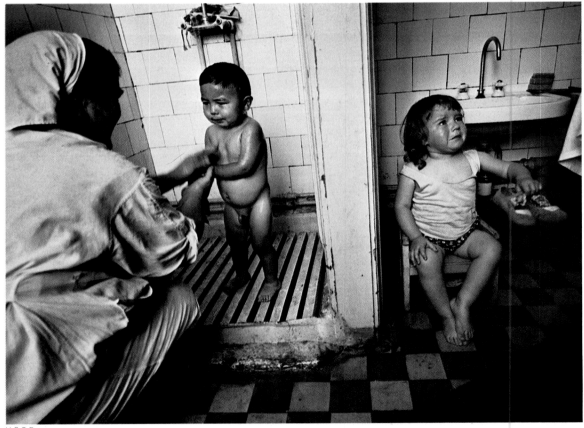
U.S.S.R.

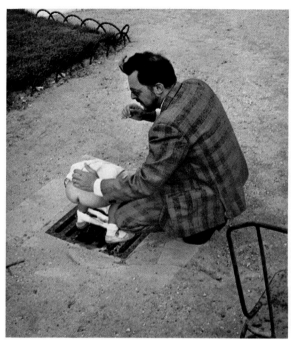

FRANCE

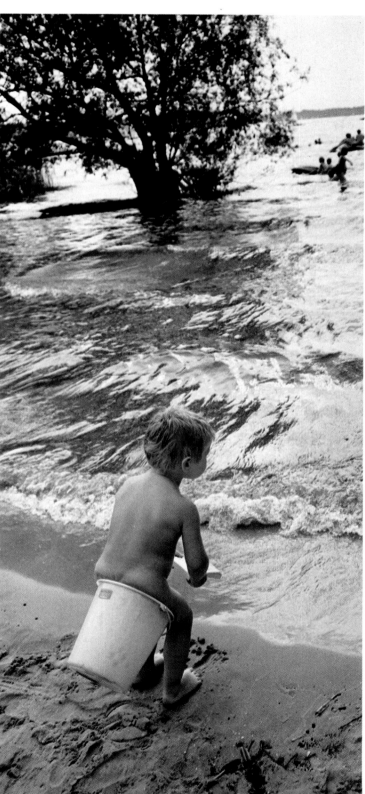

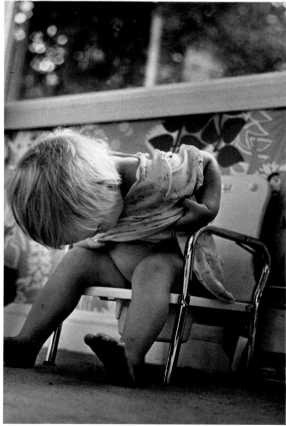

U.S.A.

WEST GERMANY

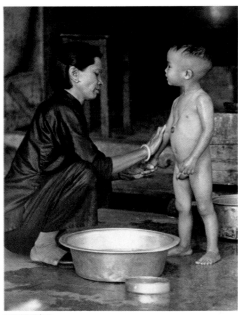
HONG KONG

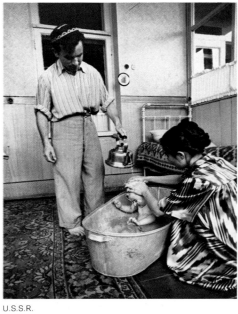
U.S.S.R.

NIGERIA

28

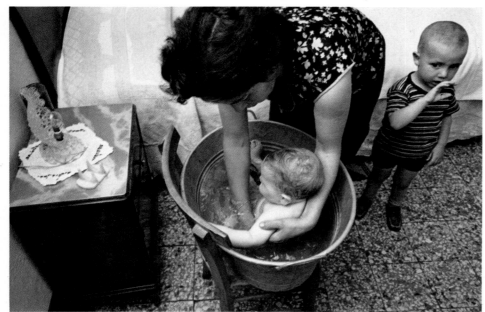

ITALY

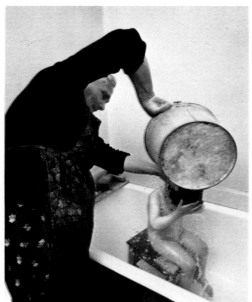

U.S.S.R.

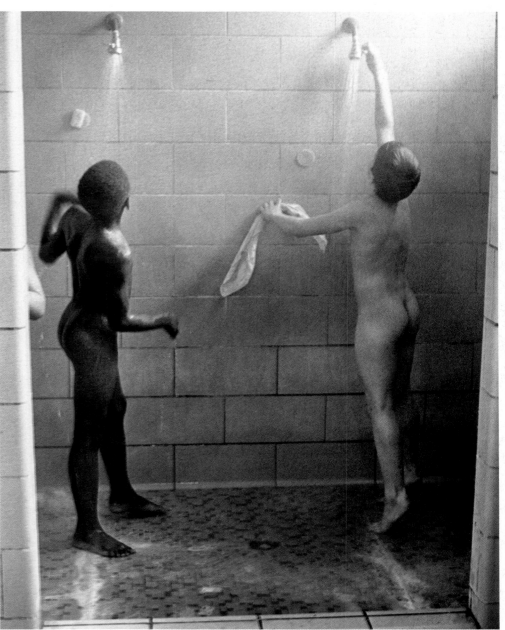

U.S.A.

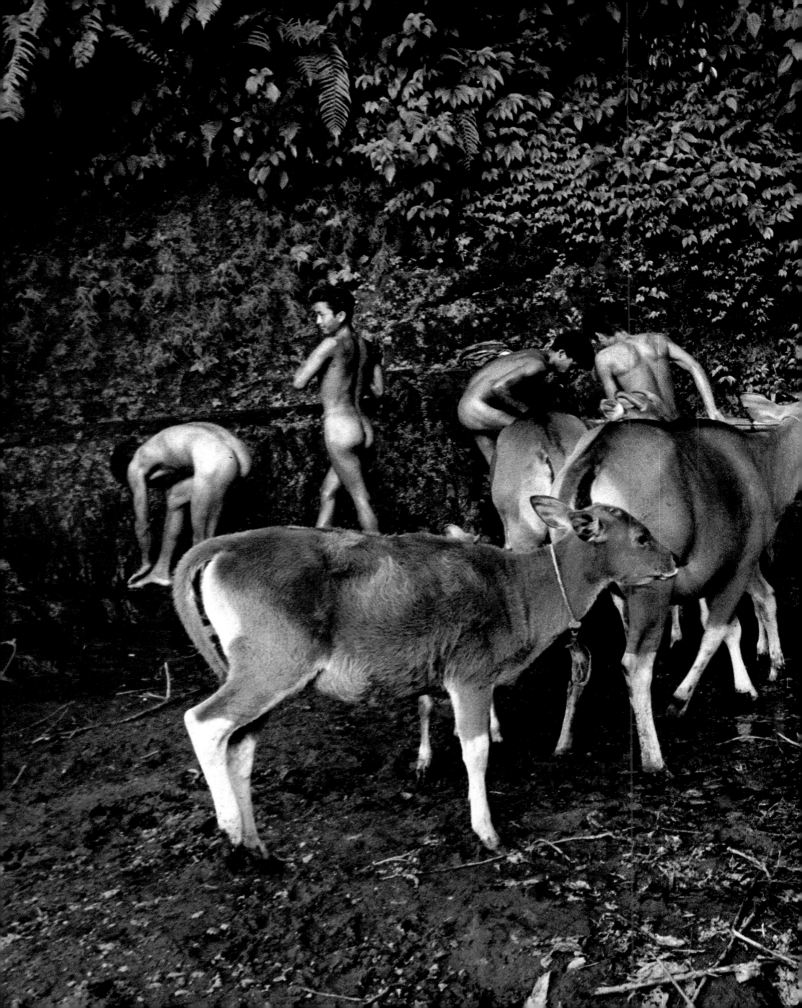

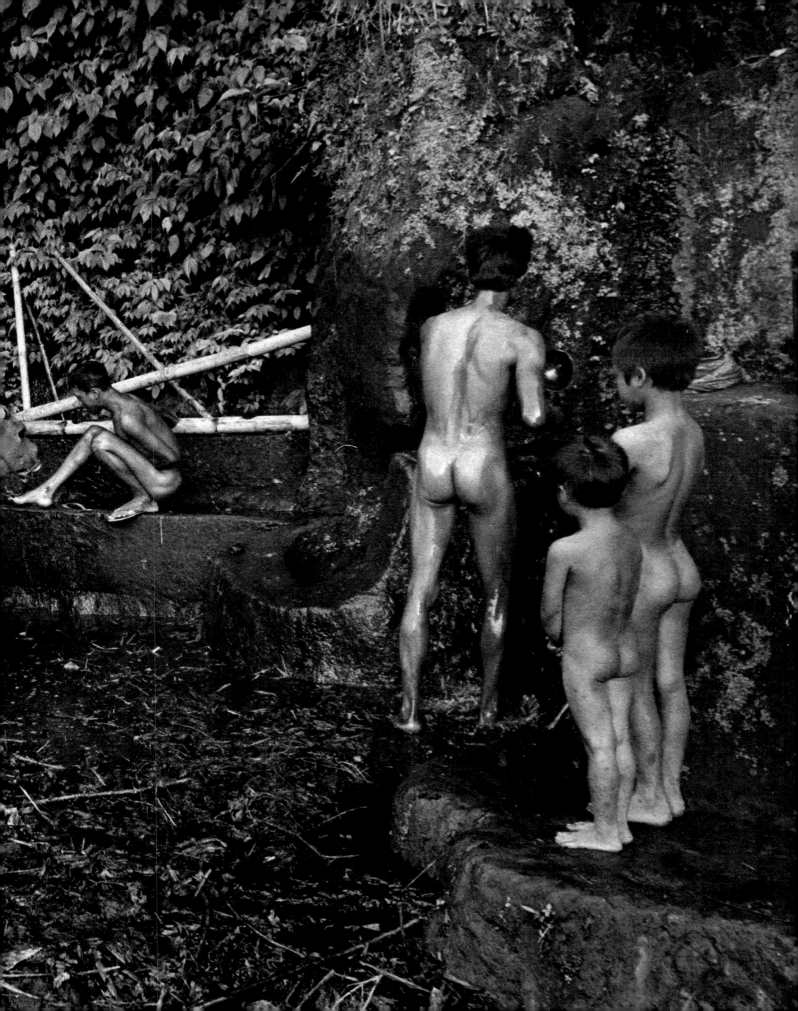

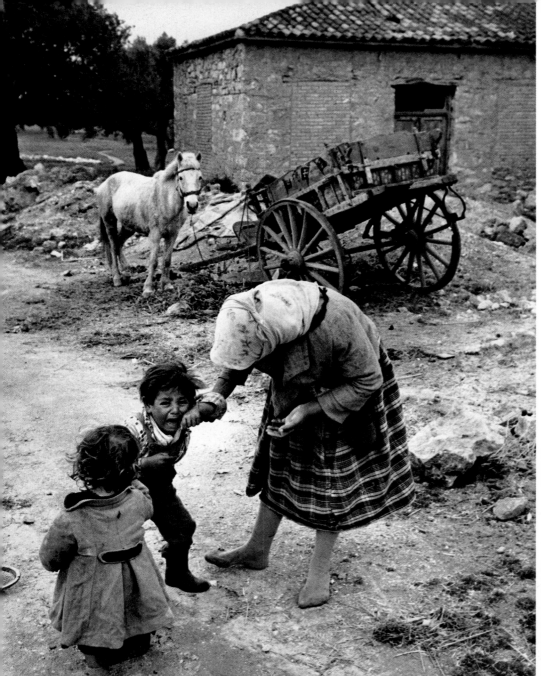

Grief melts away
Like snow in May. George Herbert

GREECE

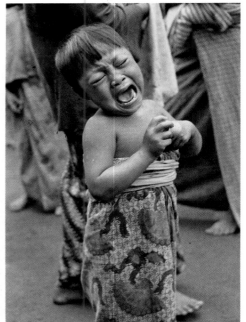

BALI

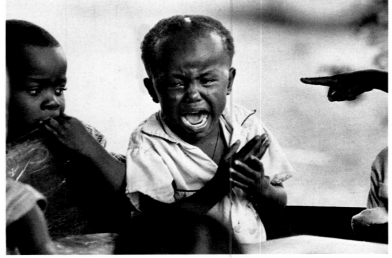

NIGERIA

Preceding pages: BALI

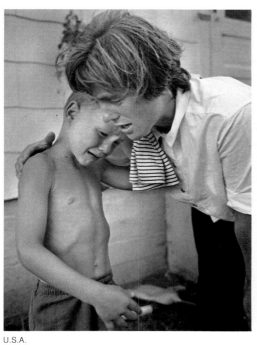

U.S.A.

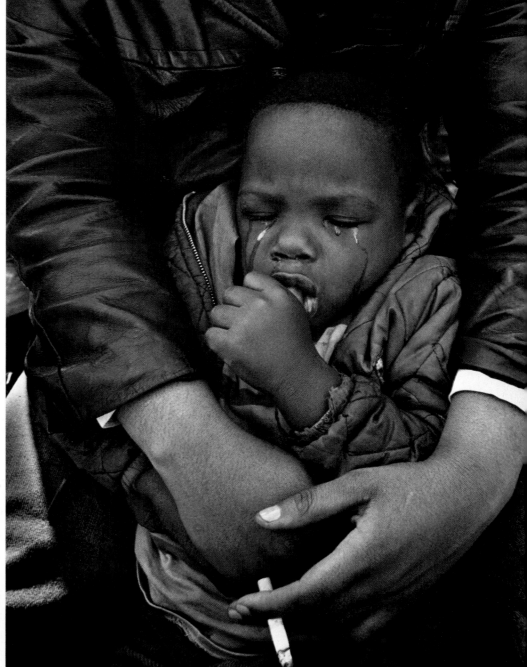

U.S.A.

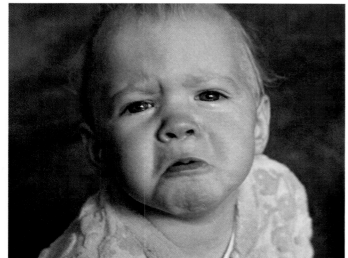

U.S.A.

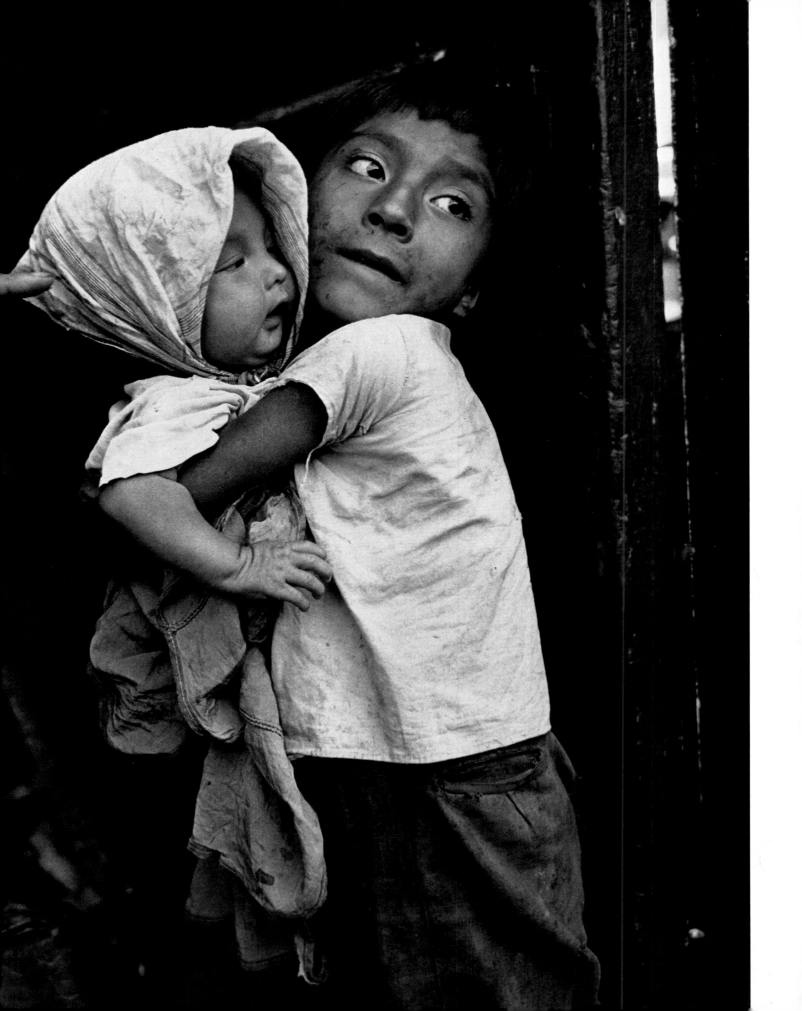

A double blessing is a double grace. William Shakespeare

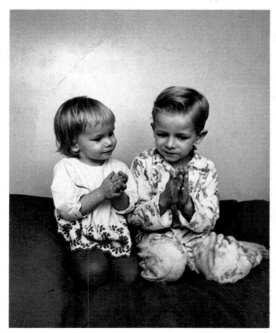

U.S.A.

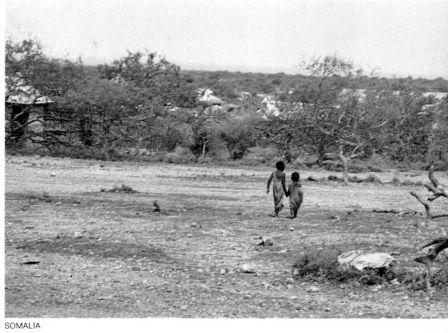

SOMALIA

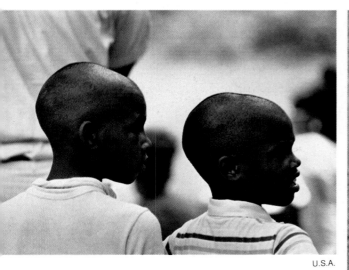

U.S.A.

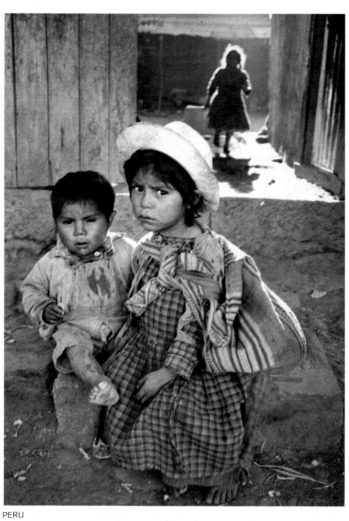

EL SALVADOR

PERU

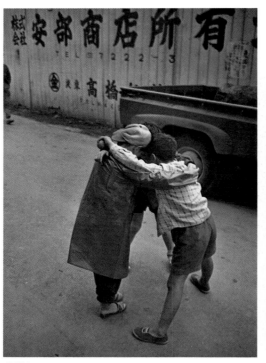
JAPAN

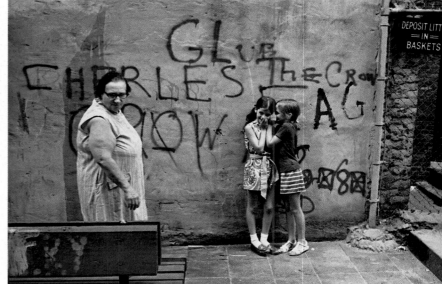
U.S.A.

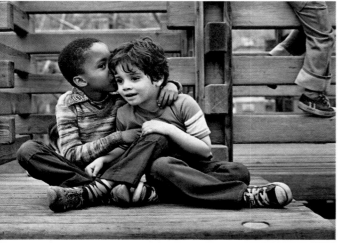
U.S.A.

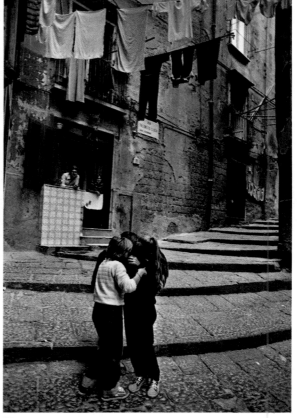
ITALY

I'm nobody! Who are you?
Are you nobody too?
Then there's a pair of us?
Don't tell! Emily Dickinson

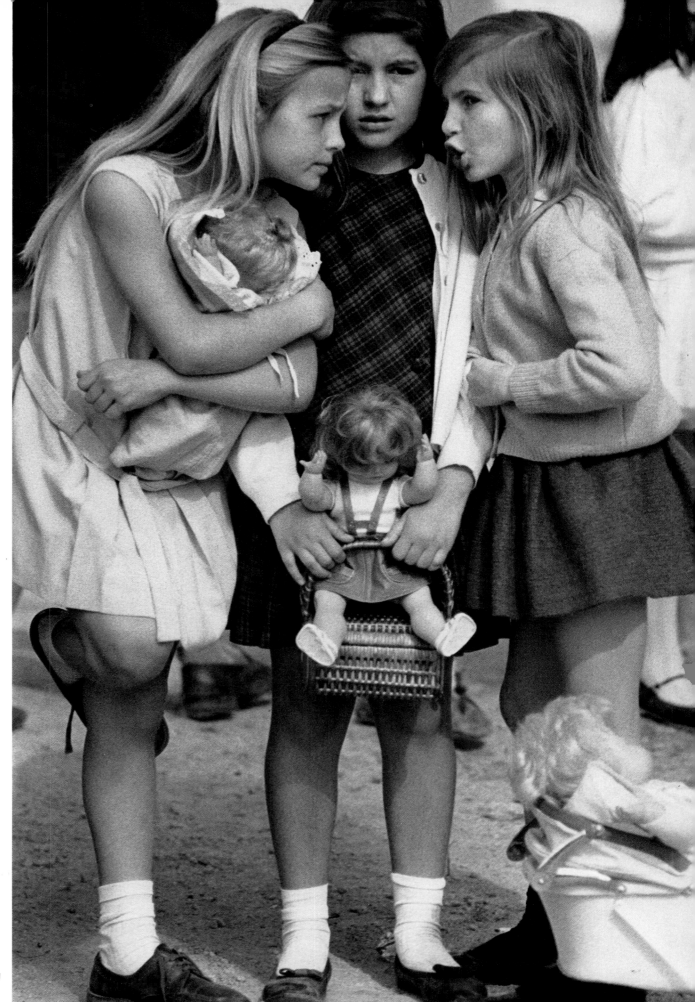

SPAIN

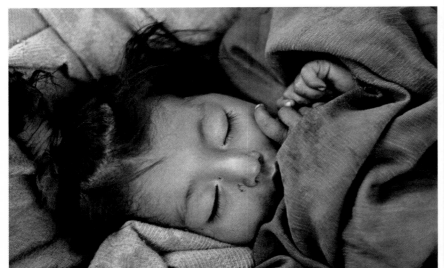

EL SALVADOR

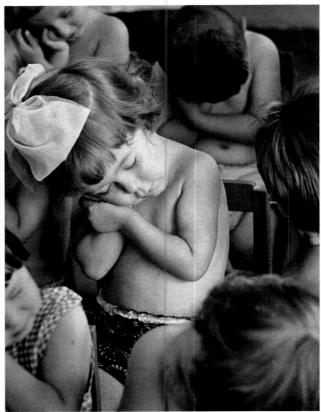

U.S.S.R.

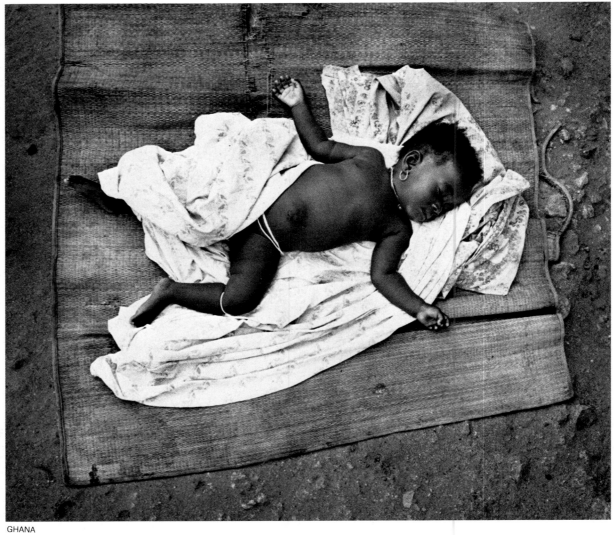

38

GHANA

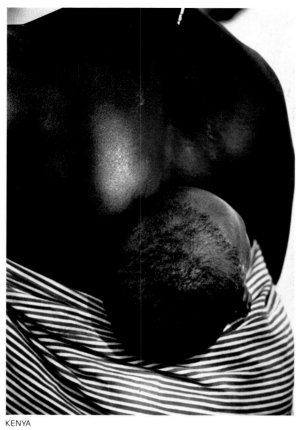

KENYA

And Innocence is closing up his eyes. Michael Drayton

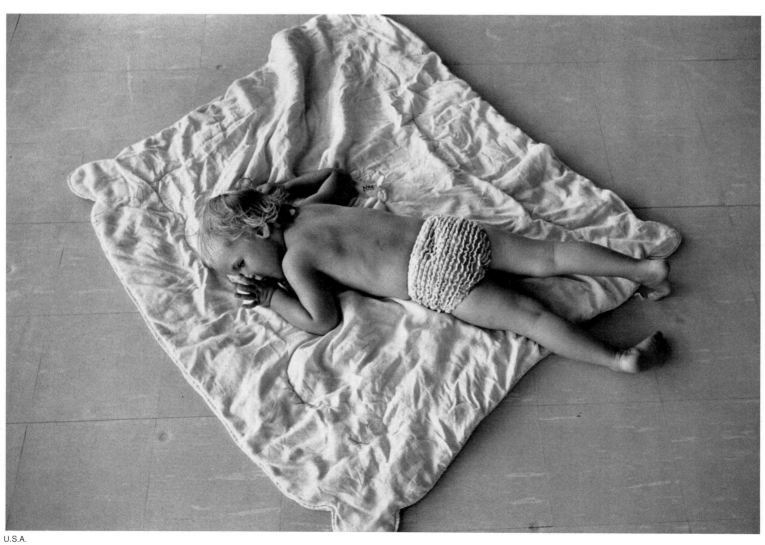

U.S.A.

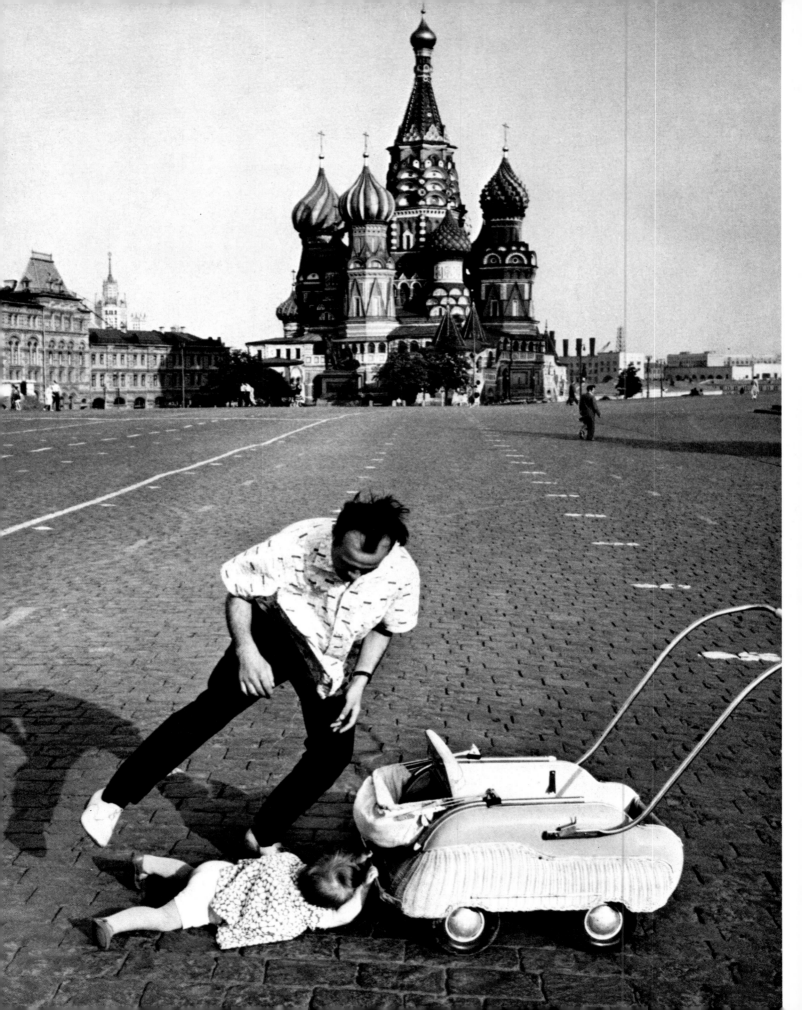

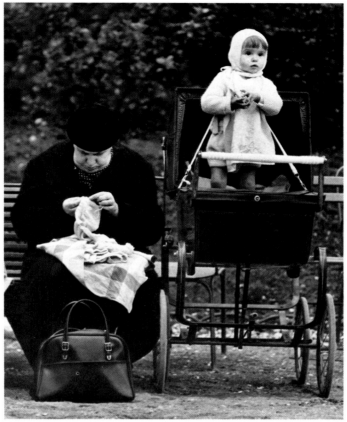

FRANCE

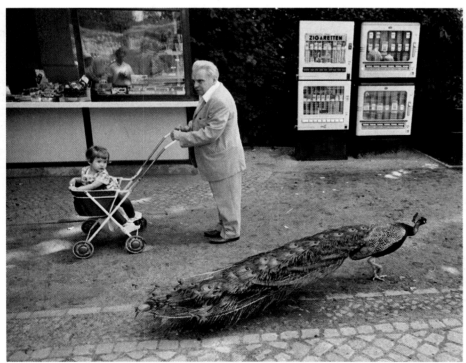

WEST GERMANY

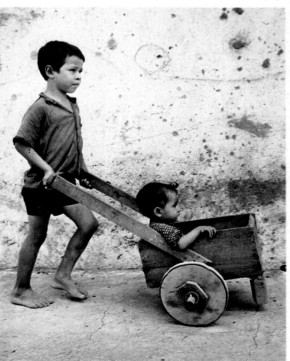

HONDURAS

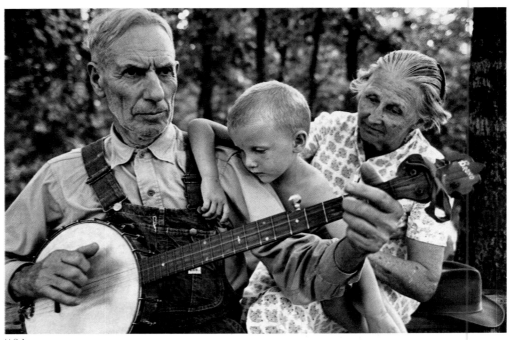

U.S.A.

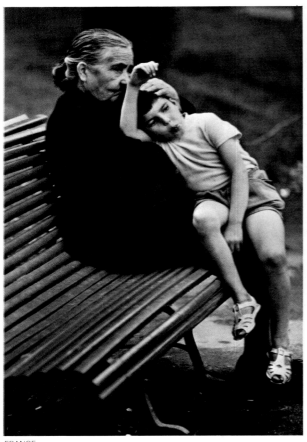

FRANCE

GREECE

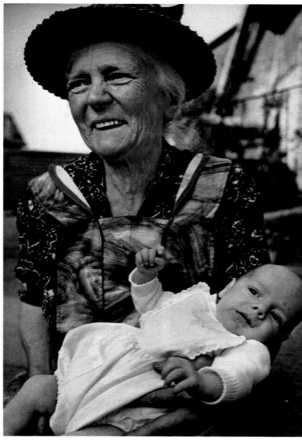

SWITZERLAND

The ways of your ancestors
Are good.
They cannot be blown away
By the winds
Because their roots reach deep
 into the soil. Okot P'Bitek

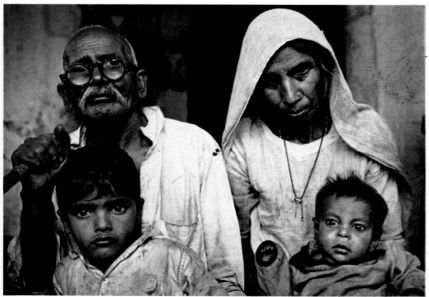

PAKISTAN

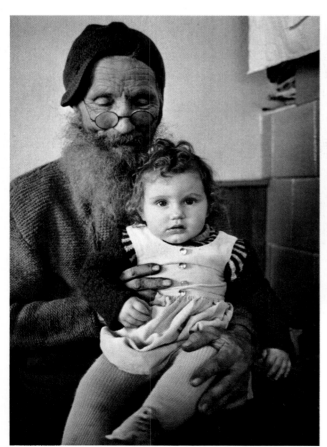

AUSTRIA

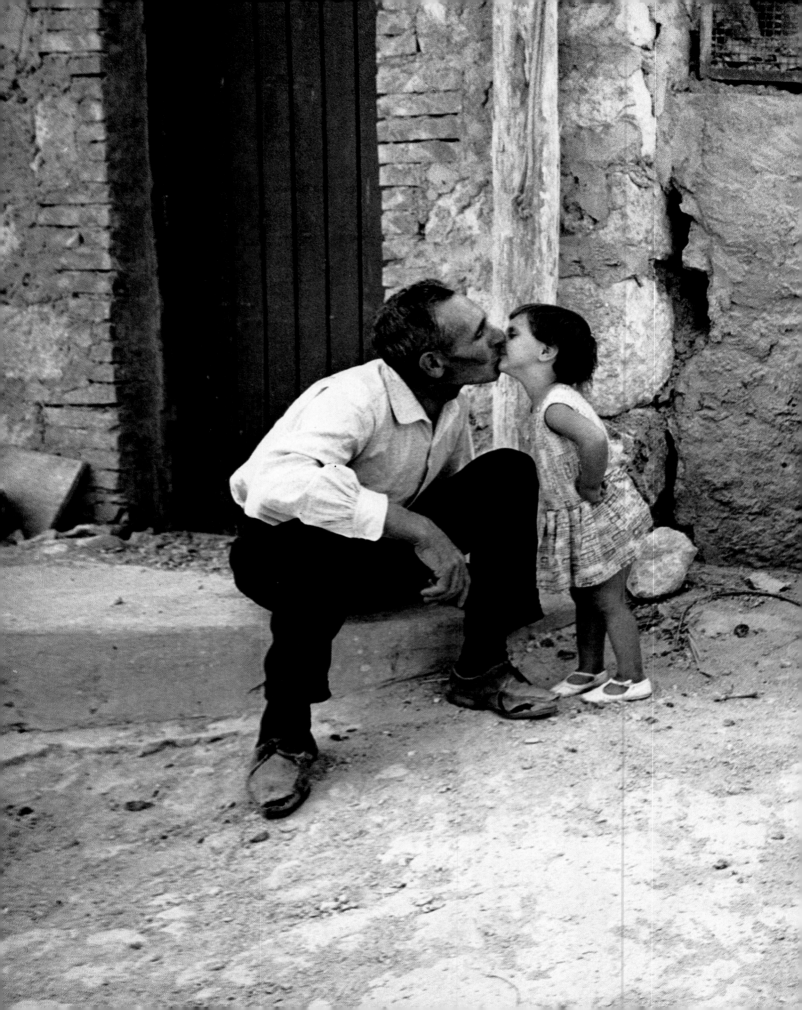

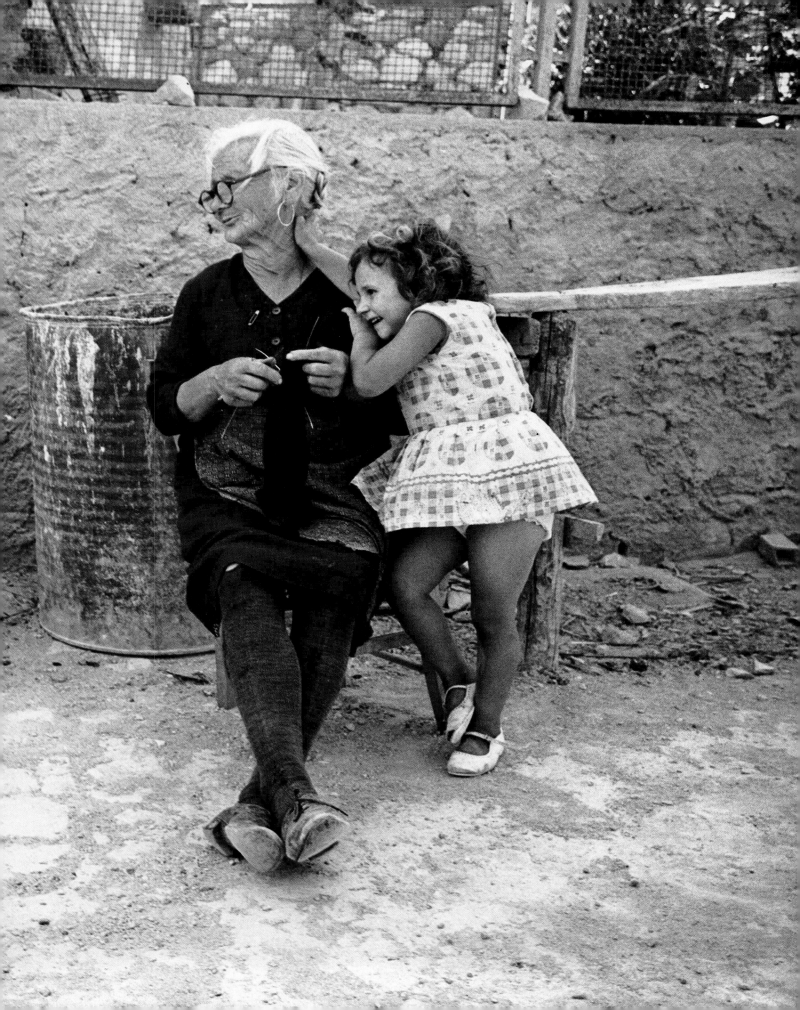

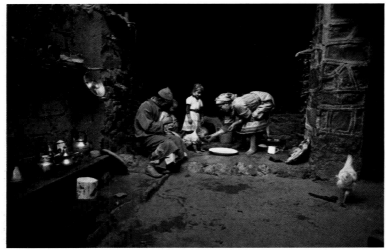
MOROCCO

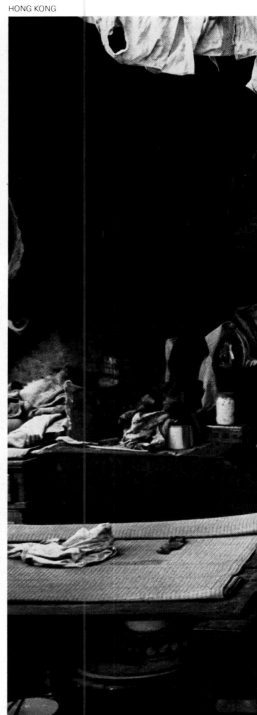
HONG KONG

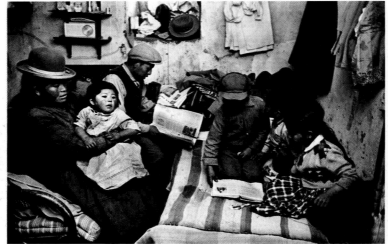
PERU

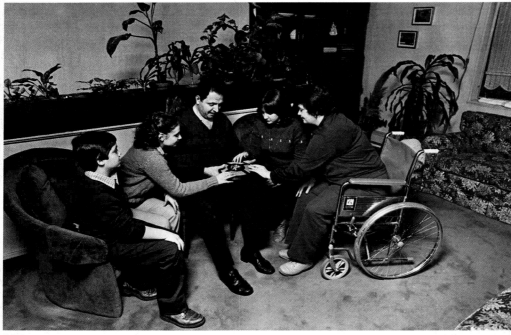
U.S.A.

Preceding pages: SICILY

Evening brings all things home.
It brings the bird to the bough
 and the lamb to the fold—
And the child to the mother. Euripides

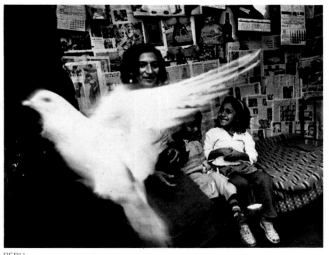

PERU

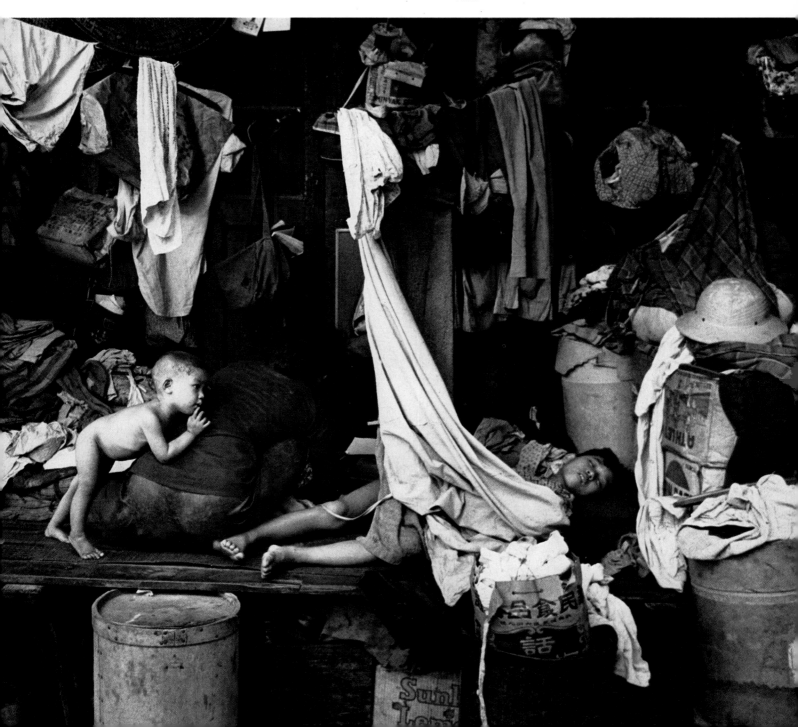

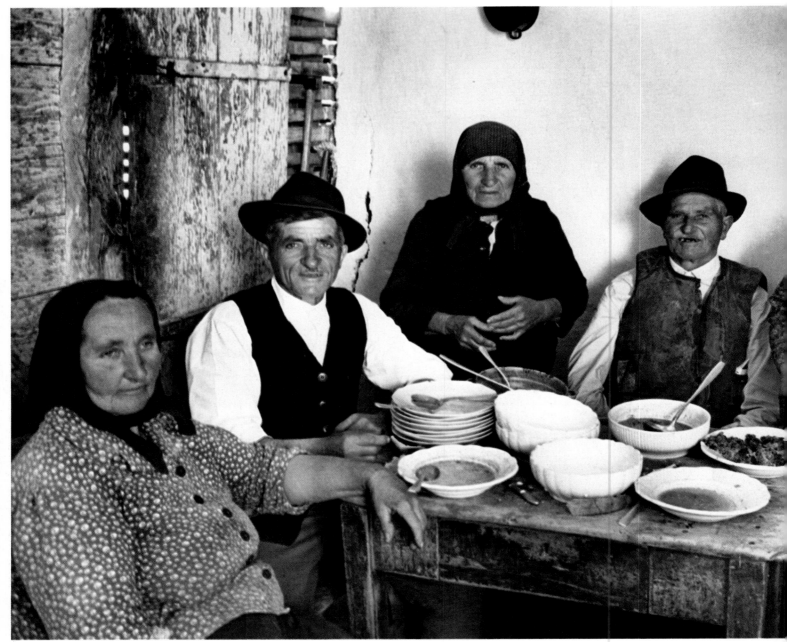

YUGOSLAVIA

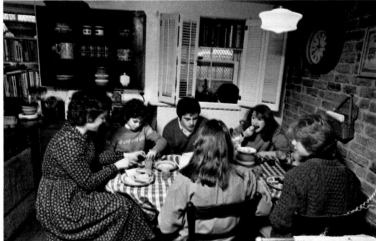

U.S.A.

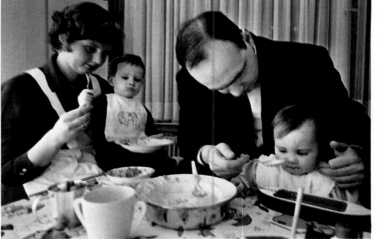

WEST GERMANY

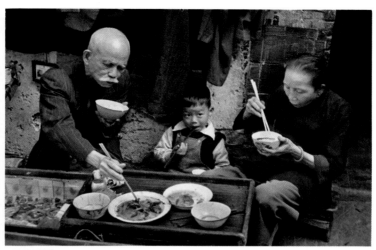

HONG KONG

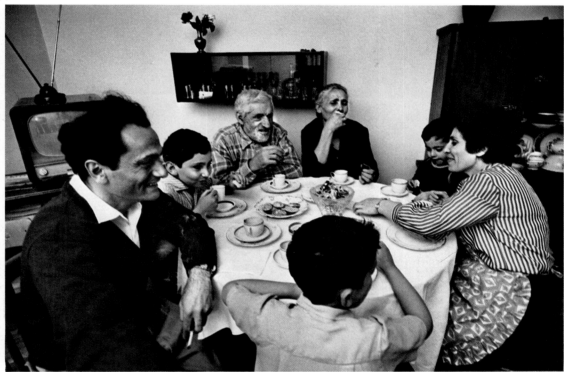

U.S.S.R.

We must laugh and we must sing,
We are blest by everything,
Everything we look upon is blest. William Butler Yeats

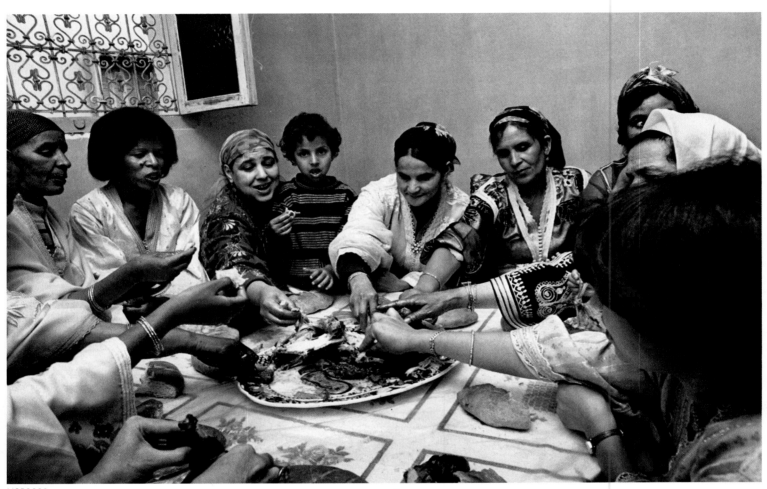

MOROCCO

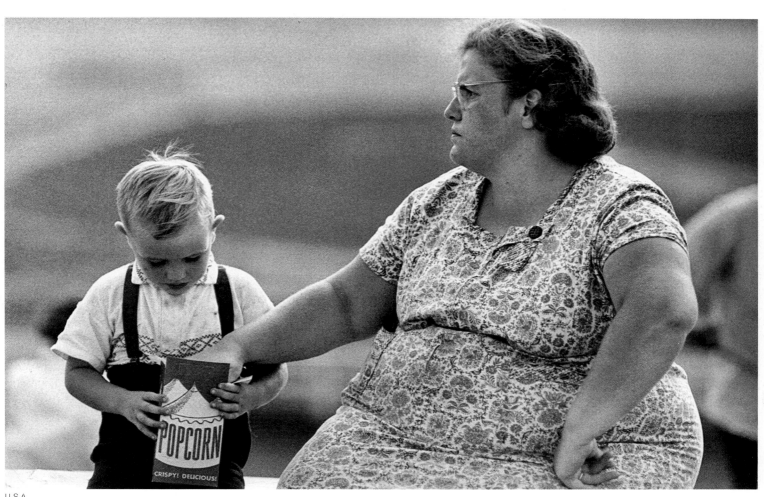

U.S.A.

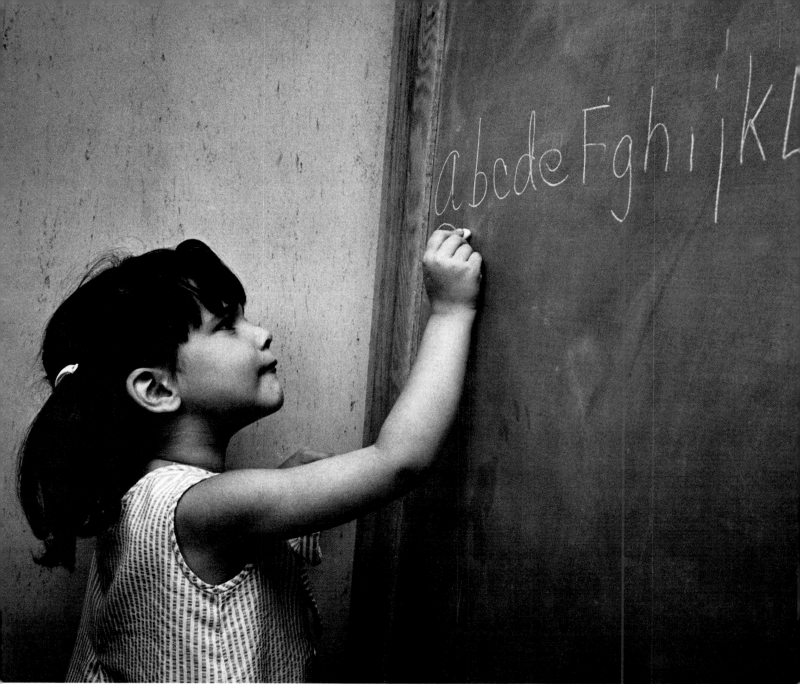

U.S.A.

"The Mind Is An Enchanting Thing" Marianne Moore

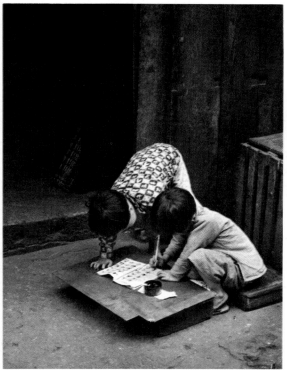

HONG KONG

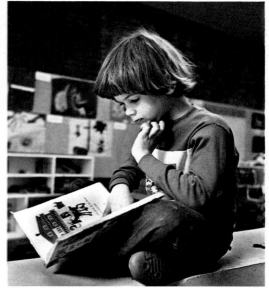

U.S.A.

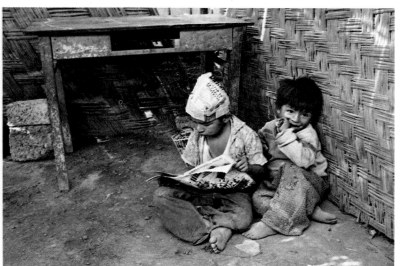

COLOMBIA

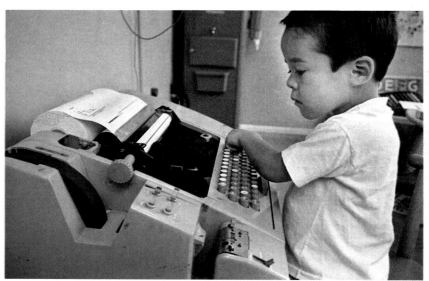

U.S.A.

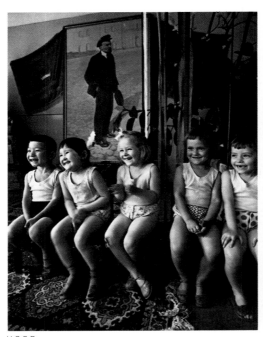

U.S.S.R.

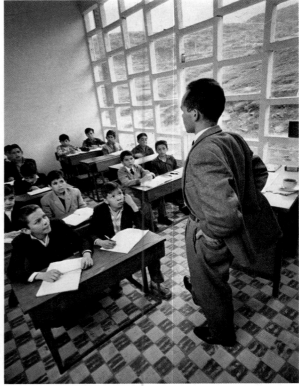

PERU

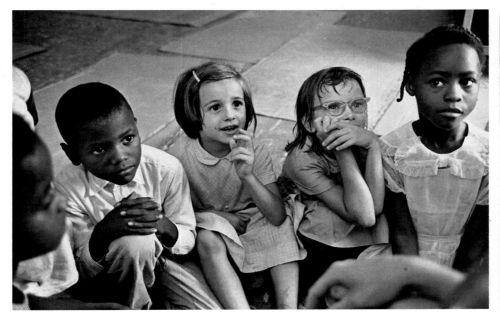

U.S.A.

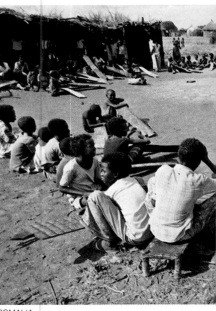

SOMALIA

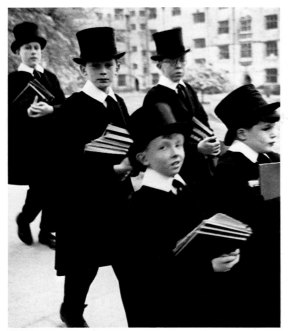

ENGLAND

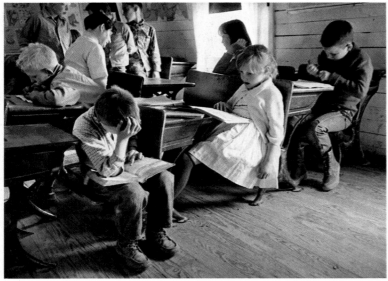

U.S.A.

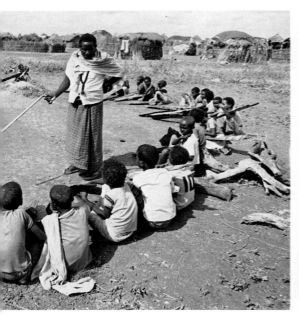

EL SALVADOR

Ask questions, for they are the keys that unlock the storehouse of knowledge. Blaise Pascal

BULGARIA

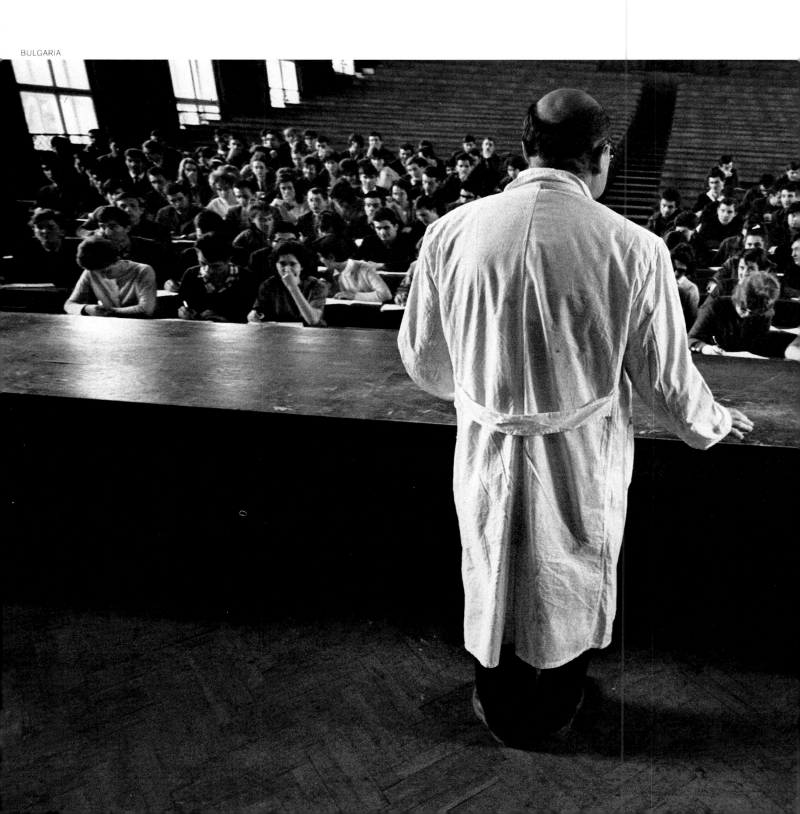

PERU

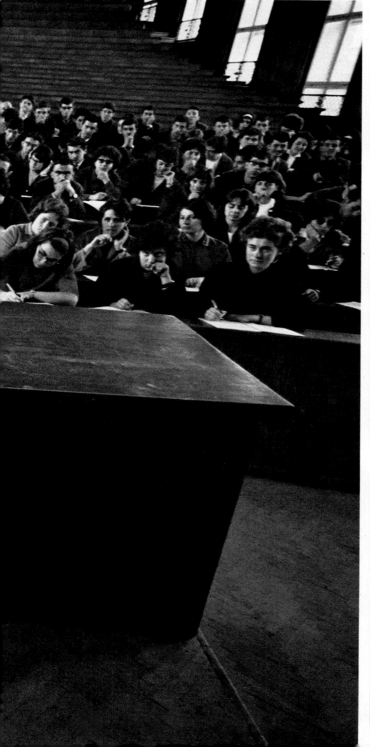

NICARAGUA

U.S.A.

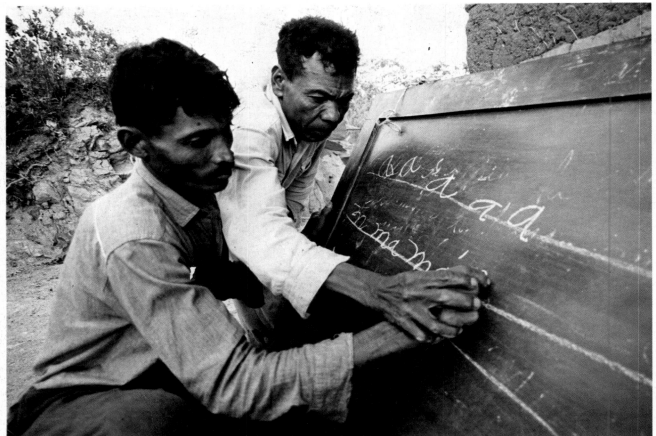

NICARAGUA

PERU

U.S.A.

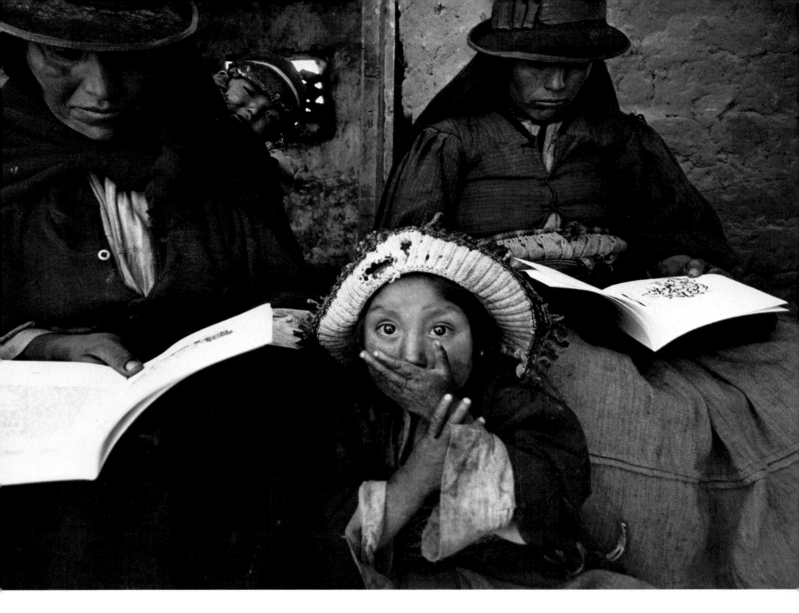

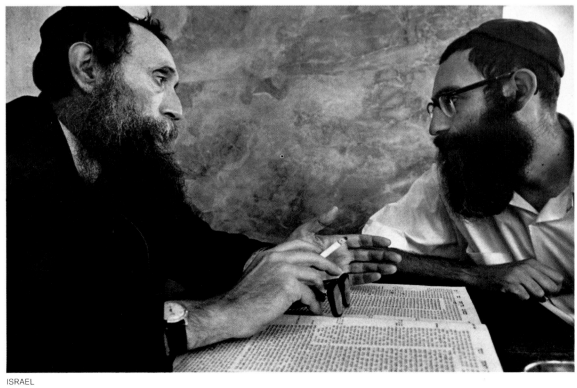

ISRAEL

Then we could dance a round around the world,
if all the people in the world wanted to join hands. Paul Fort

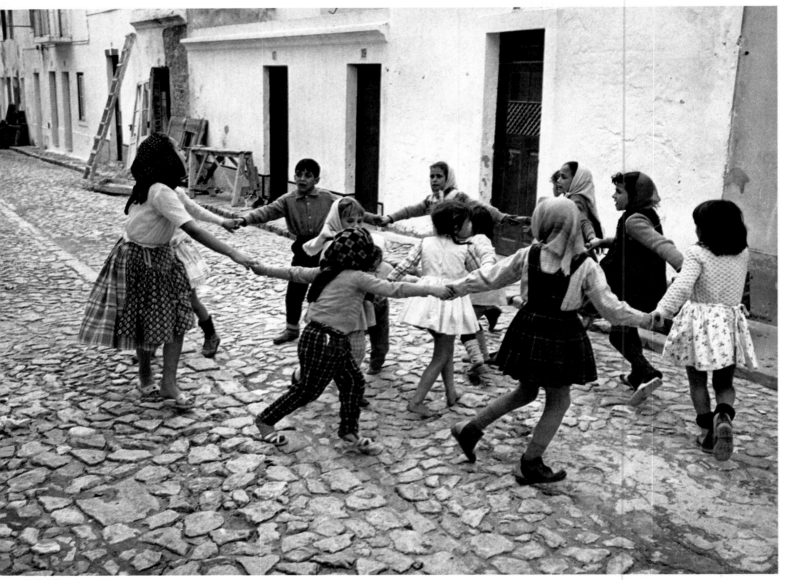

PORTUGAL

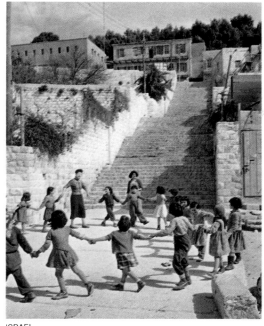

ISRAEL

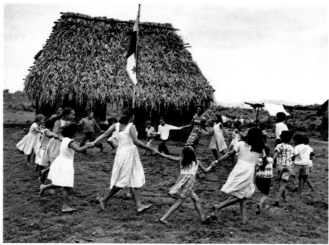

PANAMA

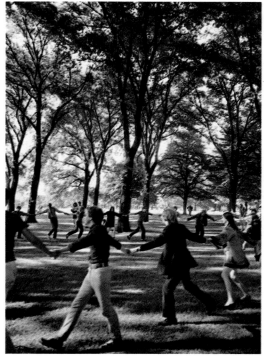

ENGLAND

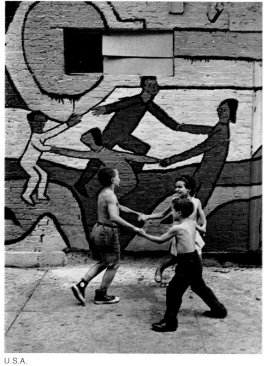

U.S.A.

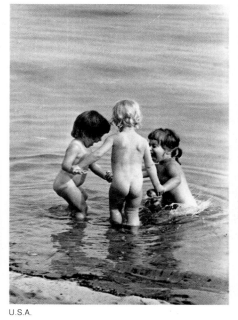

U.S.A.

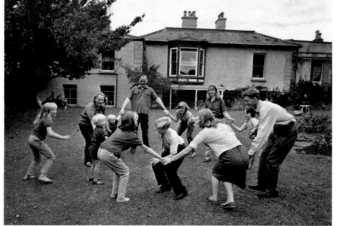

IRELAND

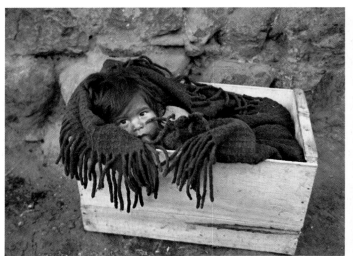

PERU

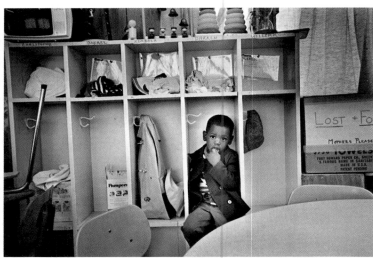

U.S.A.

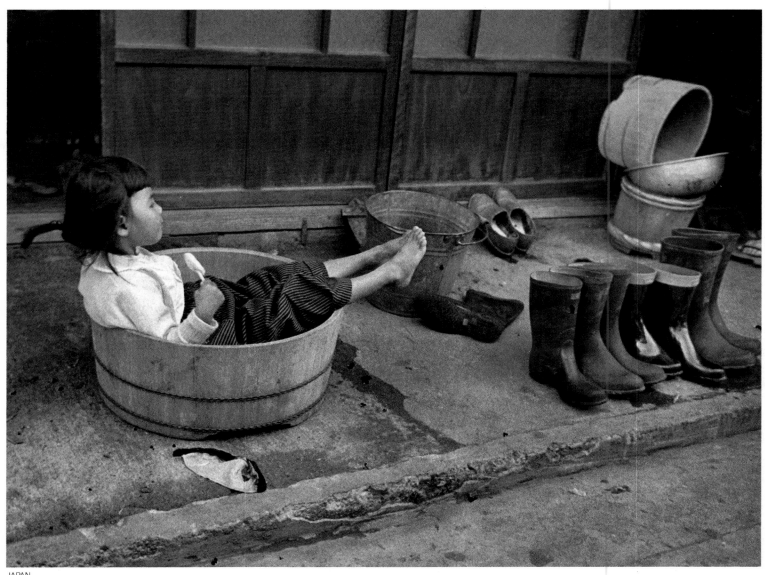

JAPAN

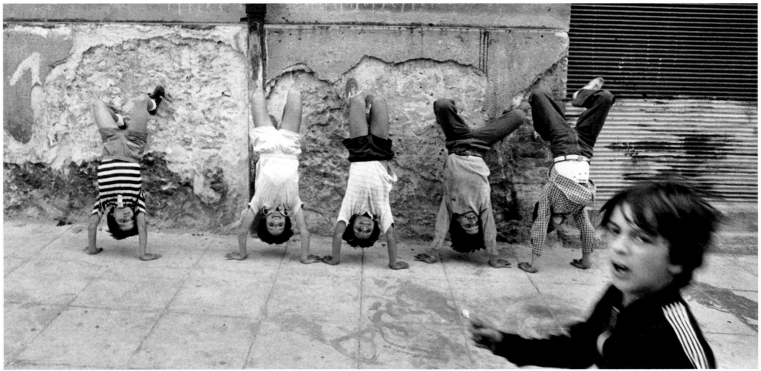

SICILY

When I was young,
every day was as a beginning
of some new thing,
and every evening ended
with the glow of the next day's dawn.

Eskimo poem

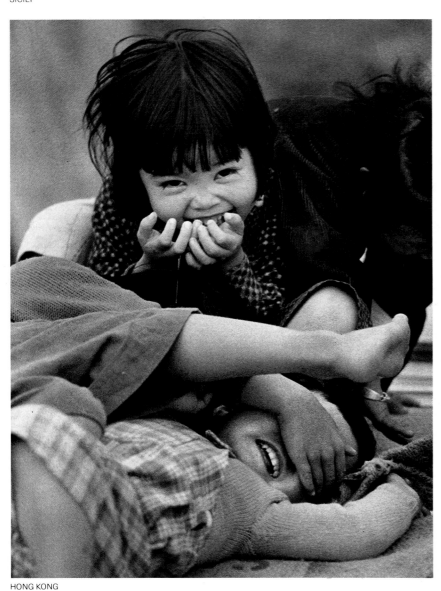

HONG KONG

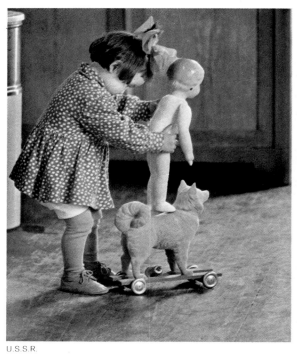

U.S.S.R.

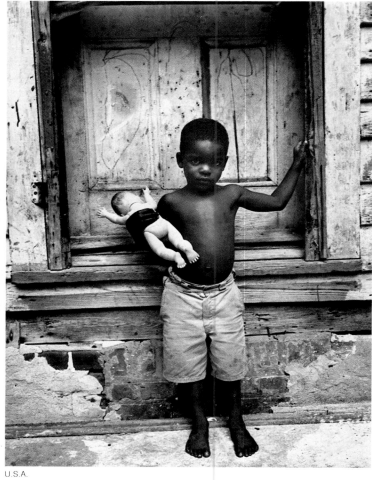

U.S.A.

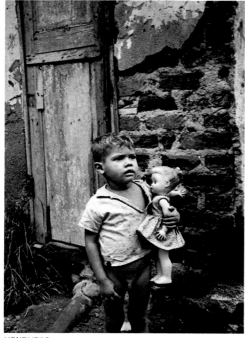

HONDURAS

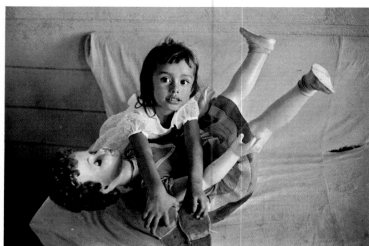

NICARAGUA

Several of nature's people
I know, and they know me;
I feel for them a transport
Of cordiality. Emily Dickinson

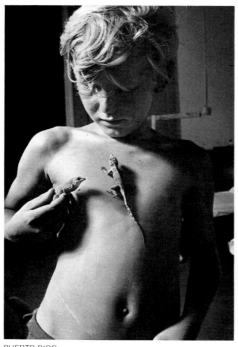

PUERTO RICO

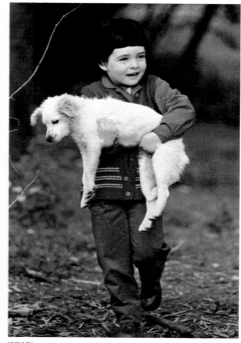

ISRAEL

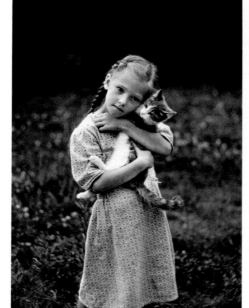

U.S.A.

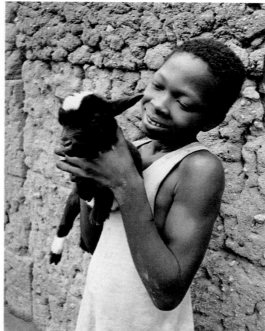

GHANA

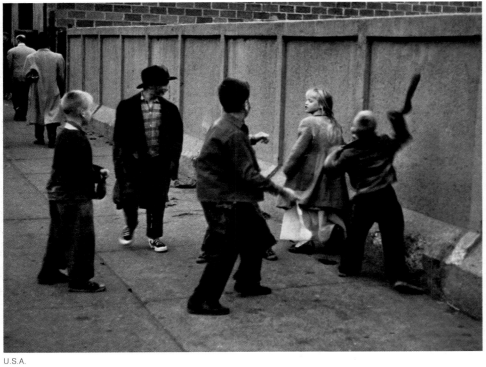

U.S.A.

BULGARIA

I am the enemy you killed, my friend. Wilfred Owen

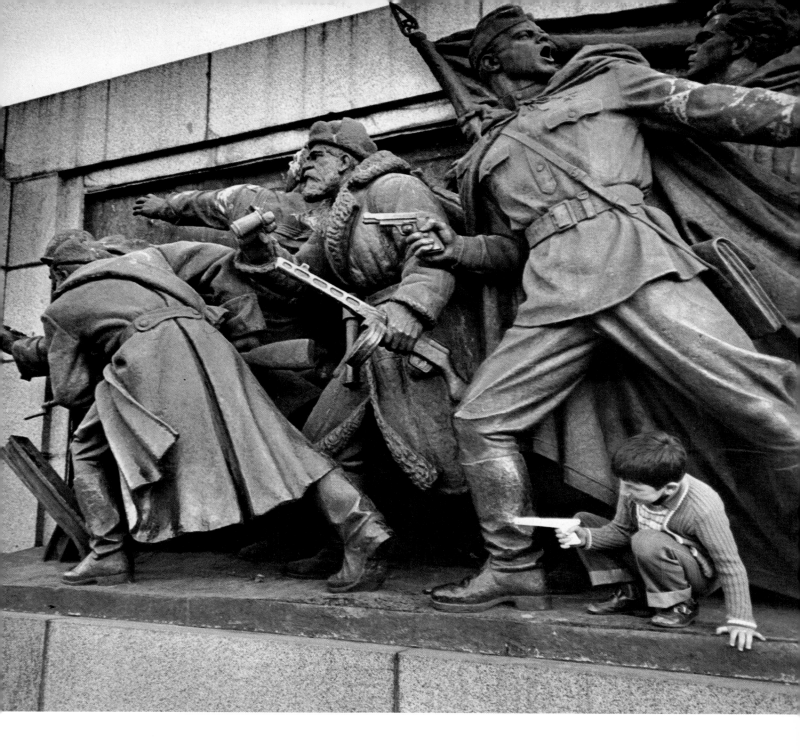

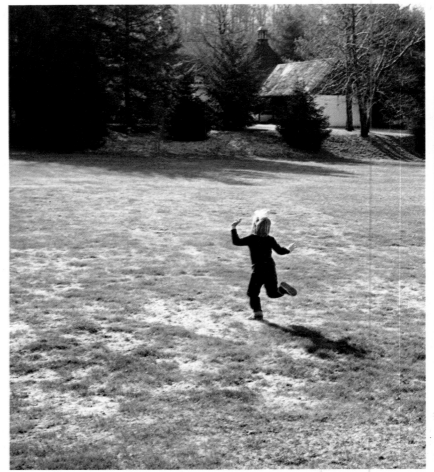

U.S.A.

EL SALVADOR

SOMALIA

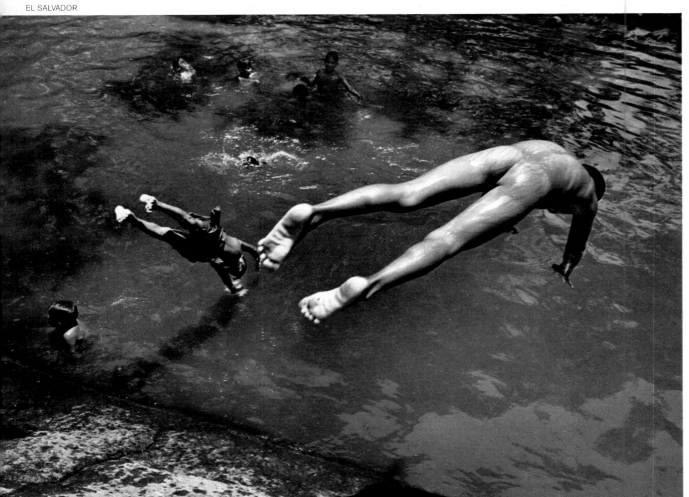

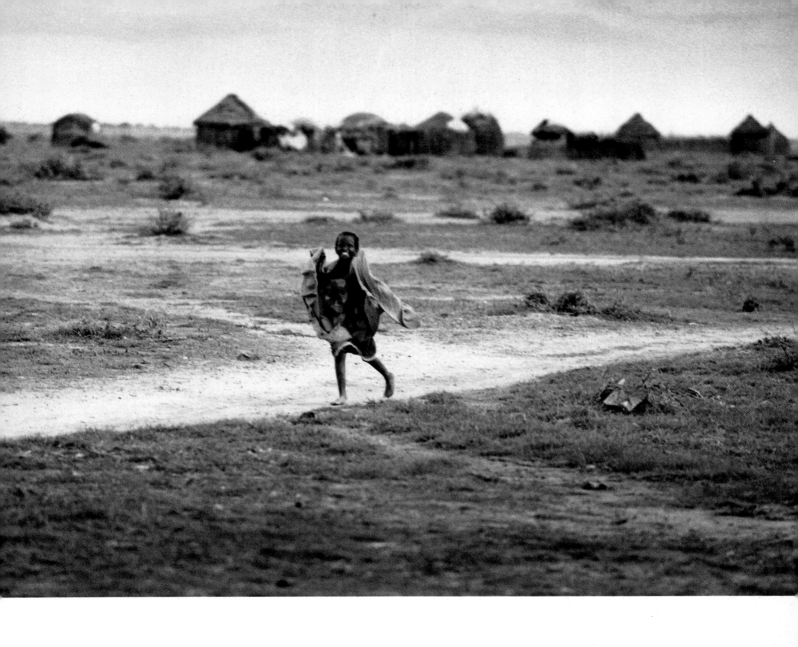

All the sun long it was running, it was lovely. Dylan Thomas

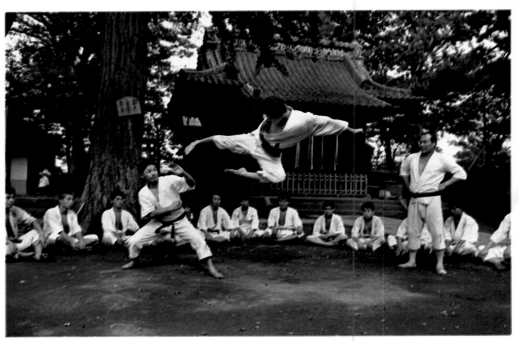

JAPAN

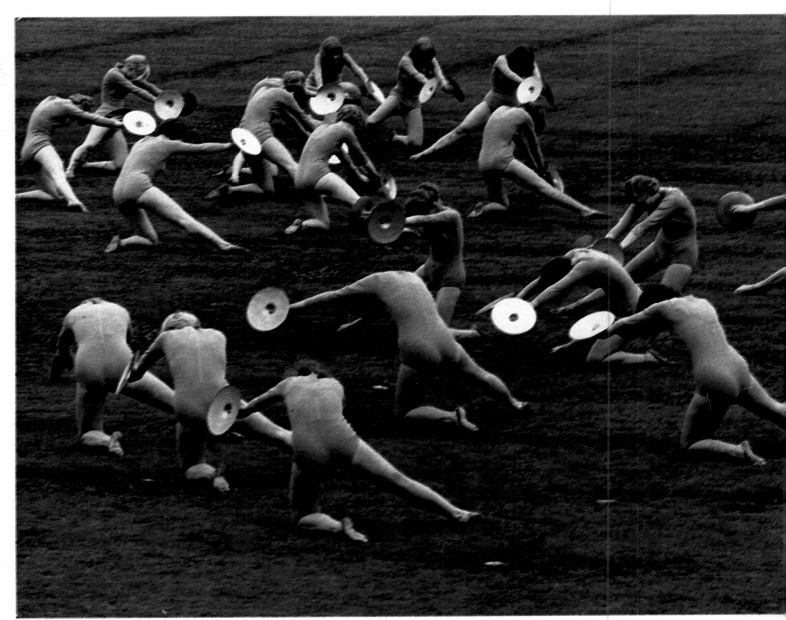

FINLAND

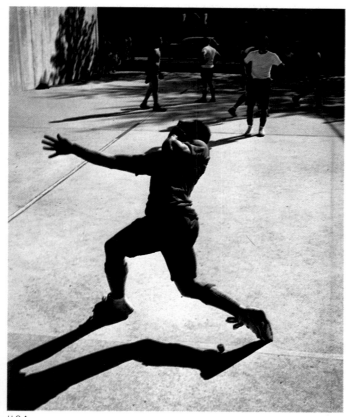

U.S.A.

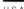

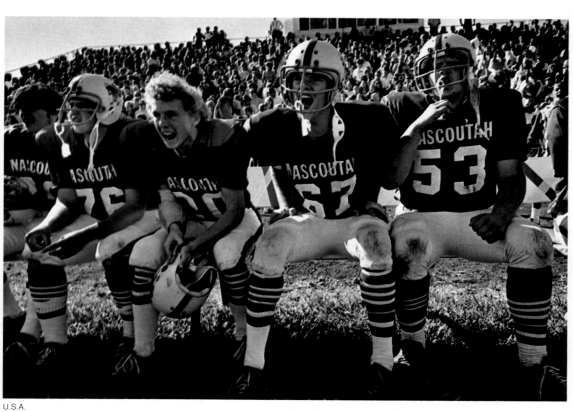

U.S.A.

Their flesh has the old divine suppleness and strength,
They know how to swim, row, ride, wrestle,
 shoot, run, strike, retreat, advance,
 resist, defend themselves. Walt Whitman

BALI

U.S.A.

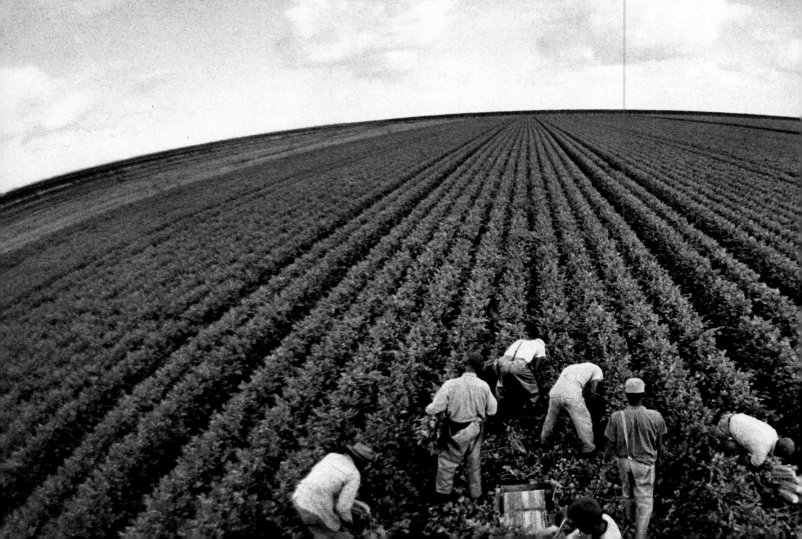

The desert shall rejoice, and blossom as the rose. Isaiah

NIGERIA

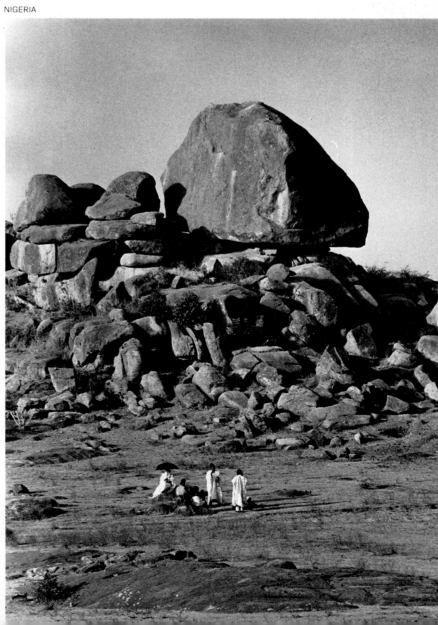

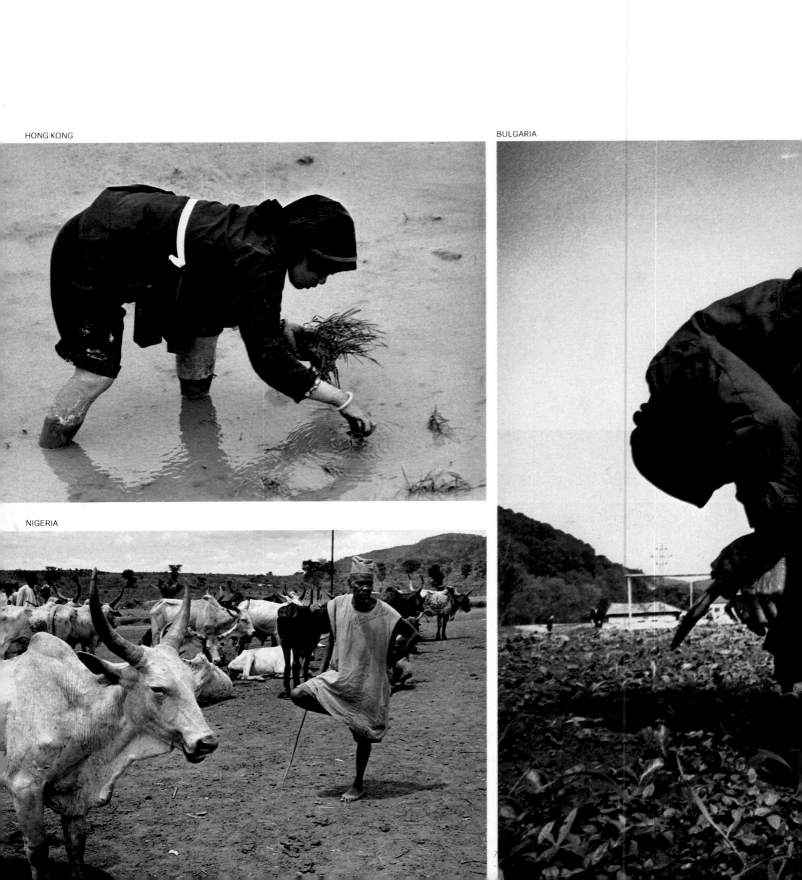

HONG KONG

NIGERIA

BULGARIA

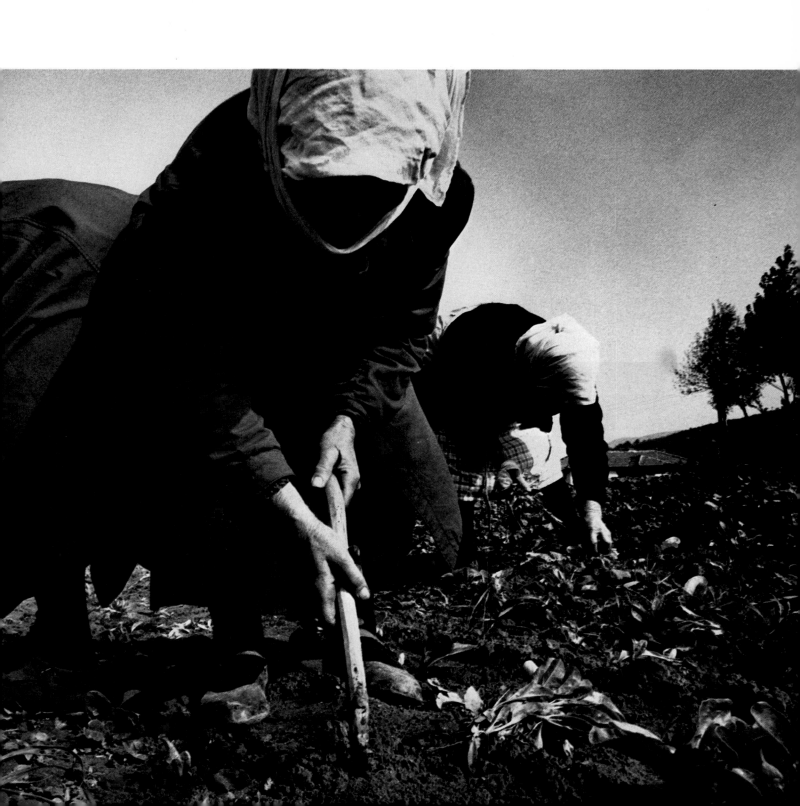

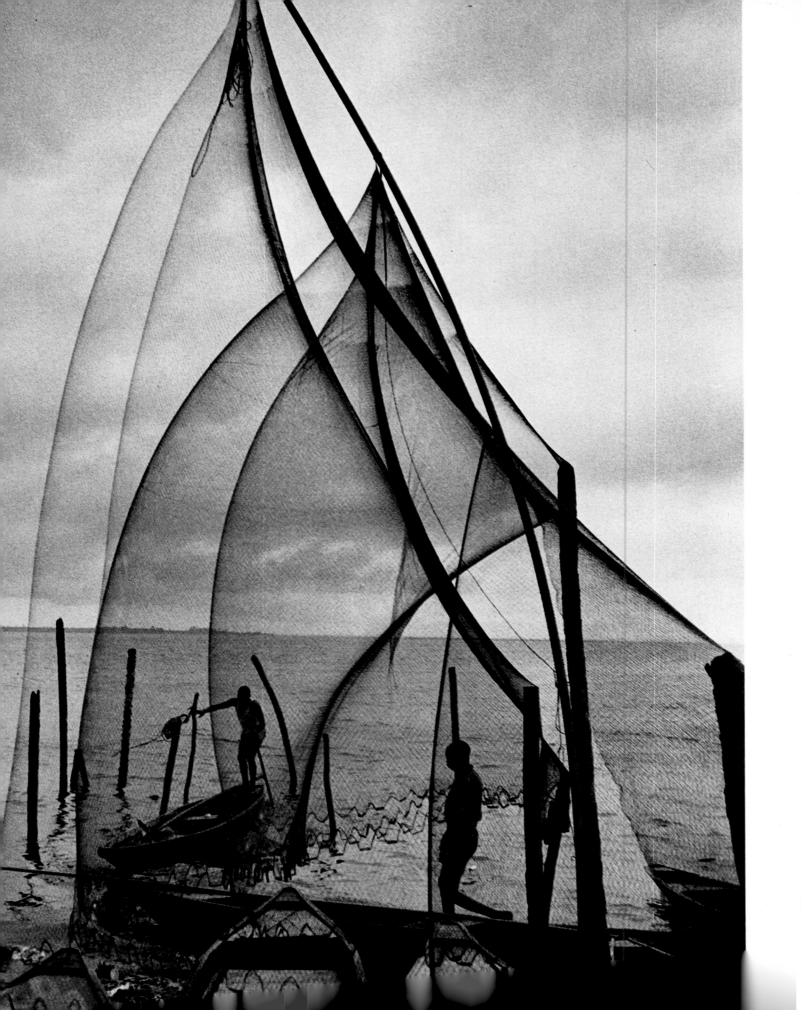

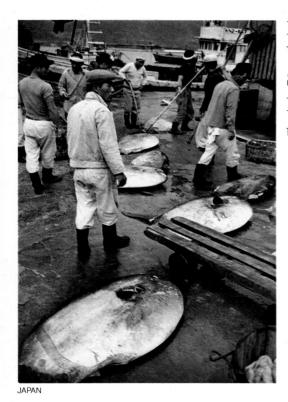

If only the world
Would always remain this way,
Some fisherman
Drawing a little rowboat
up the river bank. Minamoto No Sanetomo

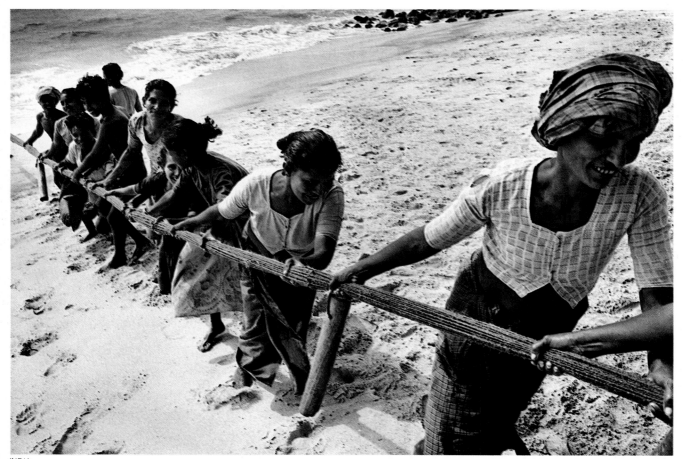

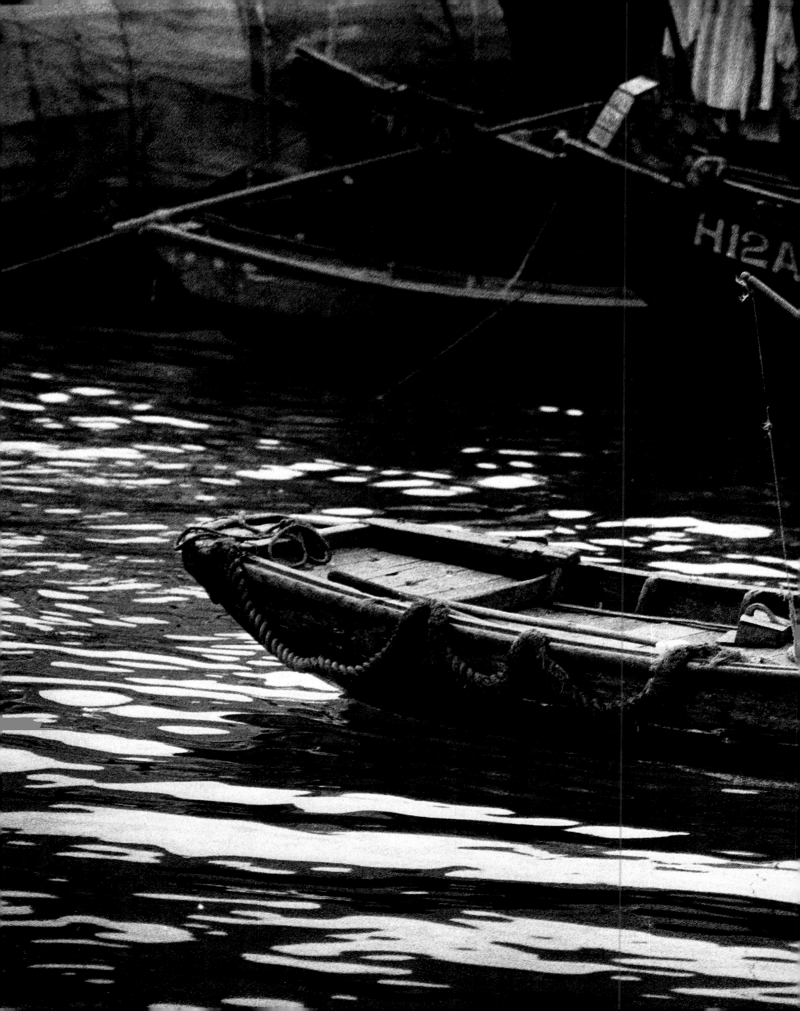

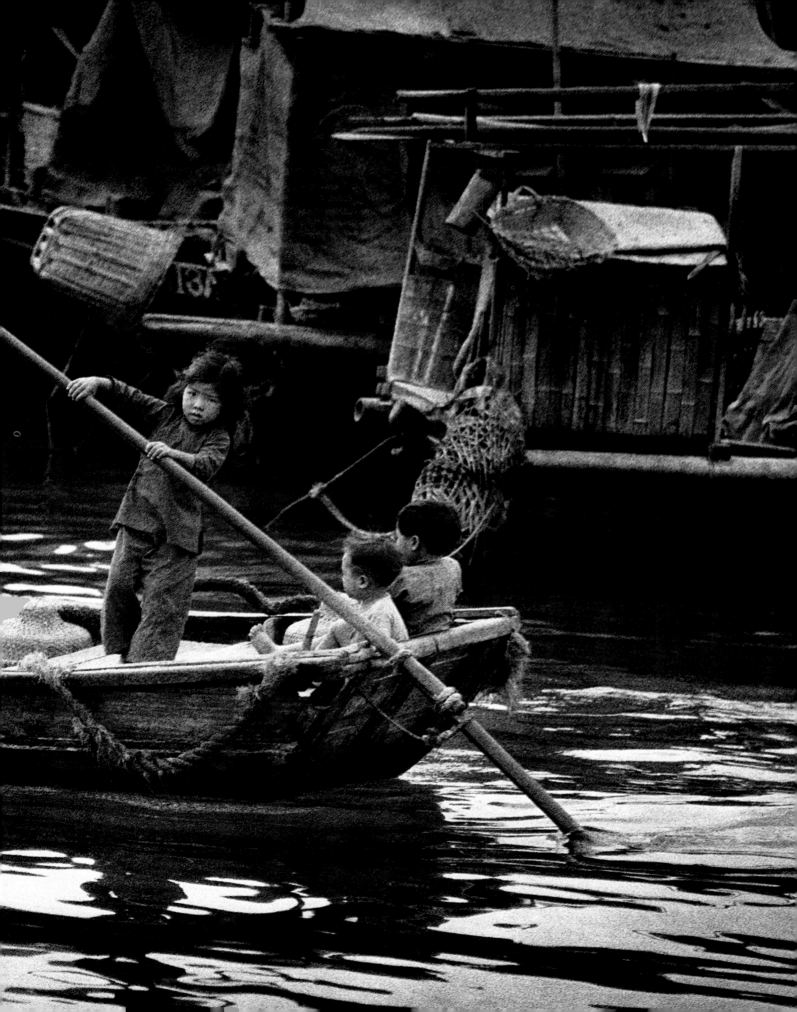

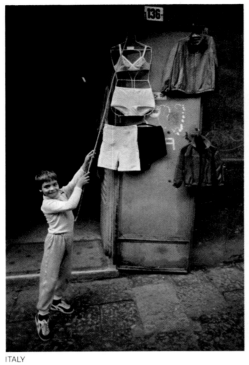

ITALY

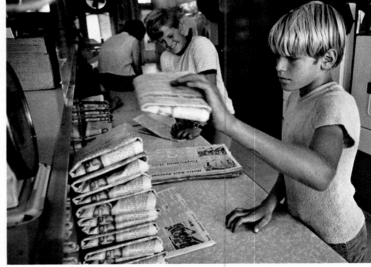

U.S.A.

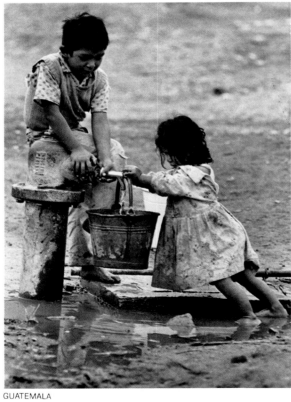

GUATEMALA

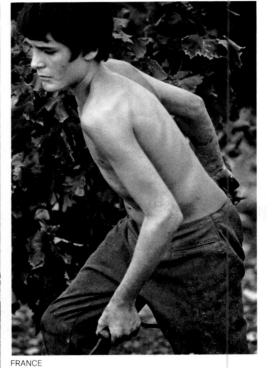

FRANCE

I arise, I face the sunrise,
And do the things my fathers learned to do. Conrad Aiken

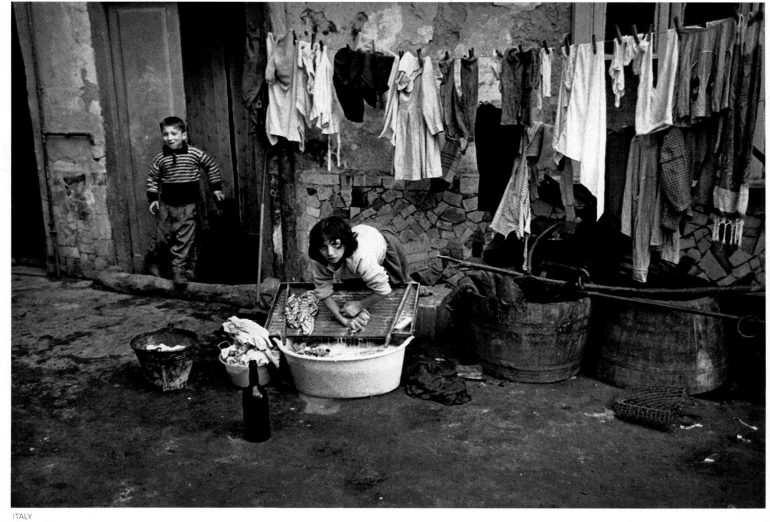

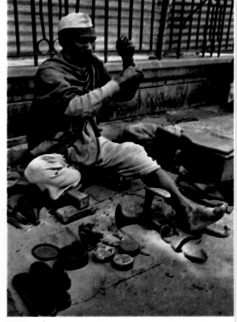

INDIA

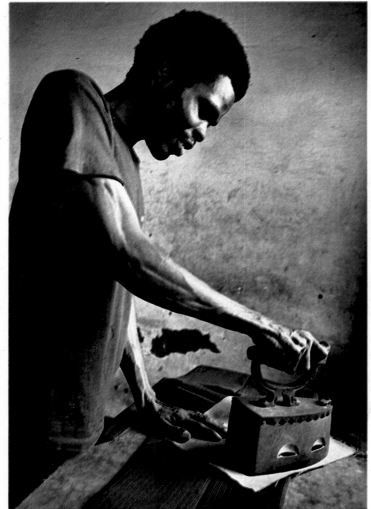

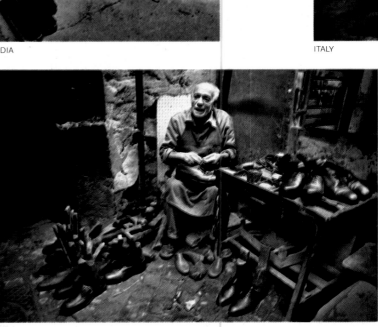

ITALY

ITALY

NIGERIA

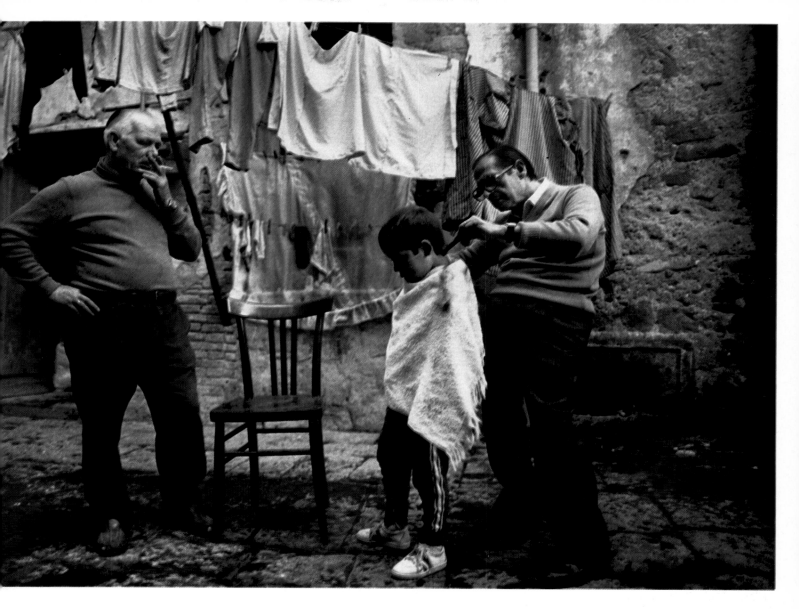

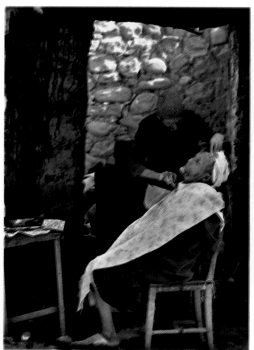

MOROCCO

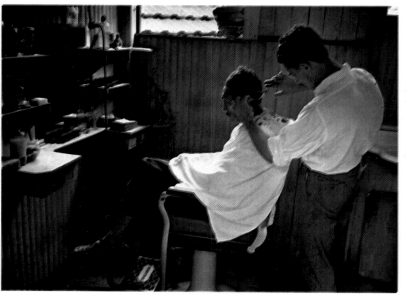

BRAZIL

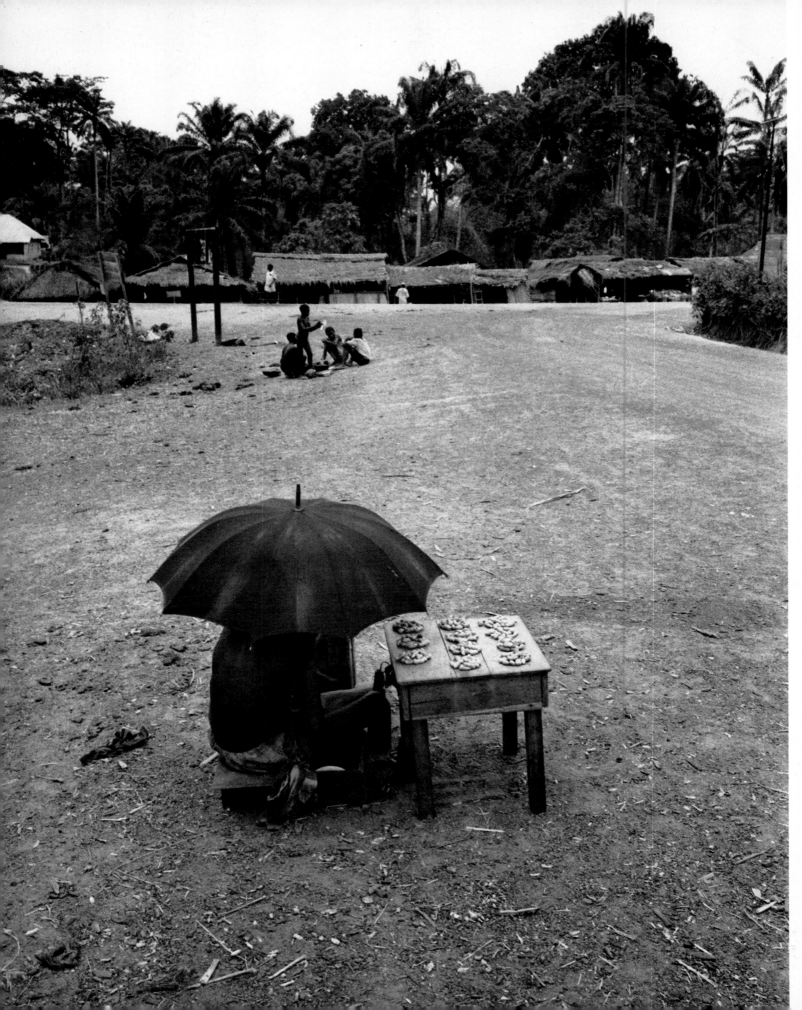

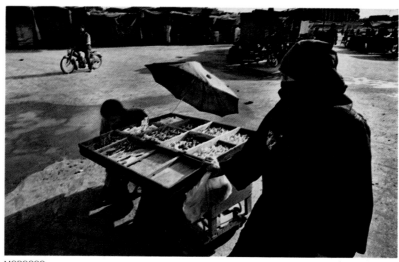

MOROCCO

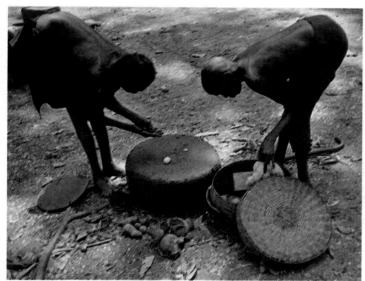

NIGERIA

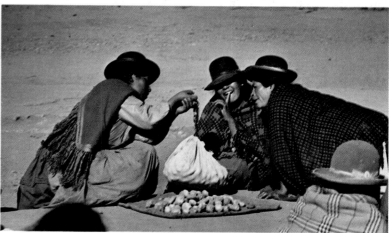

PERU

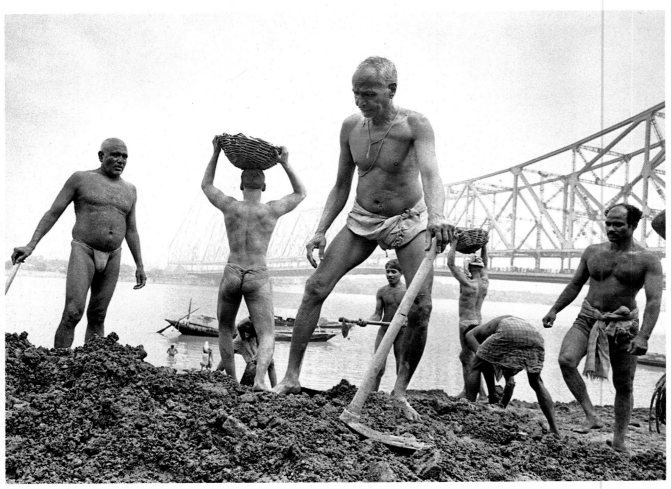

INDIA

No man is born into the world whose work
Is not born with him. James Russell Lowell

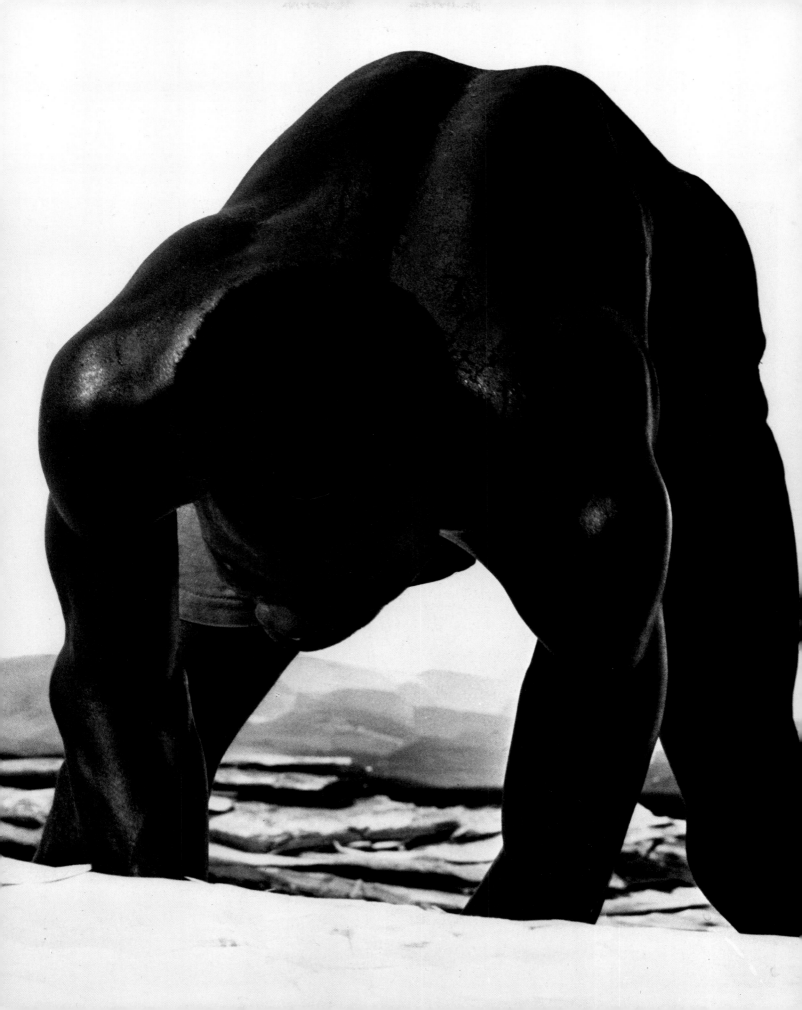

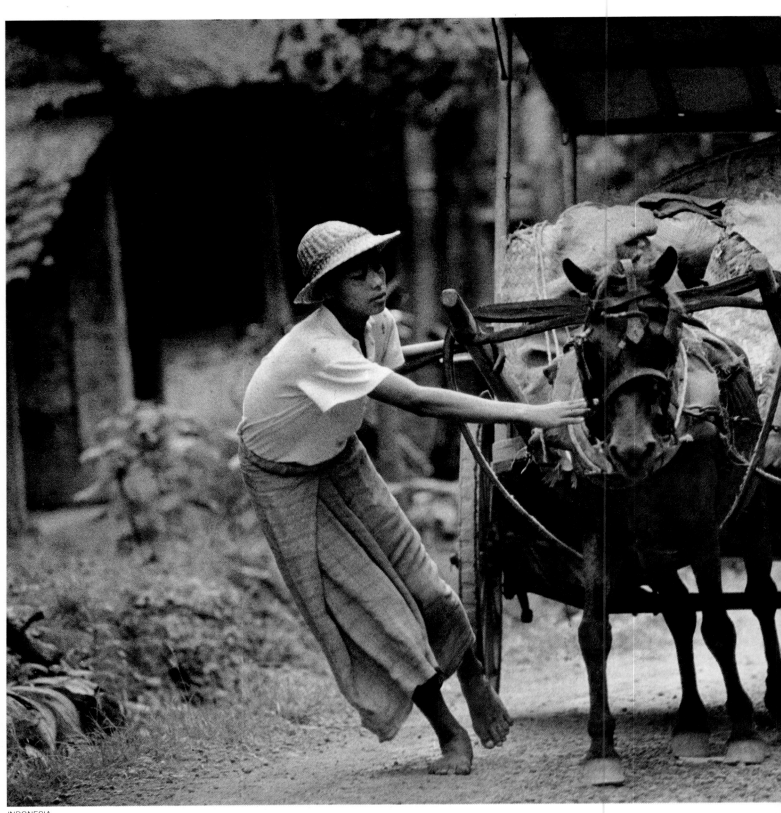

INDONESIA

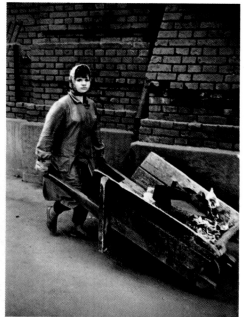

U.S.S.R.

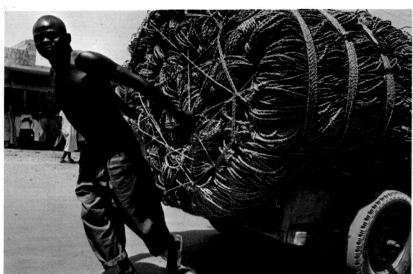

NIGERIA

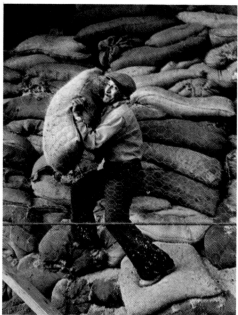

COLOMBIA

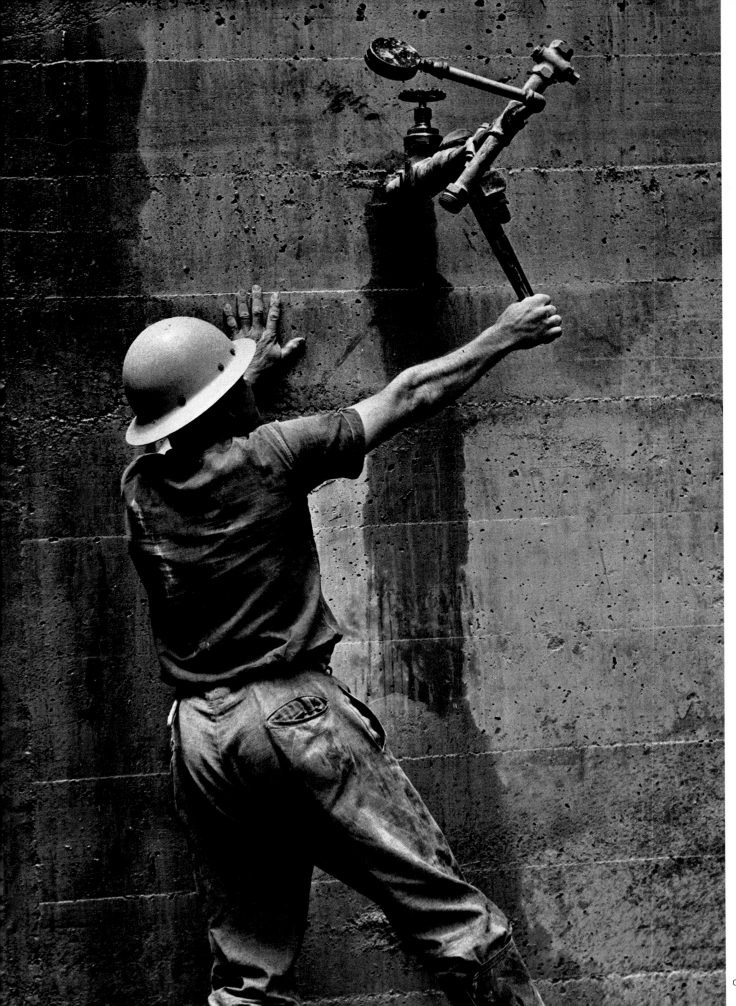

COSTA RICA

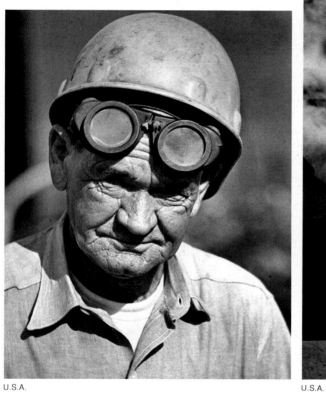

U.S.A.

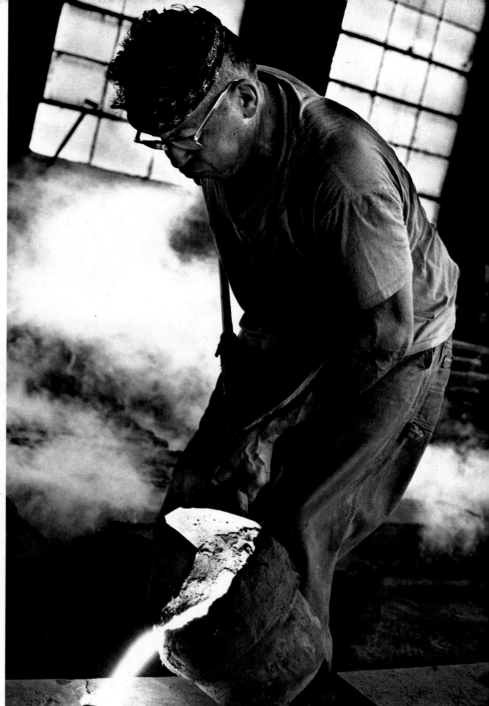

U.S.A.

When a man spends the least possible movements on some definite action: that is grace. Anton Chekhov

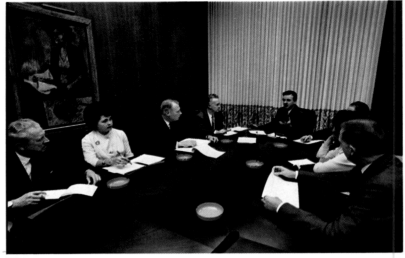

U.S.A.

BULGARIA

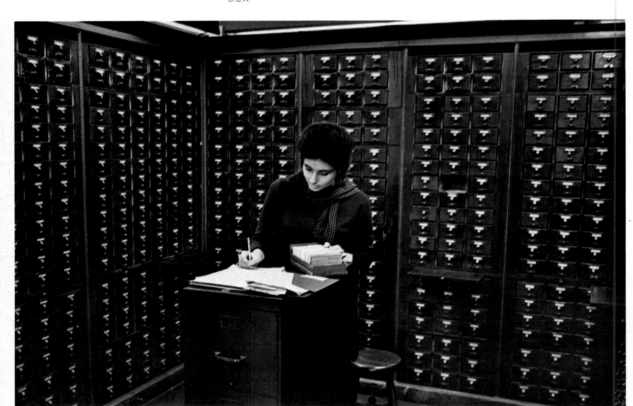

U.S.A.

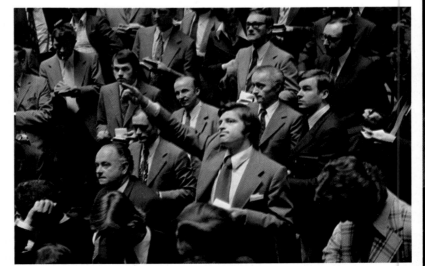

FRANCE

92

Ritual of multigraphs, paper-clip, comma,
Endless duplication of lives and objects. Theodore Roethke

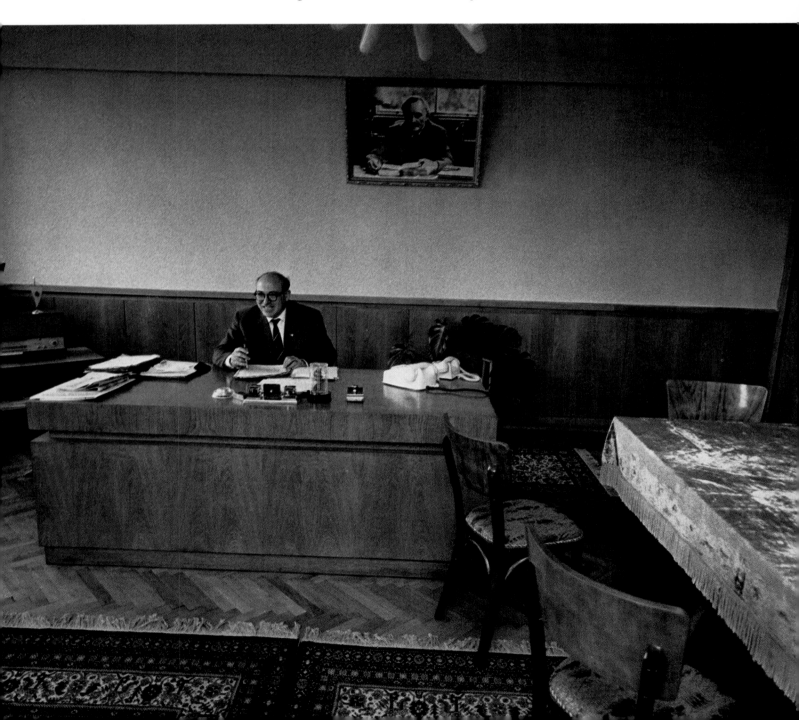

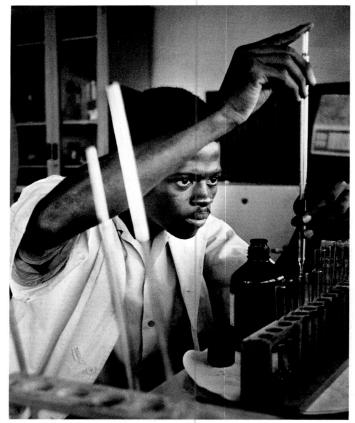

NIGERIA

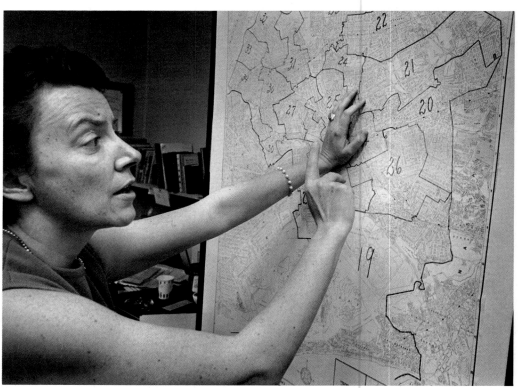

U.S.A.

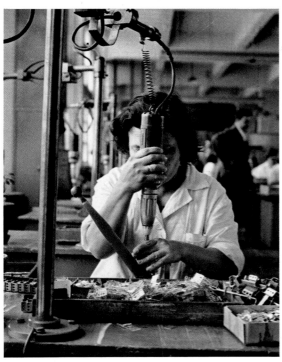

BULGARIA

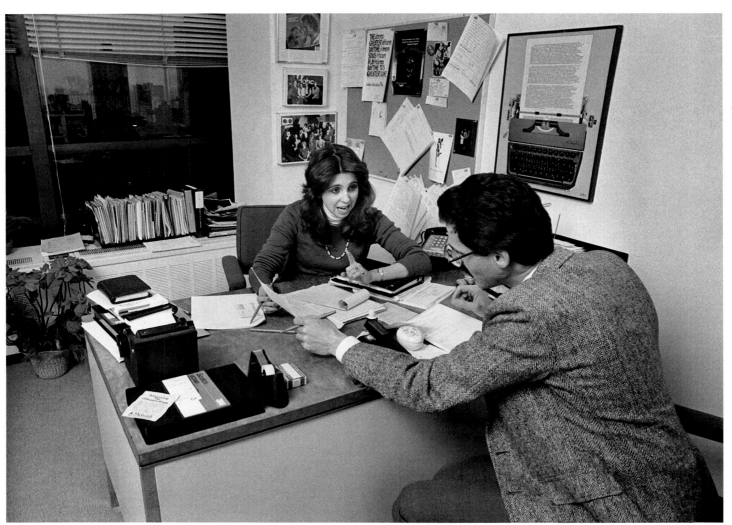

U.S.A.

U.S.A.

Curiosity is, in great and generous minds,
the first passion and the last. Samuel Johnson

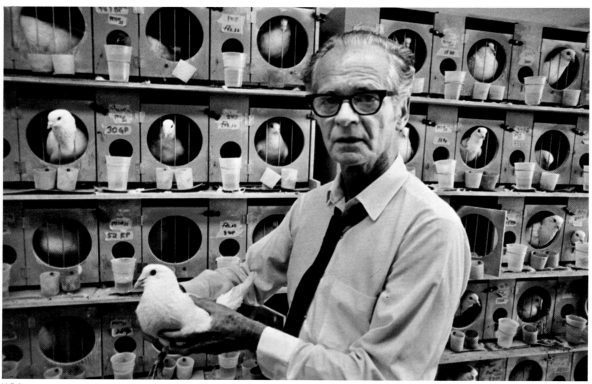

U.S.A.

U.S.A.

U.S.A.

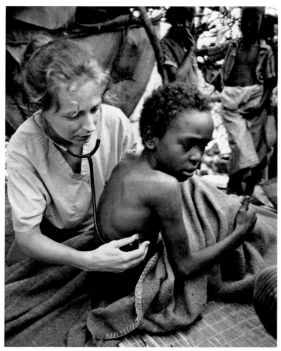

SOMALIA

U.S.A.

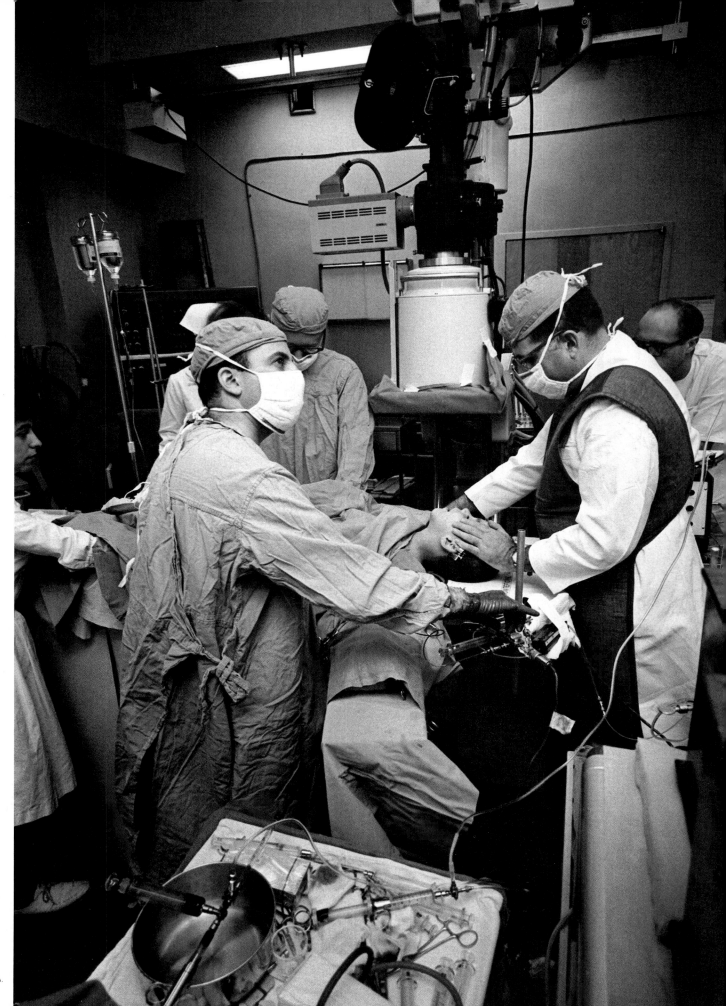

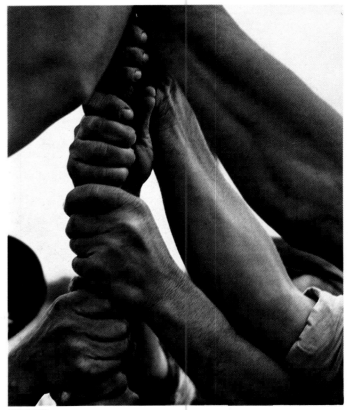

HUNGARY

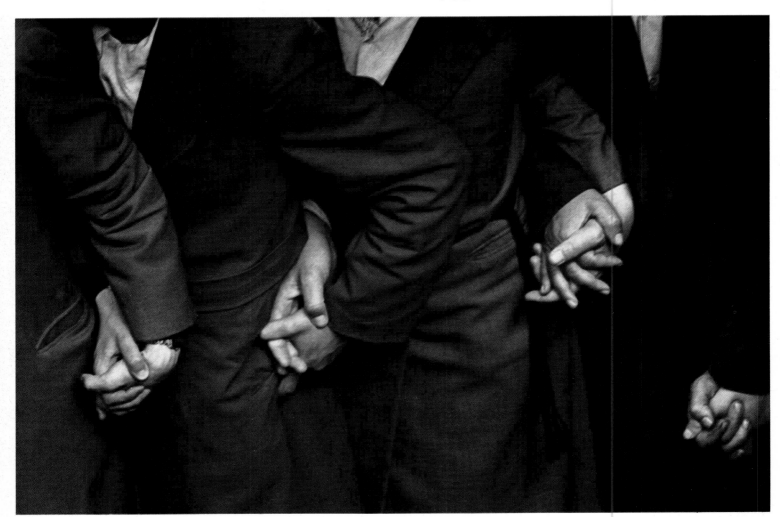

ISRAEL

Now join your hands, and with your hands your hearts. William Shakespeare

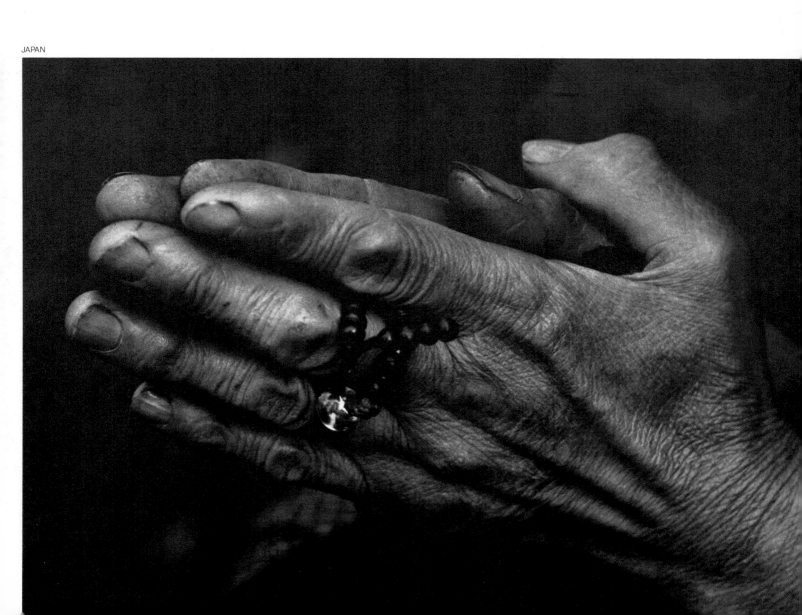

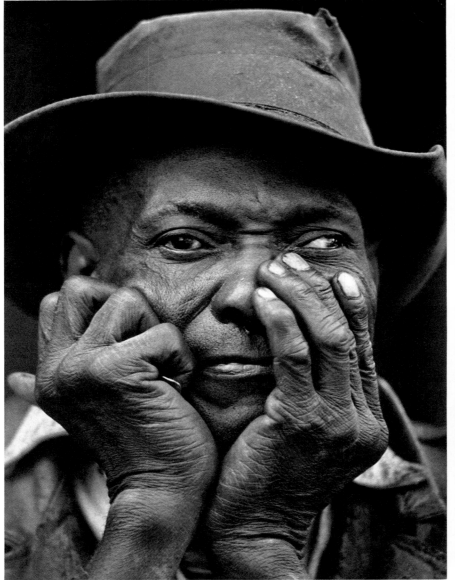

U.S.A.

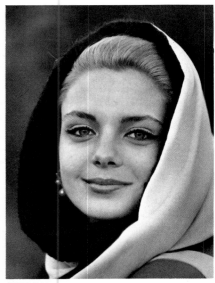

AUSTRALIA

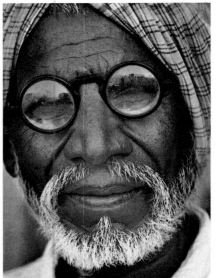

PAKISTAN

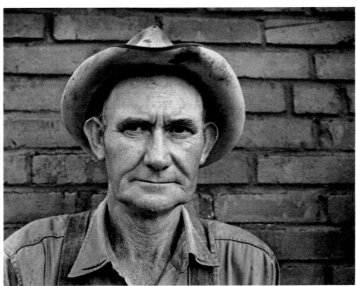

U.S.A.

KENYA

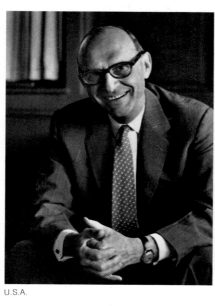

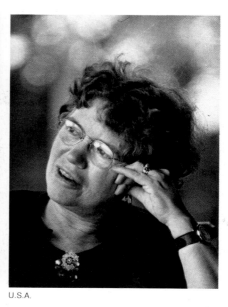

NIGERIA

U.S.A.

U.S.A.

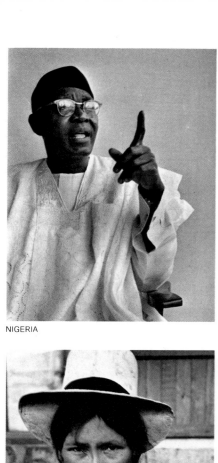

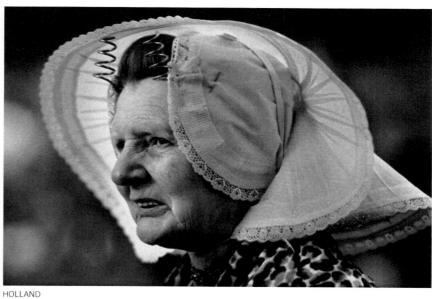

PERU

HOLLAND

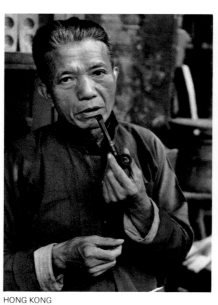

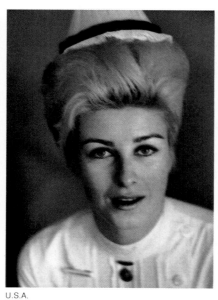

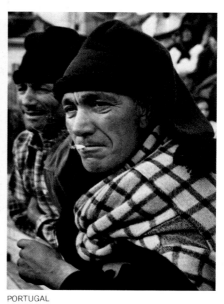

HONG KONG

U.S.A.

PORTUGAL

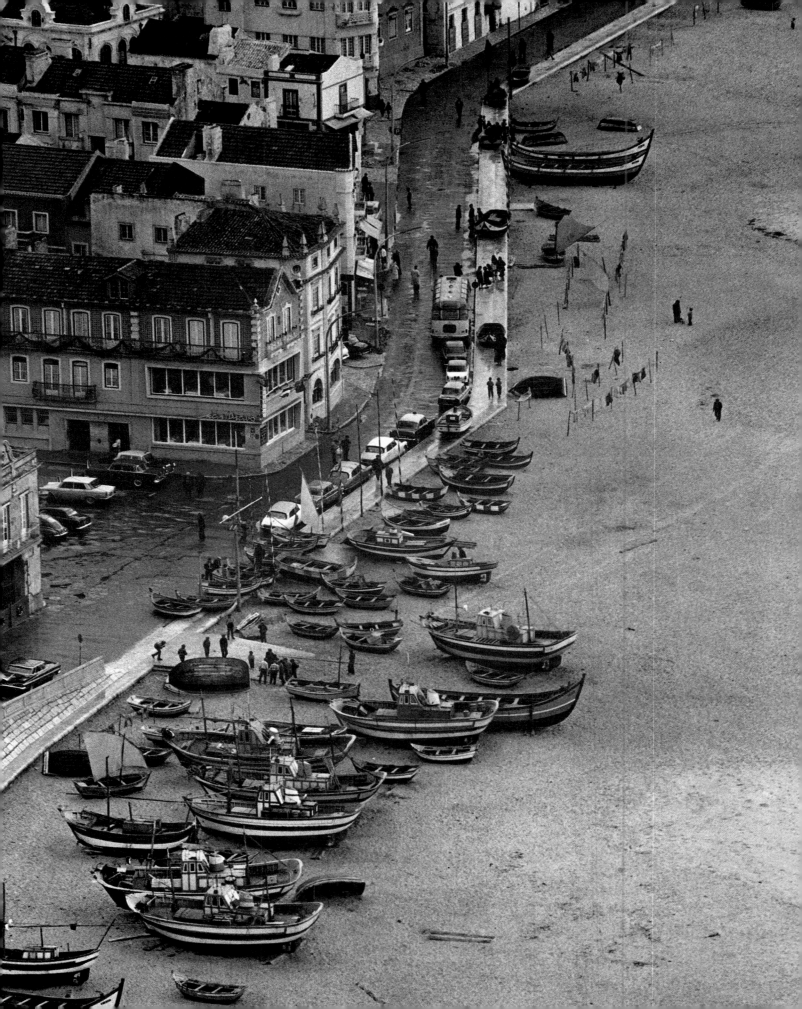

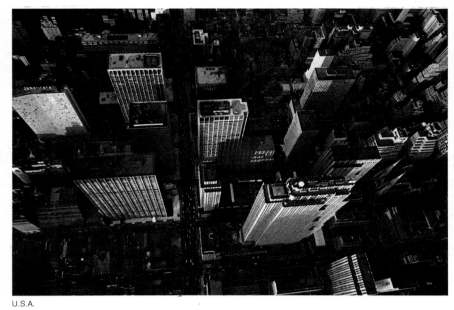

U.S.A.

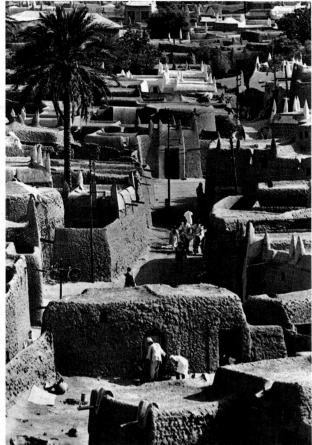

NIGERIA

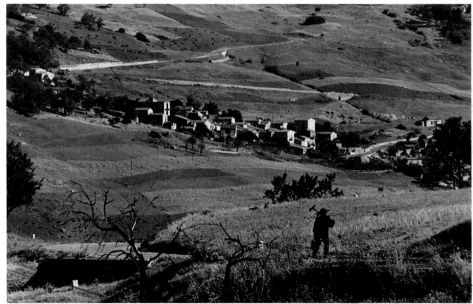

SICILY

And my people shall dwell in a peaceable habitation...
and in quiet resting places. Isaiah

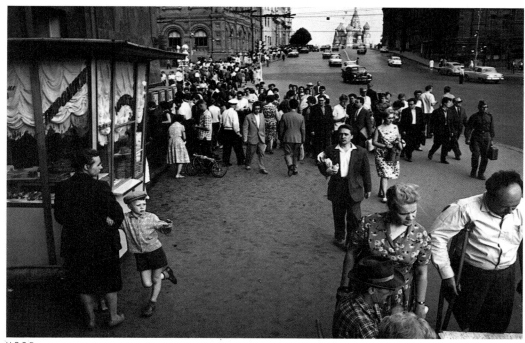

U.S.S.R.

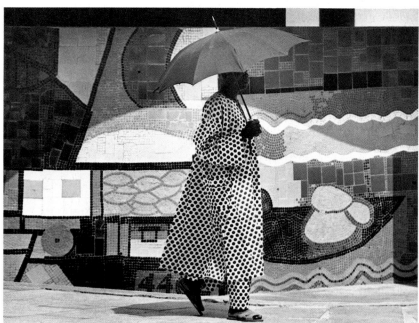

NIGERIA

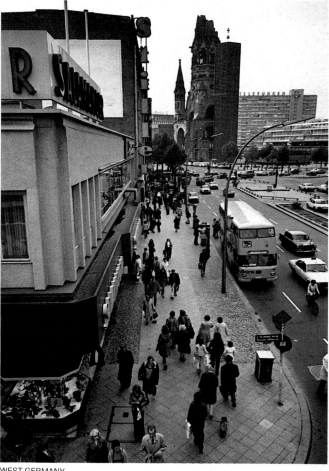

WEST GERMANY

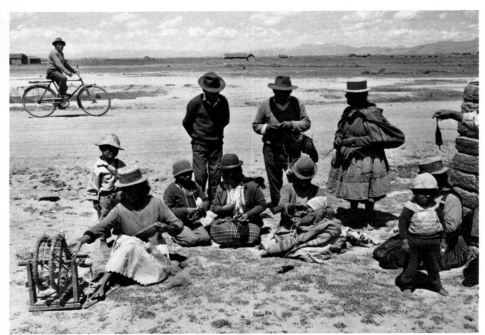

PERU

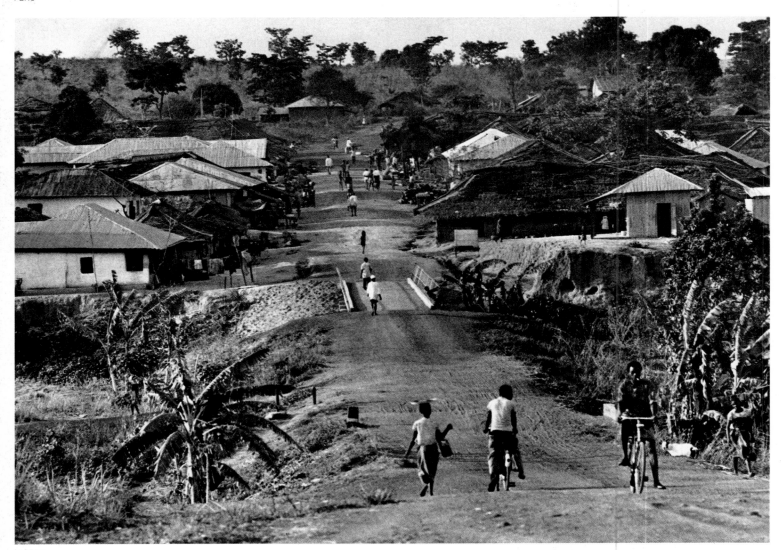

NIGERIA

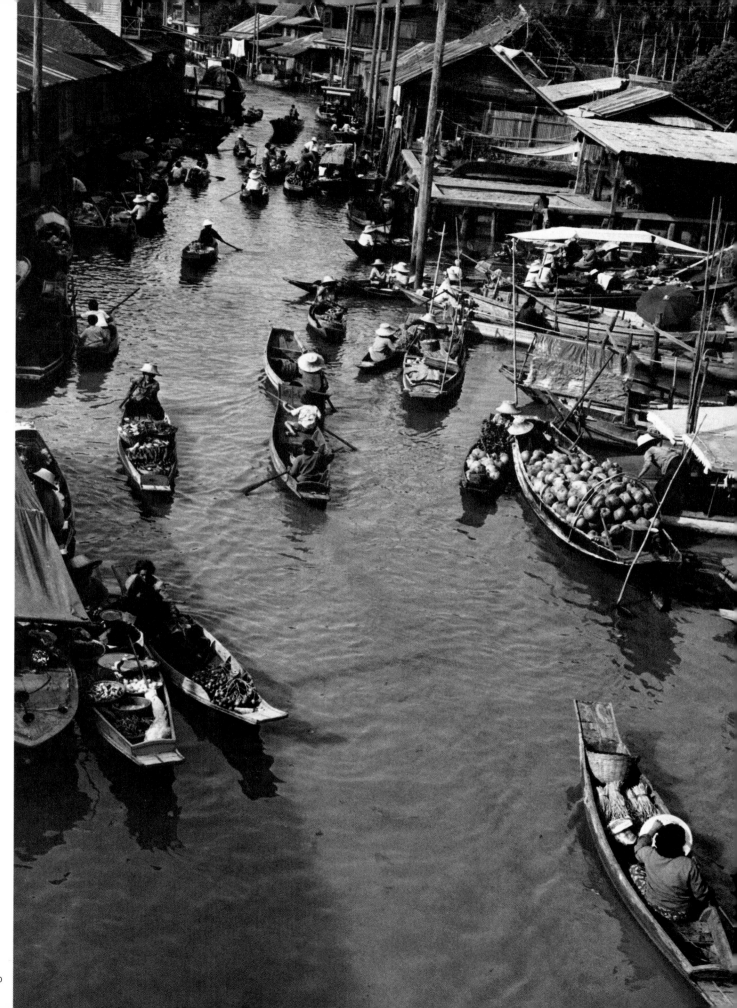

THAILAND

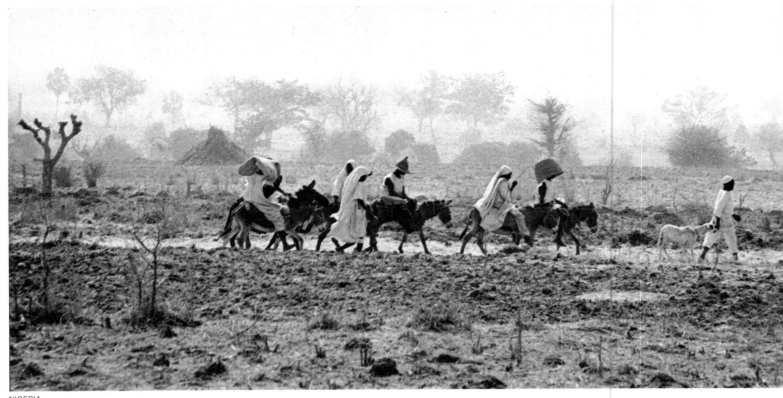

NIGERIA

All is procession;
The universe is a procession,
With measured and beautiful motion.

Walt Whitman

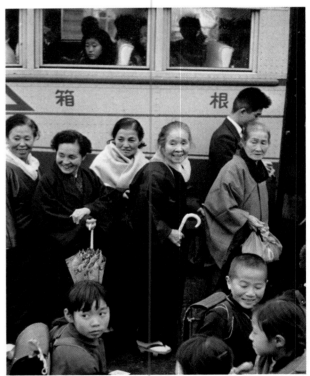

JAPAN

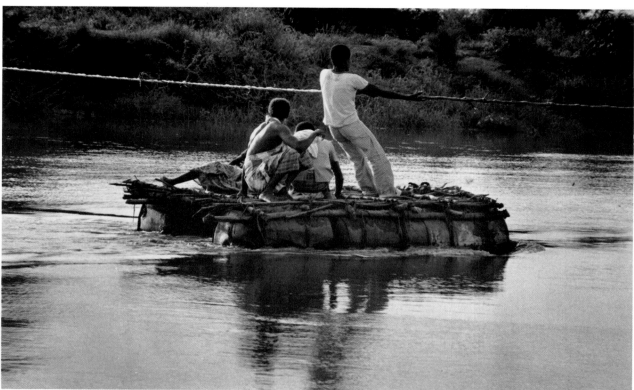

SOMALIA

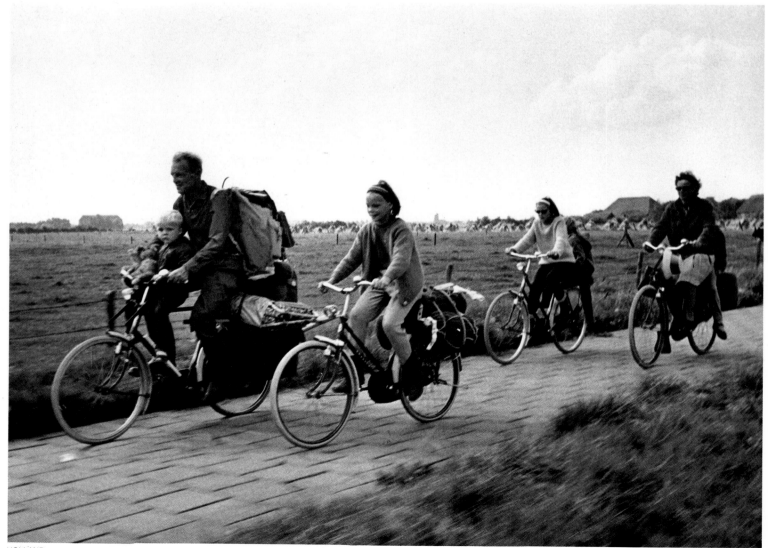

HOLLAND

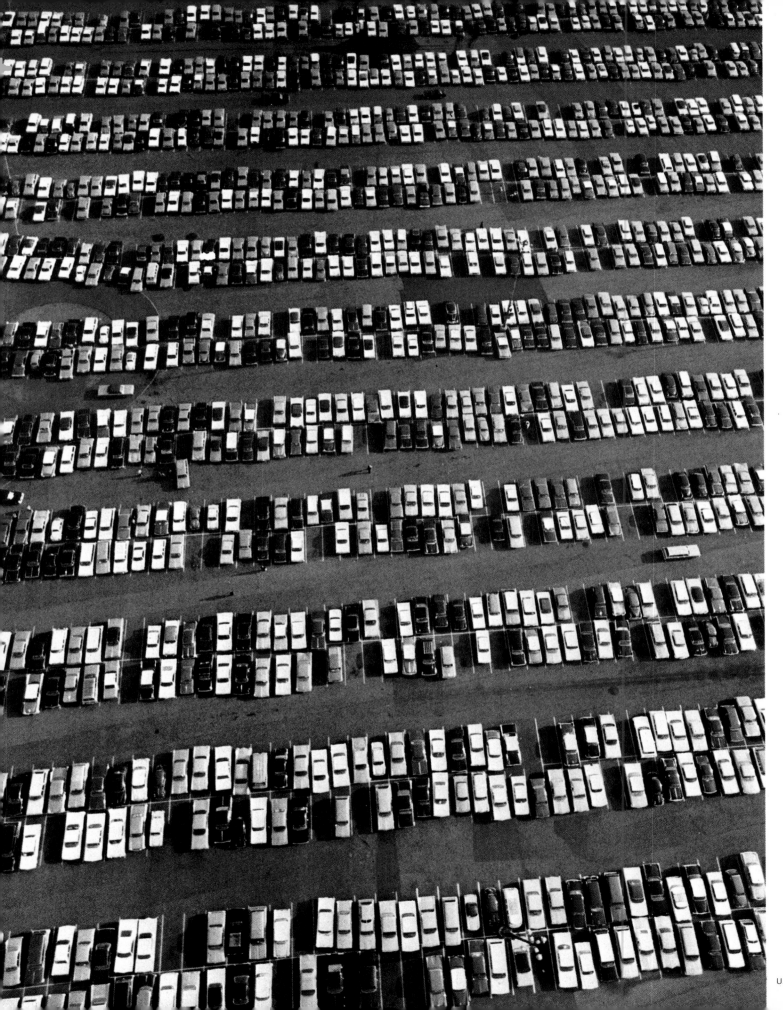

U.S.A.

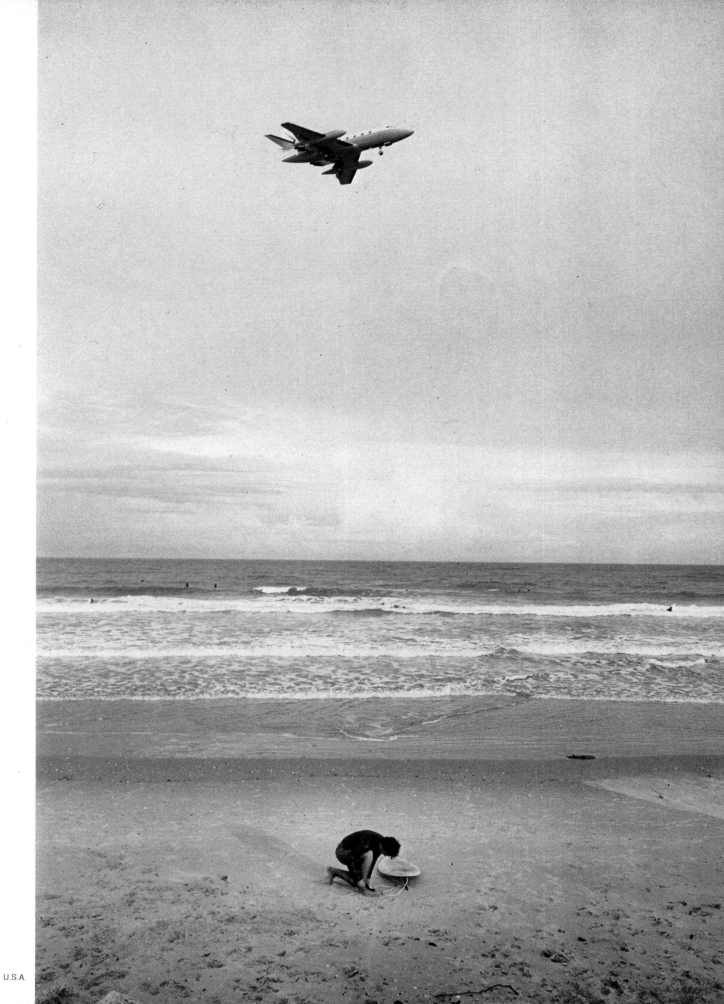

U.S.A.

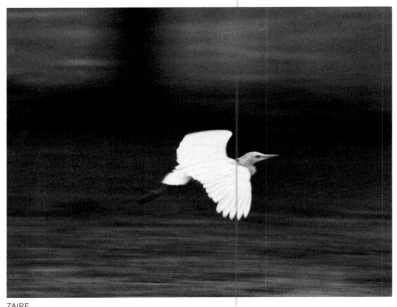

ZAIRE

For only to be alive and to see the light
Is beautiful. Only to see the light;
To see a blade of young grass,
Or the gray face of a stone. Euripides

U.S.A.

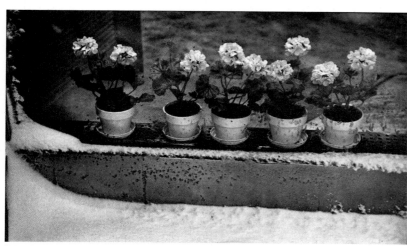

U.S.A.

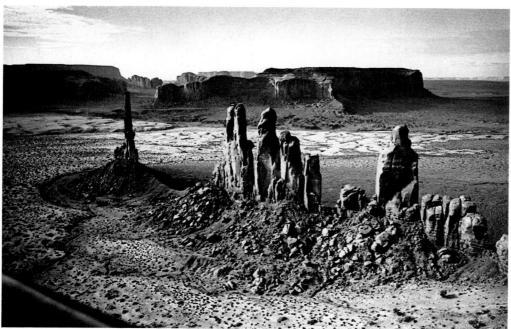

U.S.A.

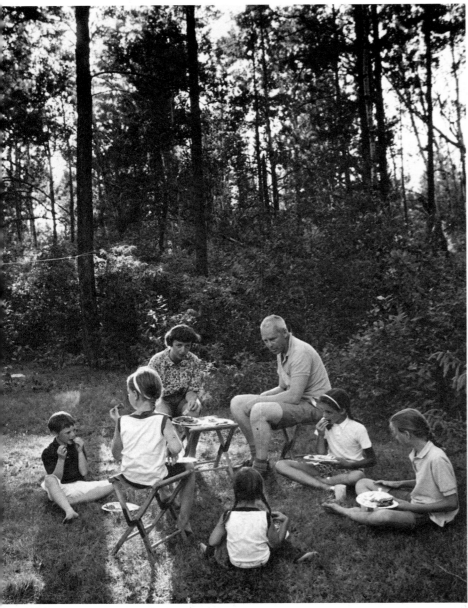

U.S.A.

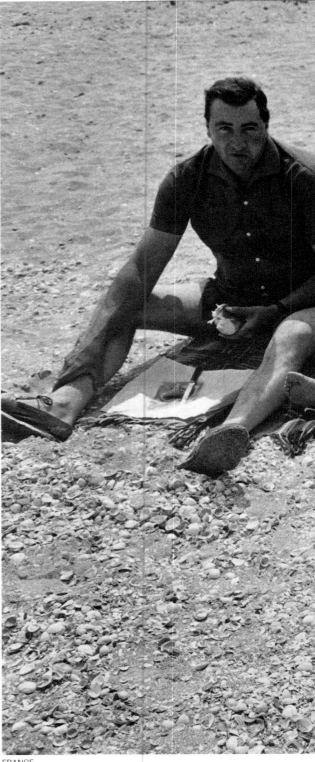

FRANCE

I said in my heart, "I am sick of four walls and a ceiling.
I have need of the sky.
I have business with the grass." Richard Hovey

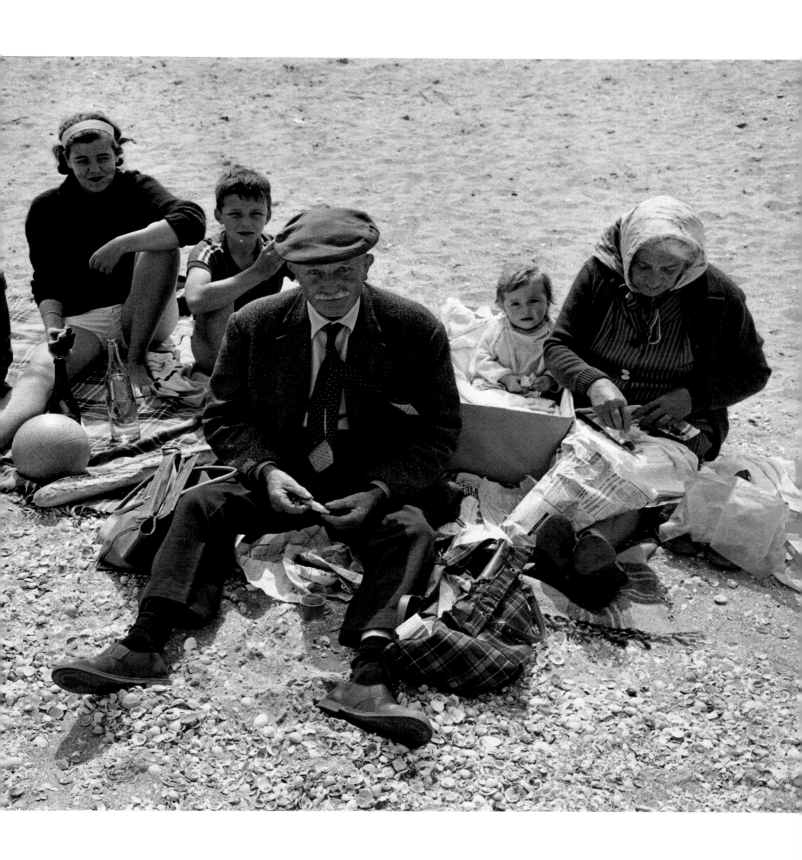

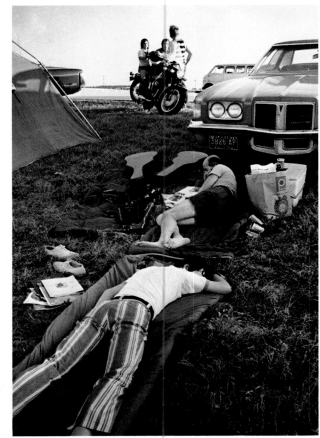

U.S.A.

ENGLAND

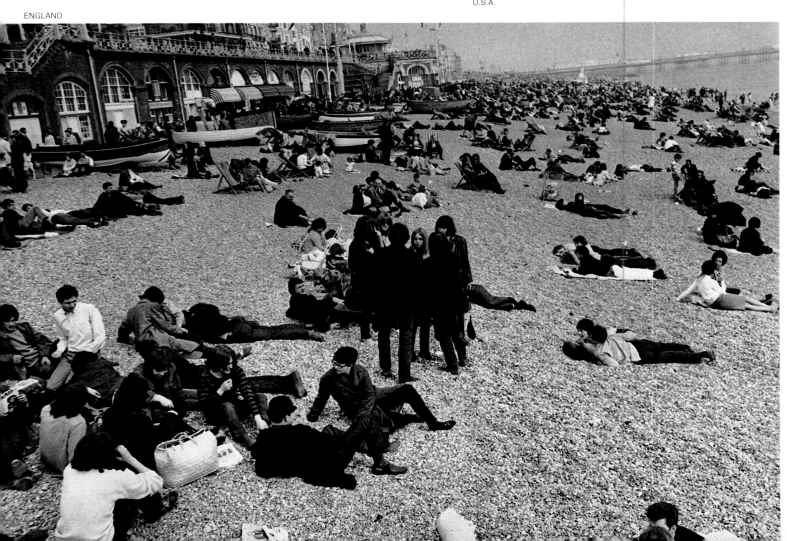

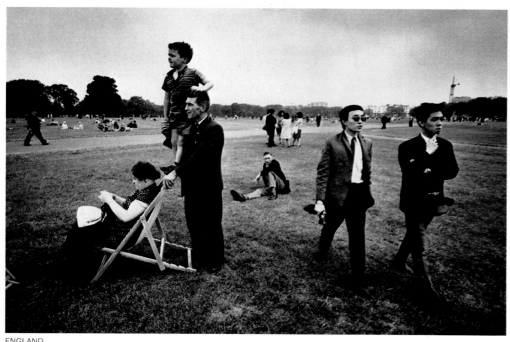

ENGLAND

ENGLAND

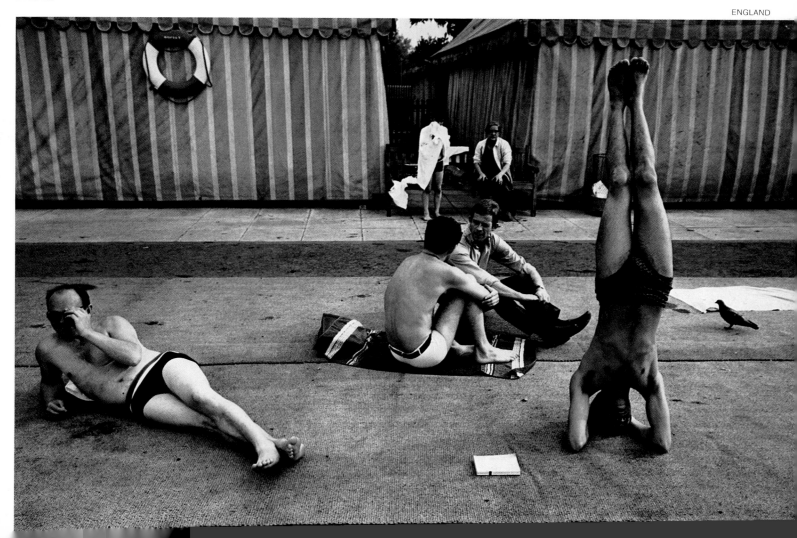

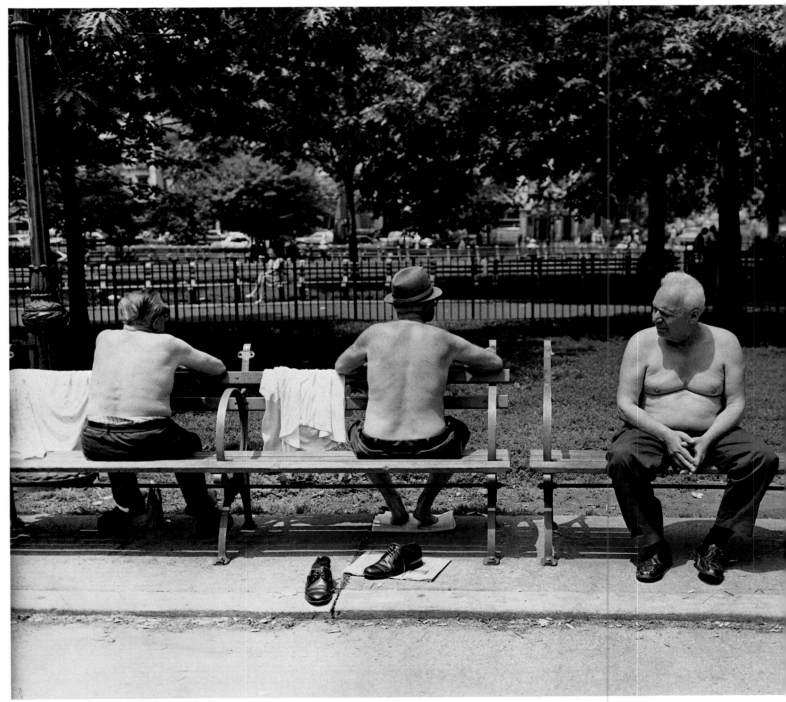

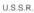

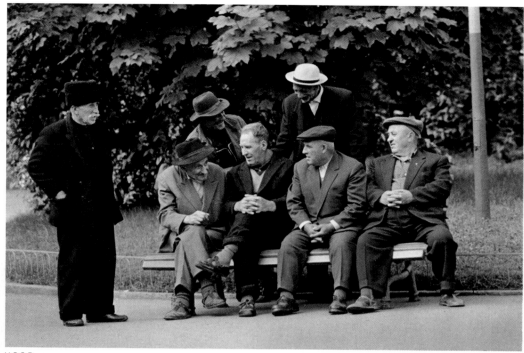

U.S.S.R.

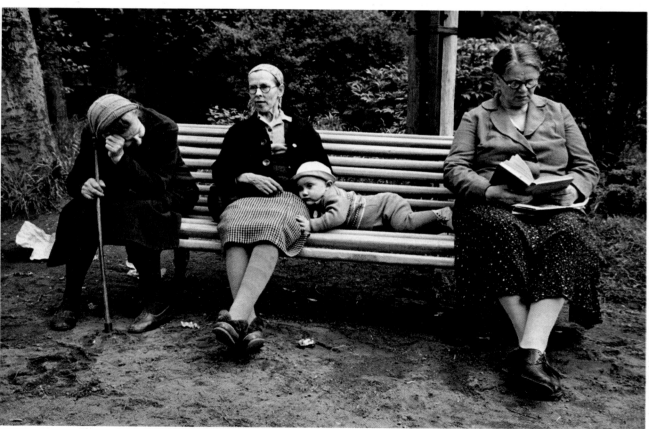

U.S.S.R.

121

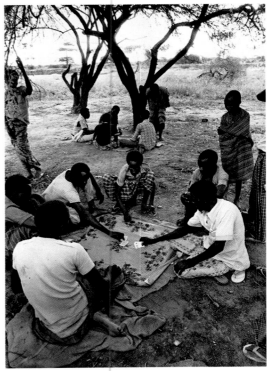

SOMALIA

What a wonderful
day! No one in the village
doing anything. Shiki

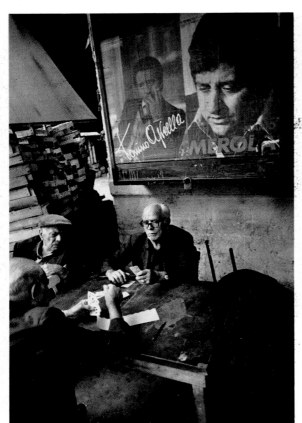

ITALY

SWITZERLAND

122

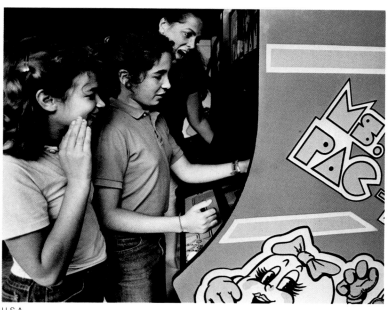

U.S.A.

COLOMBIA

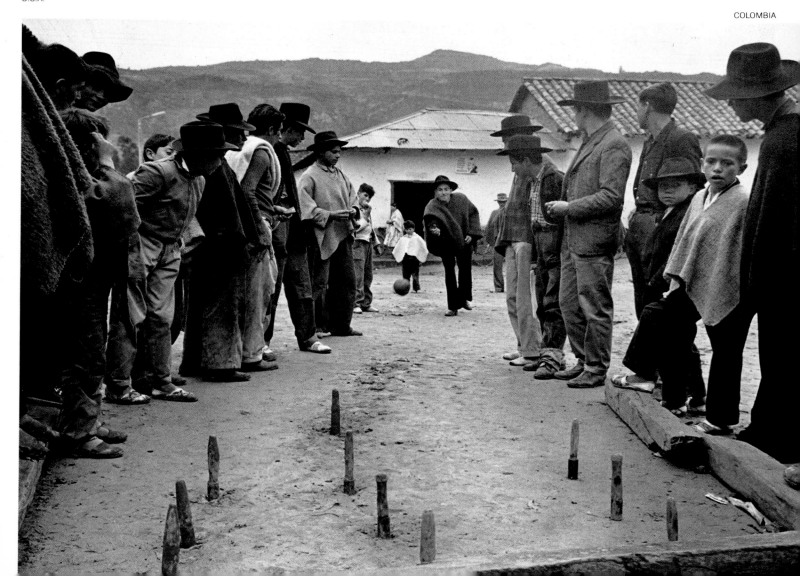

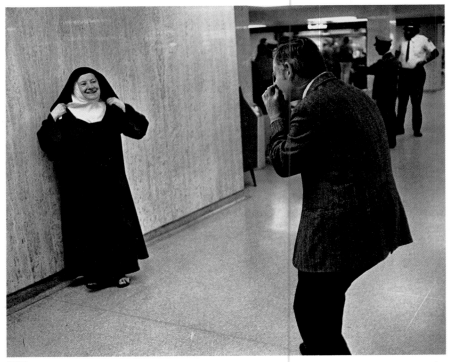

U.S.A.

U.S.A.

FINLAND

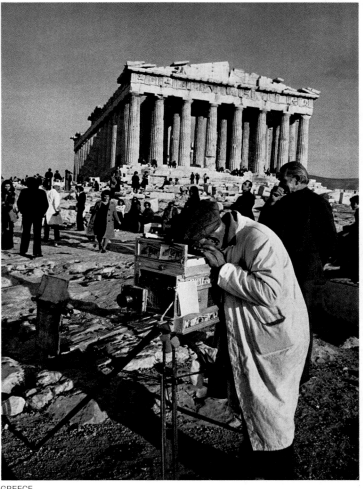

GREECE

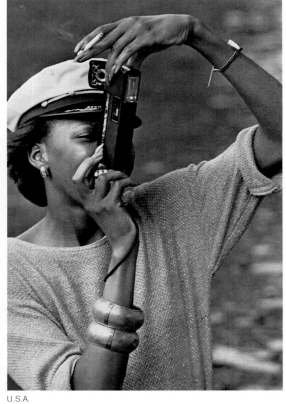

U.S.A.

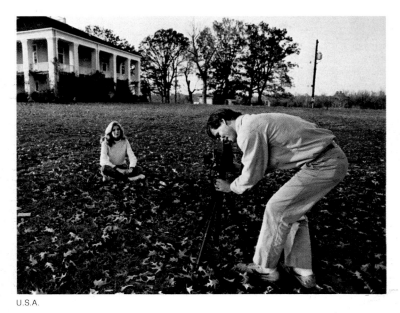

U.S.A.

How strange these early mornings
when the world
gradually
imprints itself
on paper
and I am
left behind on the negative. Sylvia Cole

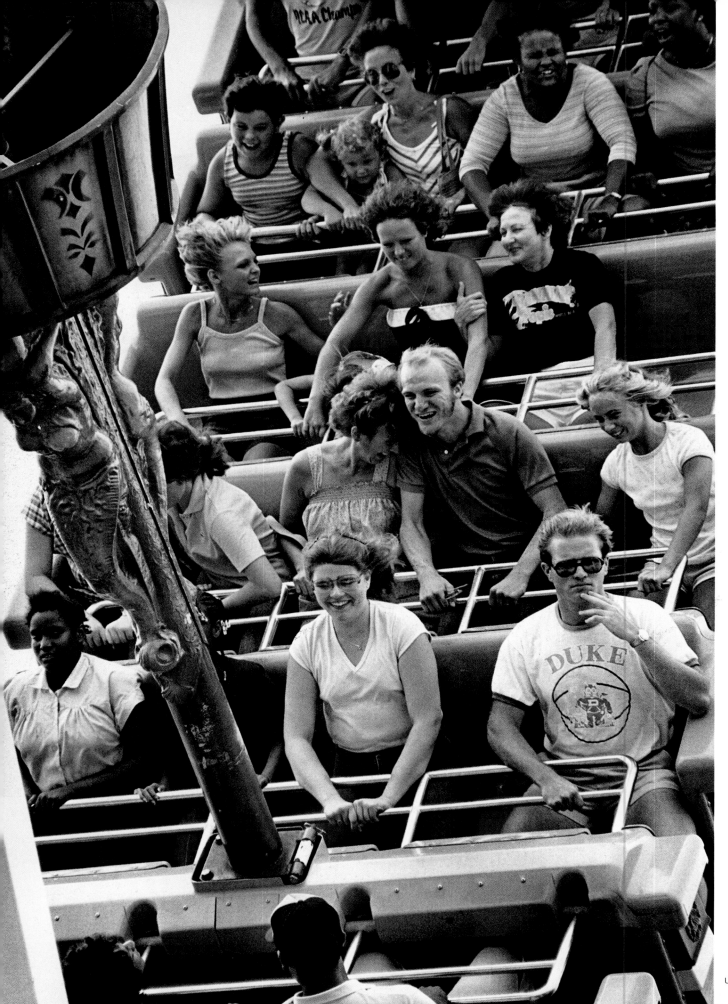

U.S.A.

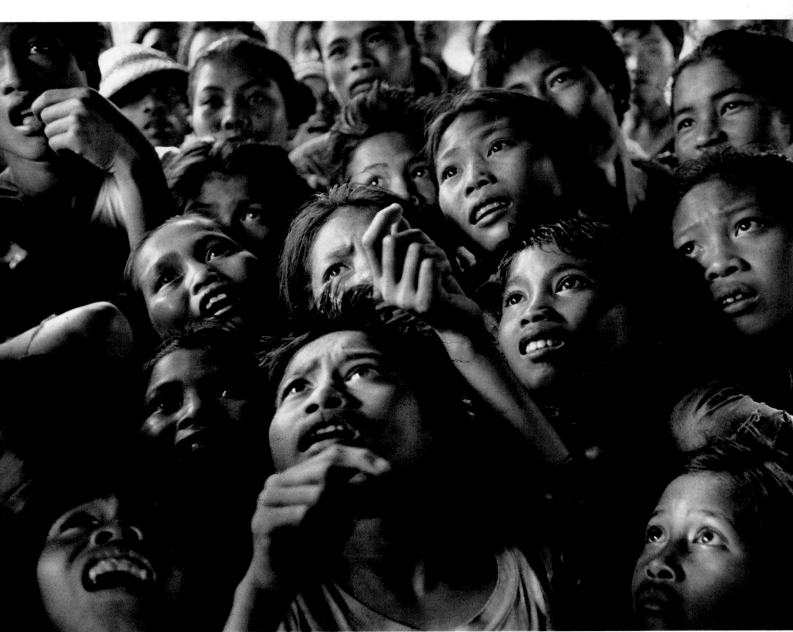

BALI

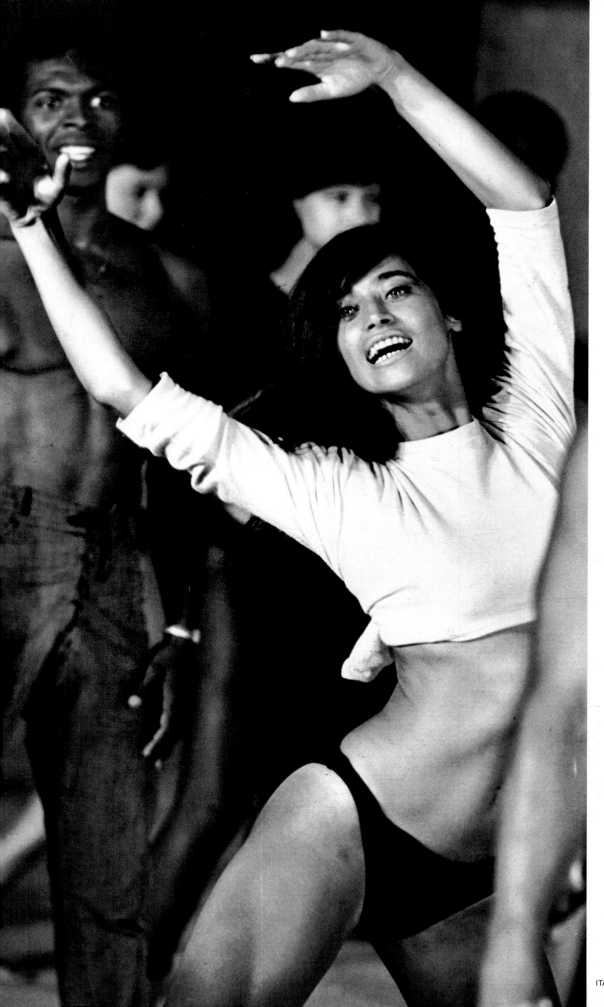

Let the flute ring out in the hall,
 let there be the sound of dancing feet. Euripides

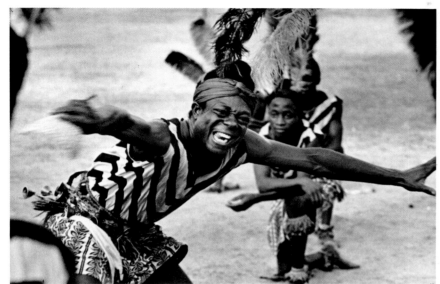

NIGERIA

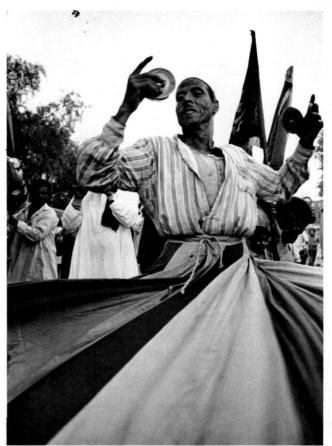

EGYPT

U.S.S.R.

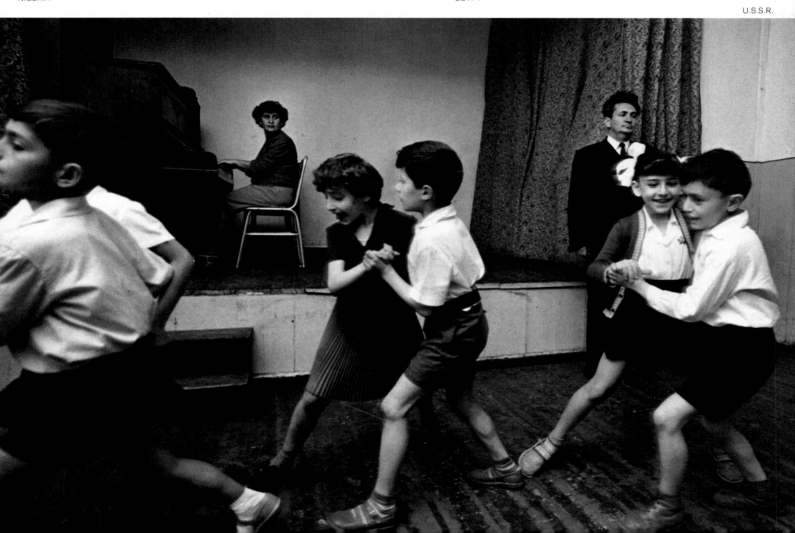

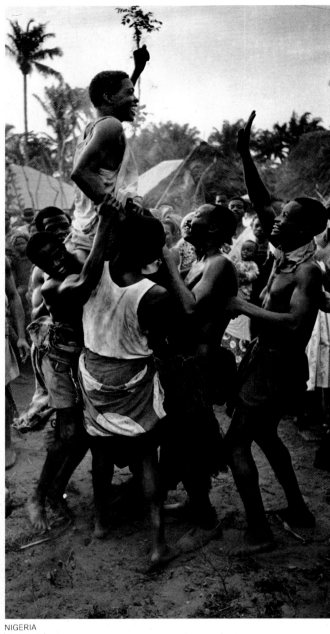

NIGERIA

Man and boy stood cheering by,
And home we brought you shoulder high. A.E. Housman

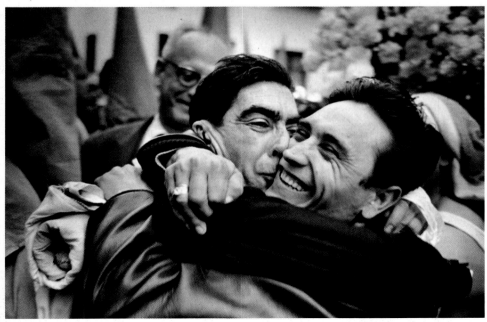

SPAIN

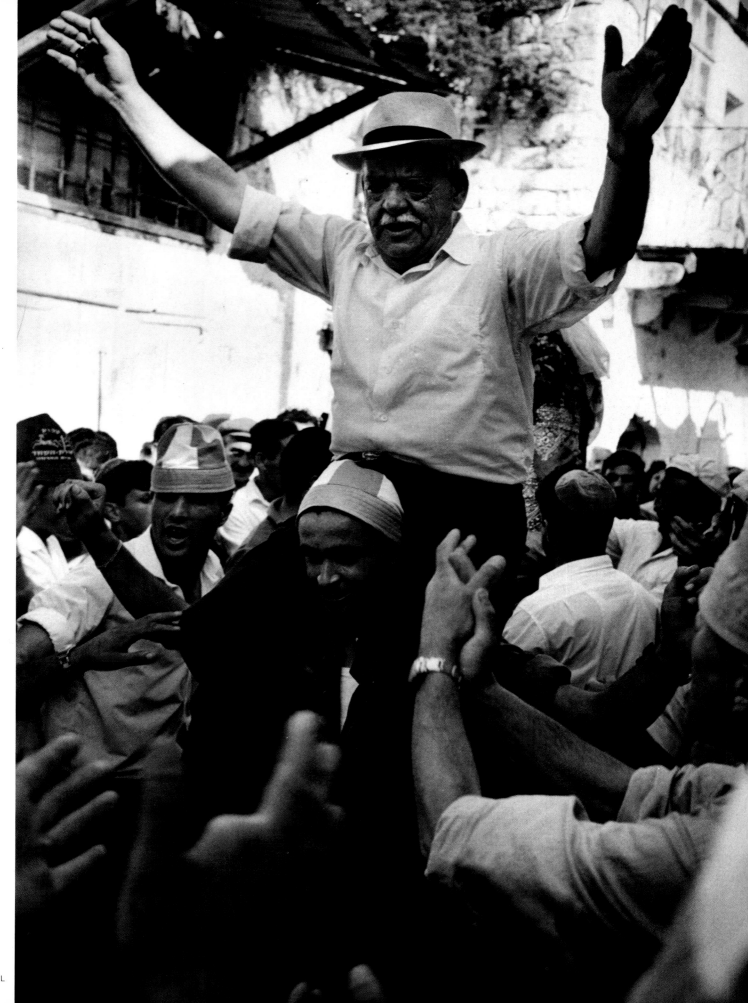

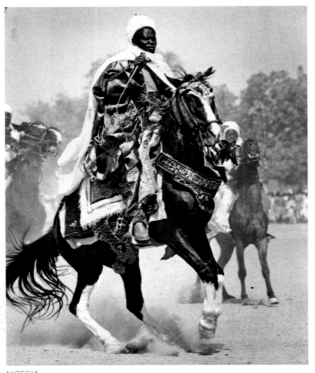

NIGERIA

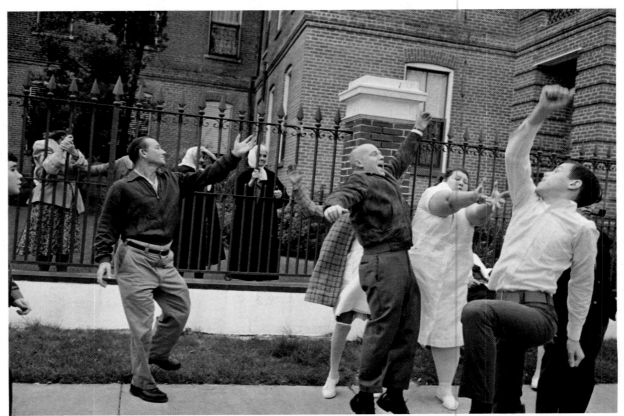

U.S.A.

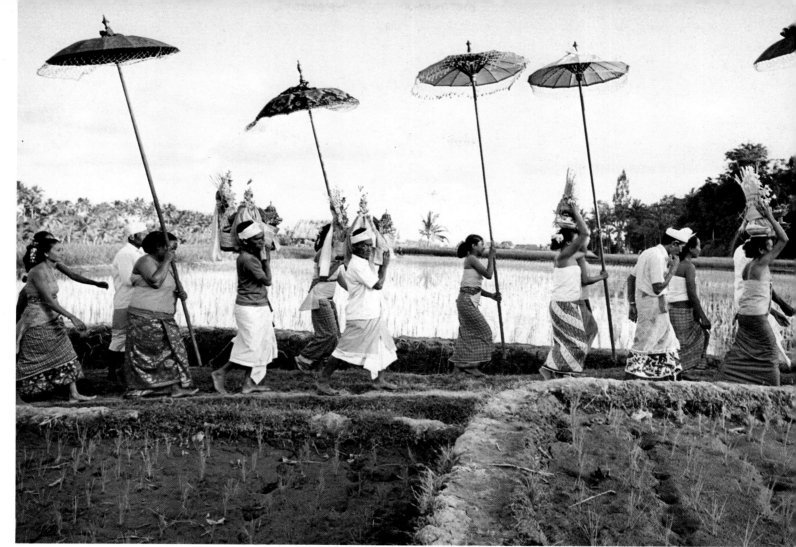

BALI

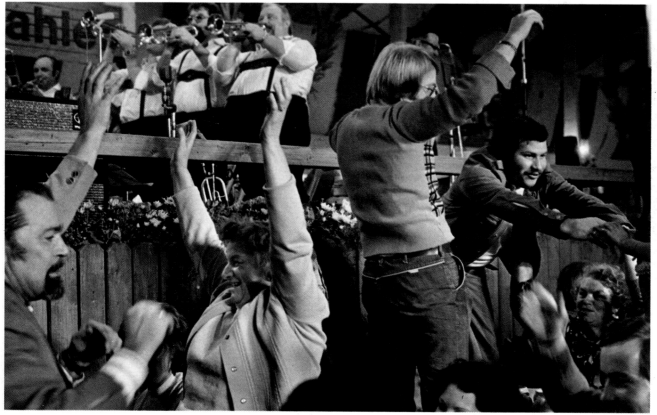

WEST GERMANY

133

Every living thing is a performance—even you. Arthur Moore

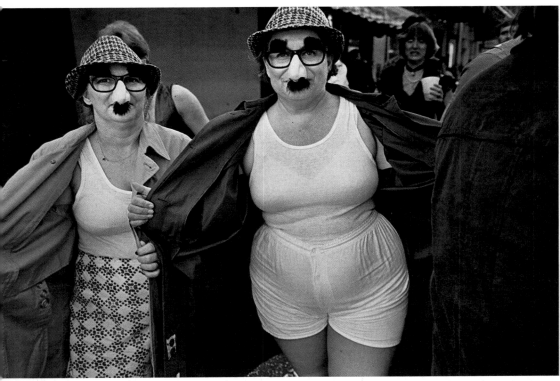

U.S.A.

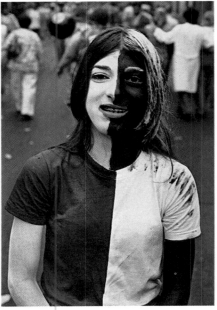

U.S.A.

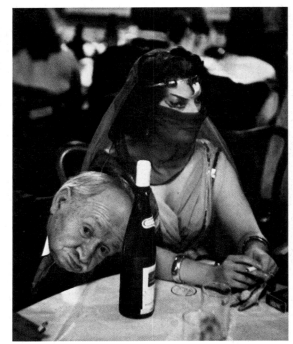

U.S.A.

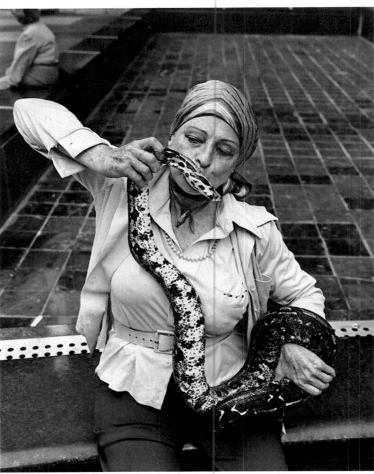

U.S.A.

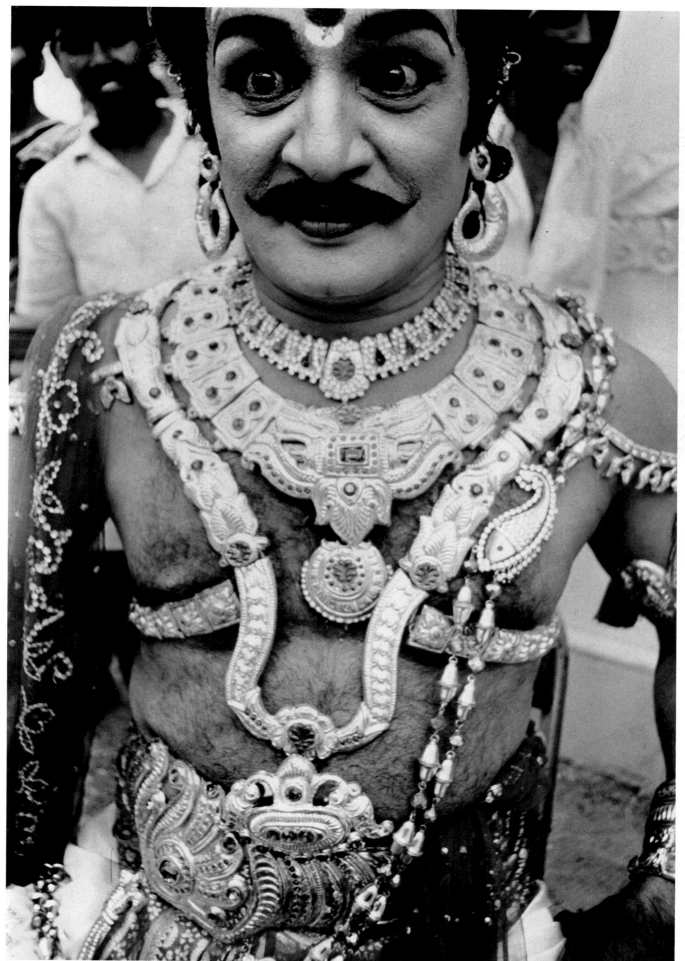

INDIA

U.S.A.

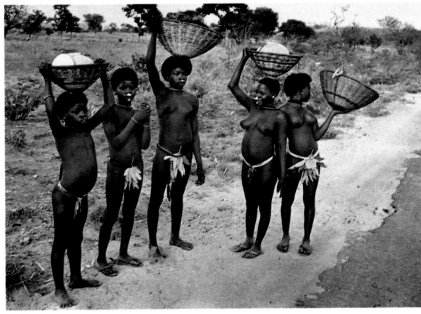

NIGERIA

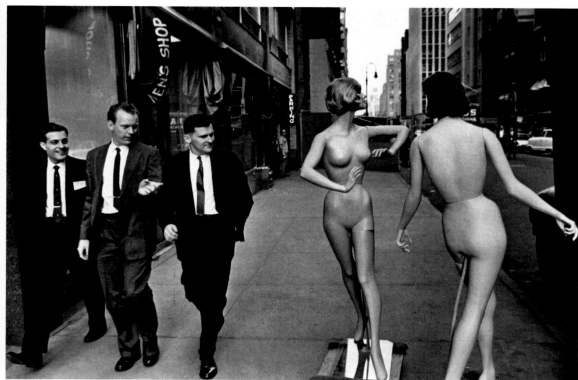

U.S.A.

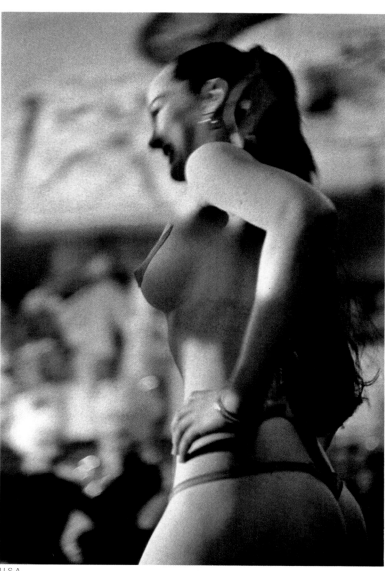

U.S.A.

137

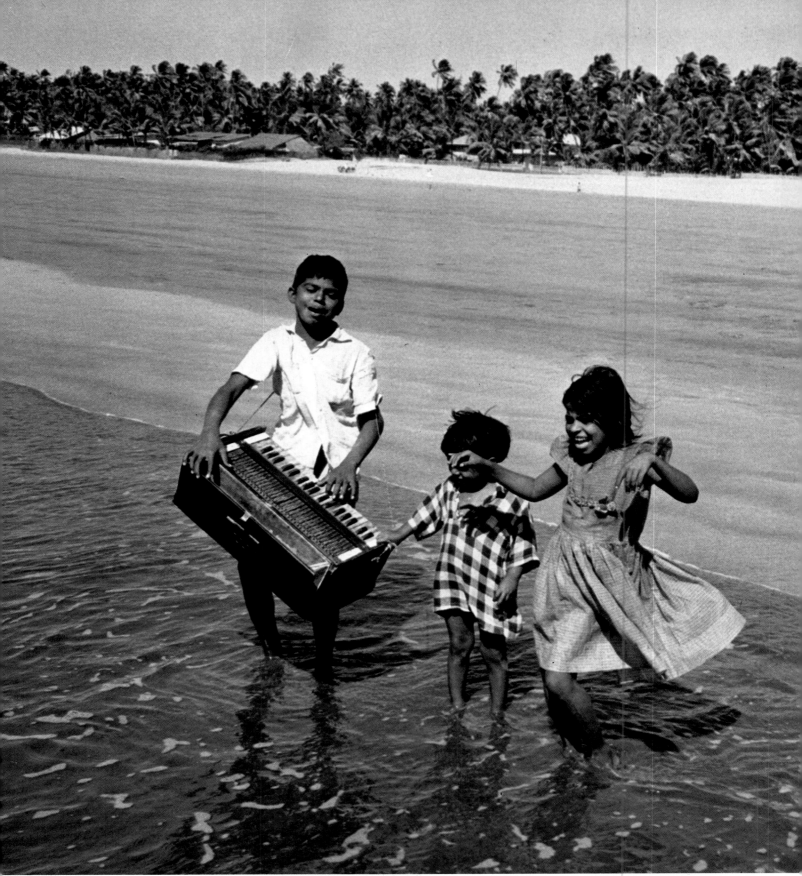

INDIA

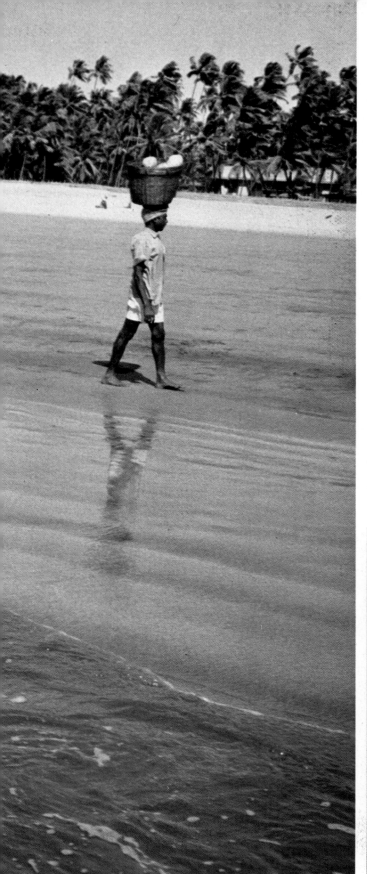

Make of each day a festival of joy,
Dance and play day and night. Gilgamesh

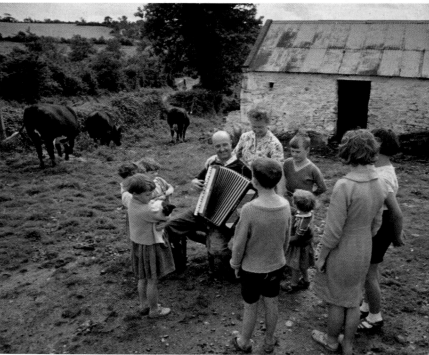

IRELAND

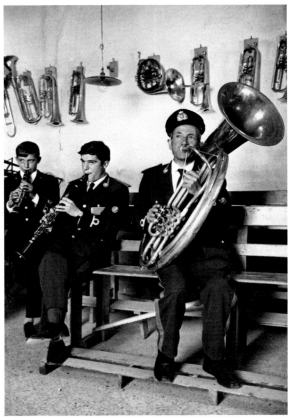

SICILY

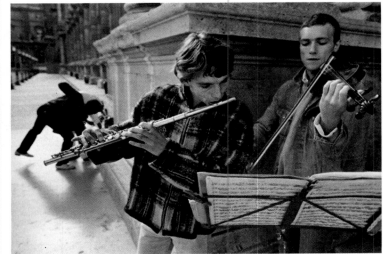

FRANCE

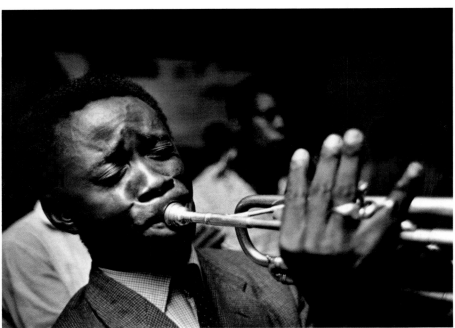

NIGERIA

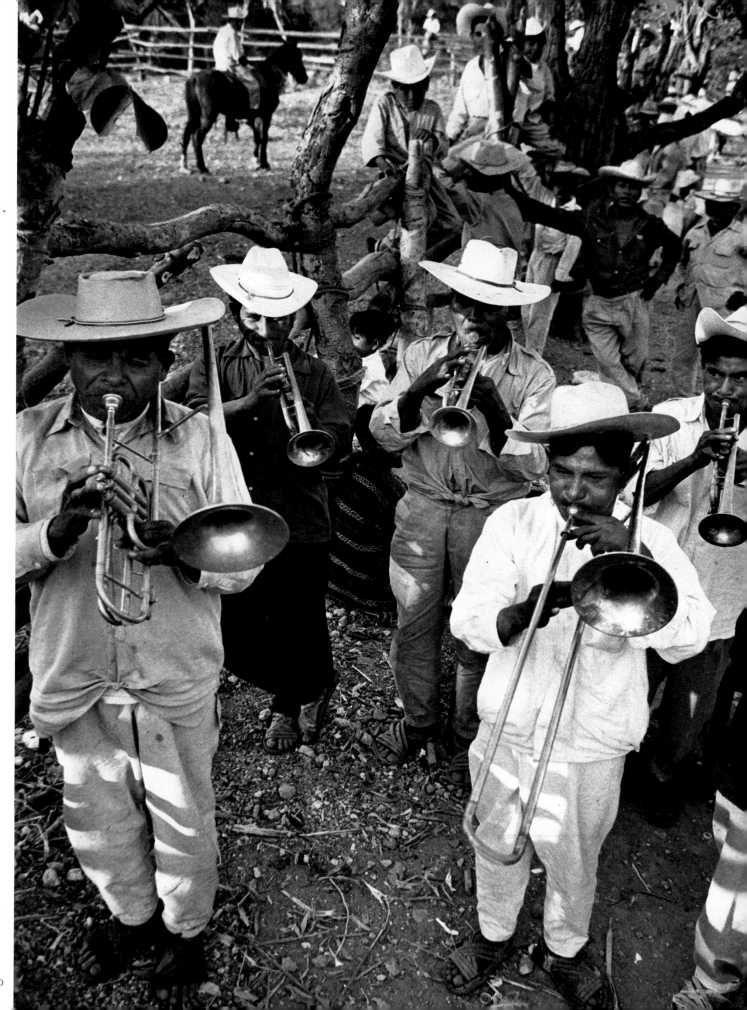

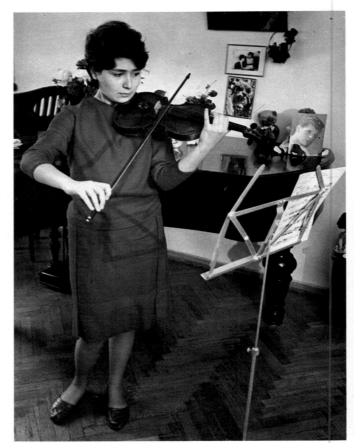

U.S.S.R.

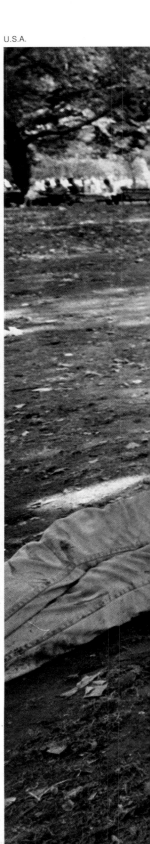

U.S.A.

U.S.A.

Music, when soft voices die,
Vibrates in the memory. Percy Bysshe Shelley

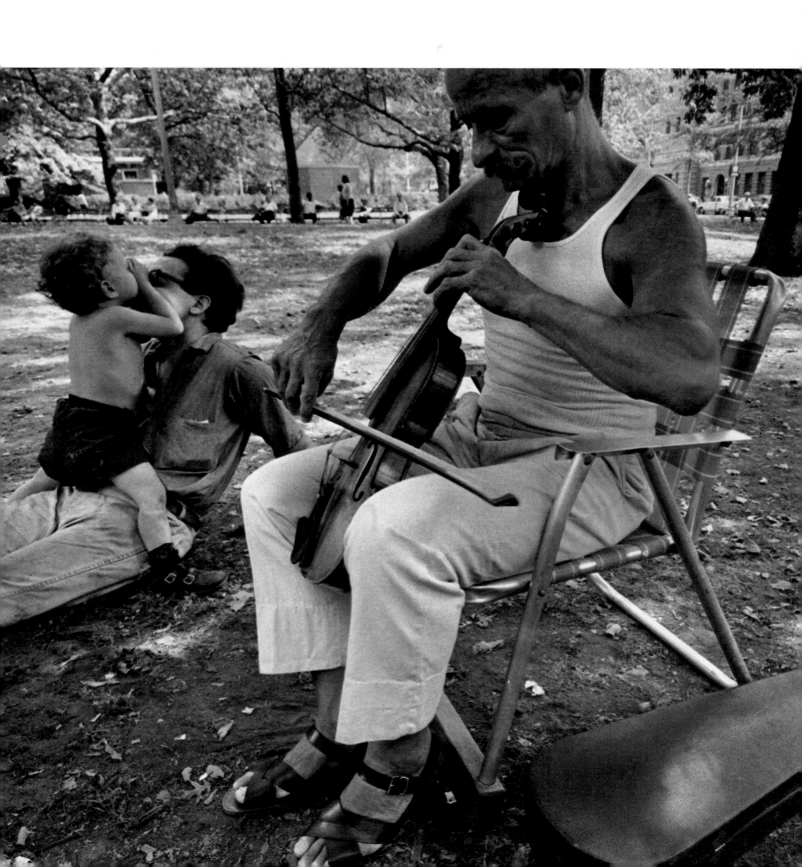

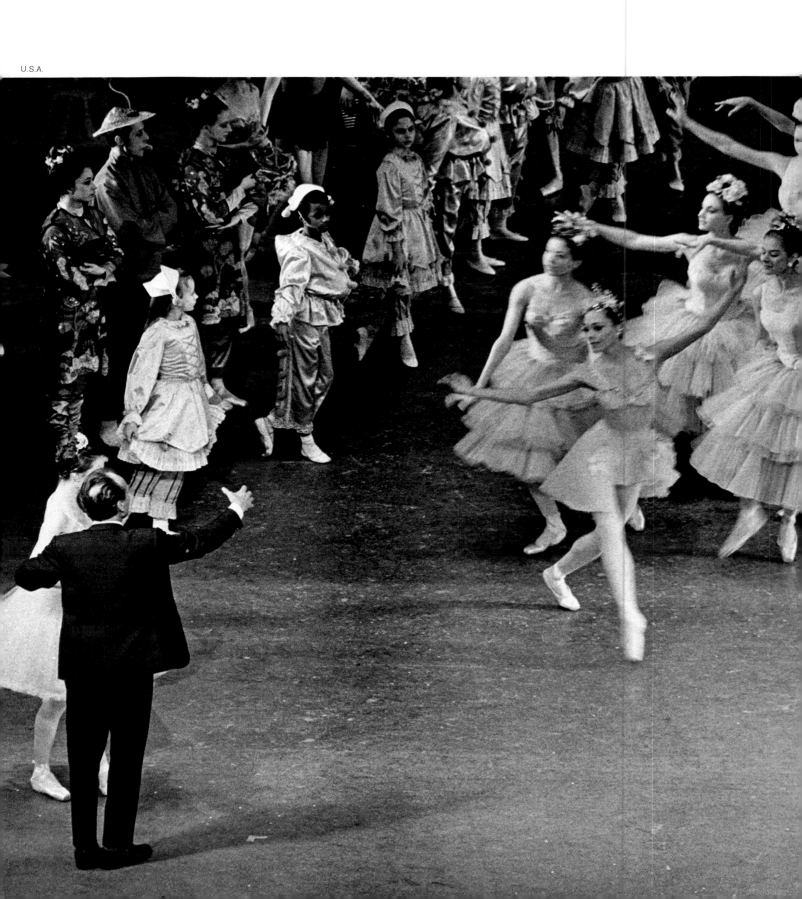

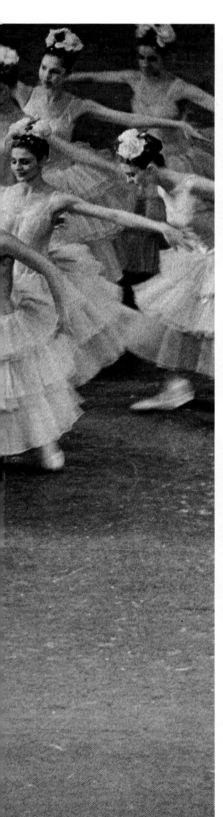

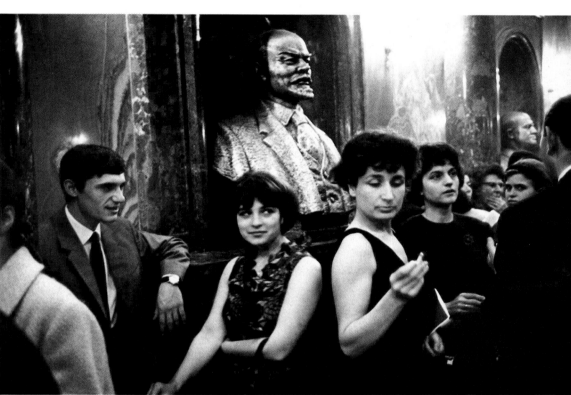

U.S.S.R.

U.S.A.

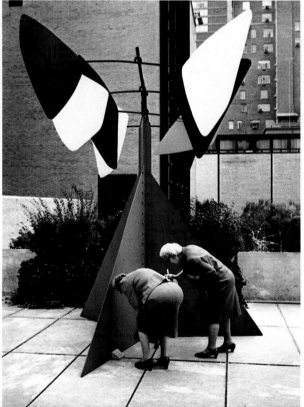

145

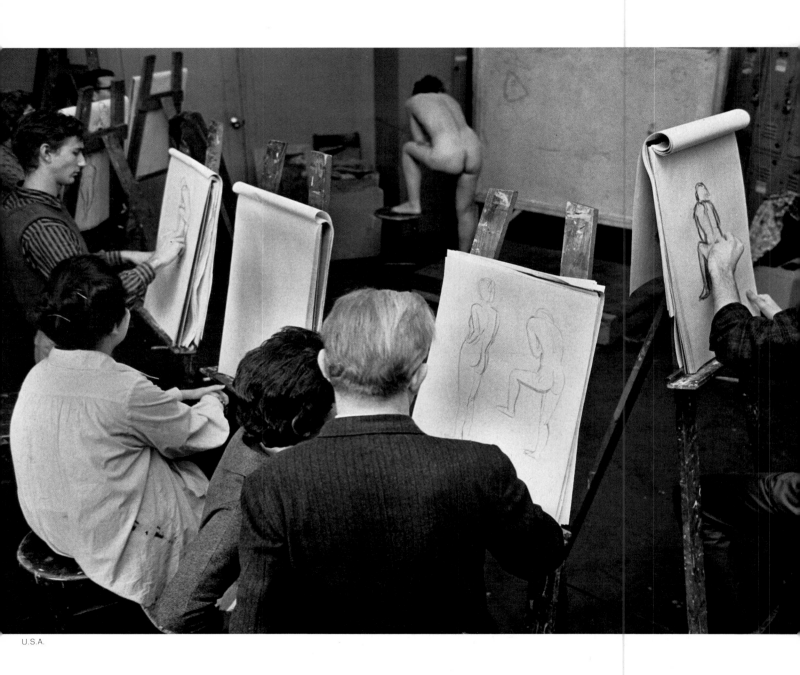

U.S.A.

Can you paint a thought? John Ford

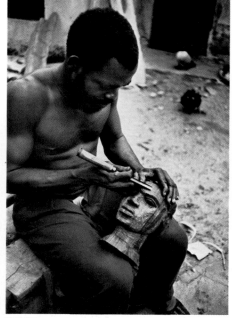

NIGERIA

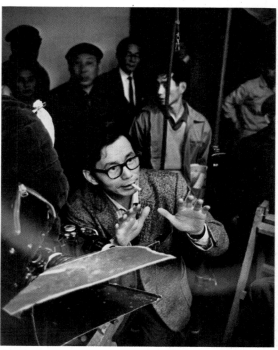

JAPAN

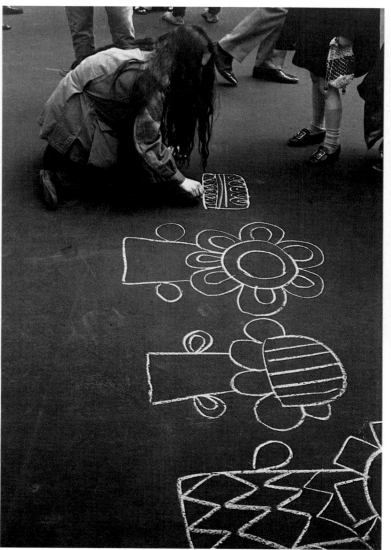

U.S.A.

147

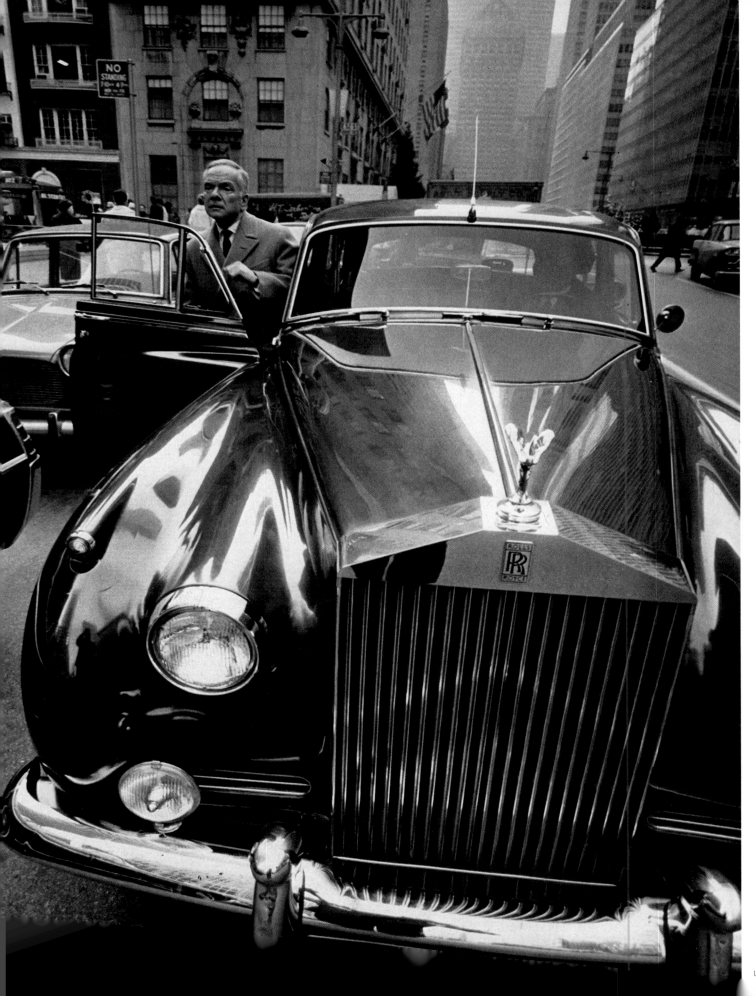

Even in a palace life may be led well. Marcus Aurelius

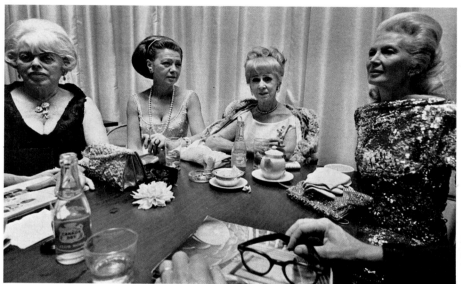

U.S.A.

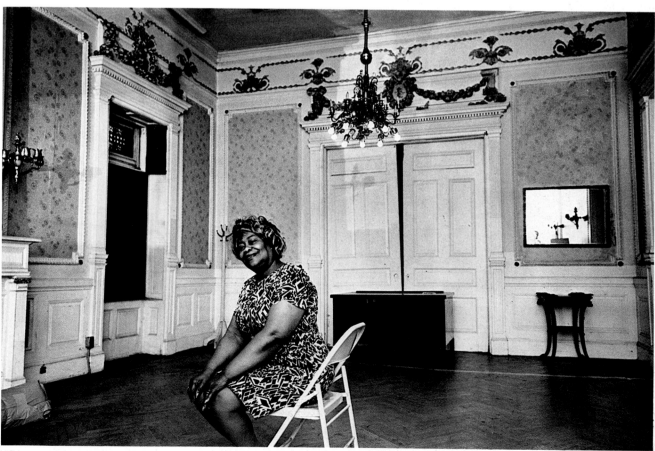

U.S.A.

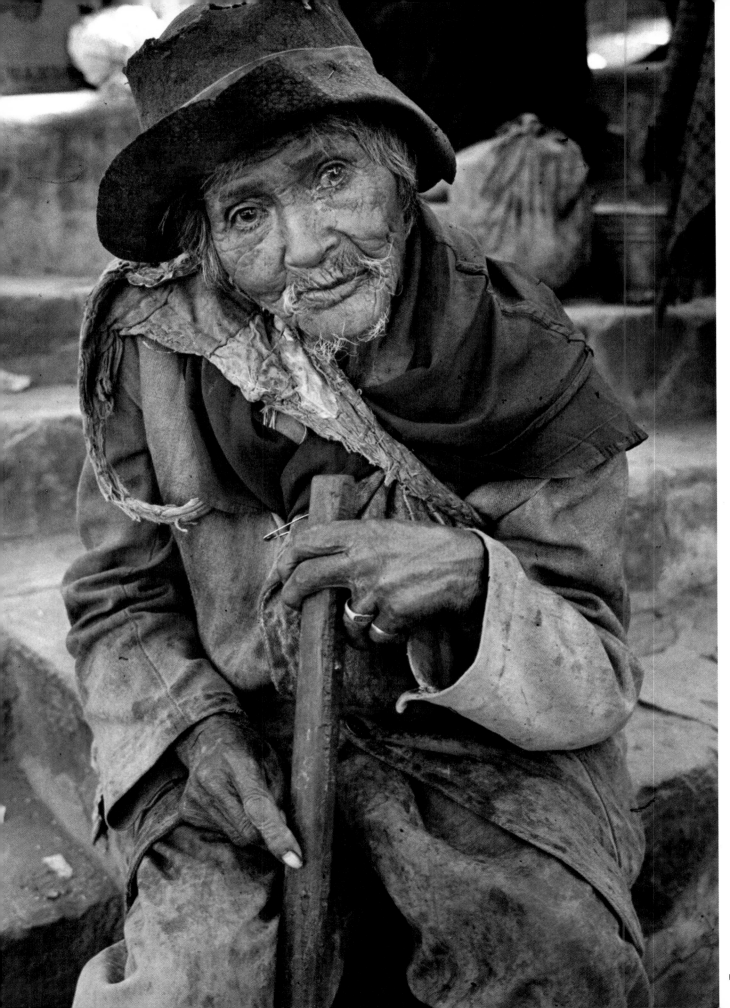

Too long a sacrifice
Can make a stone of the heart,
O when may it suffice? William Butler Yeats

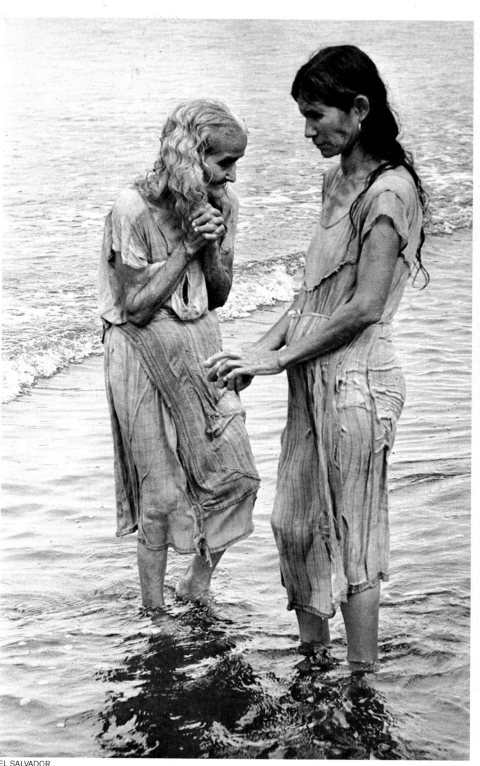

EL SALVADOR

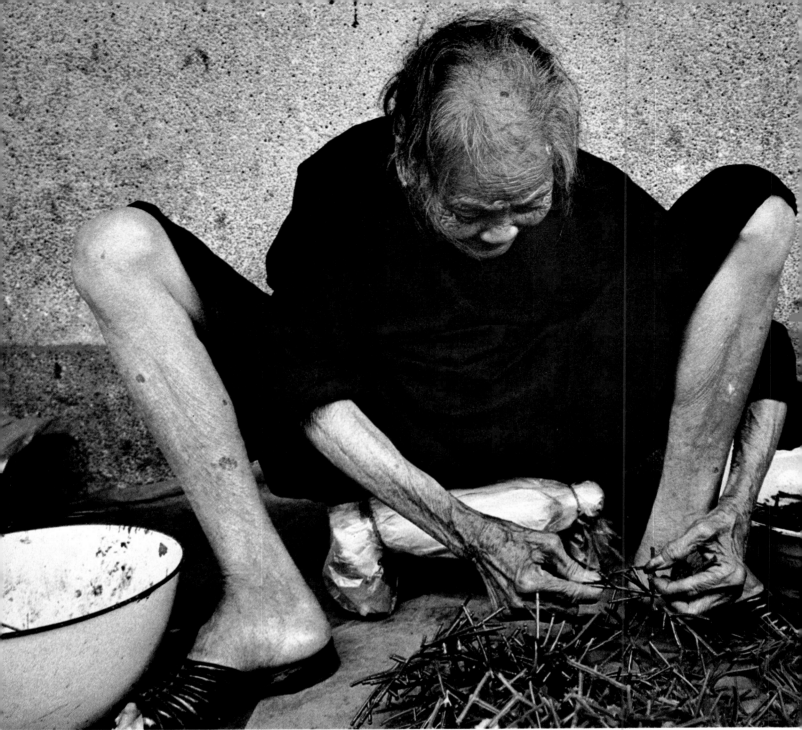

Here I and sorrows sit;
Here is my throne, bid kings come bow to it. William Shakespeare

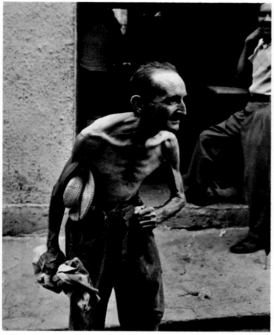

BRAZIL

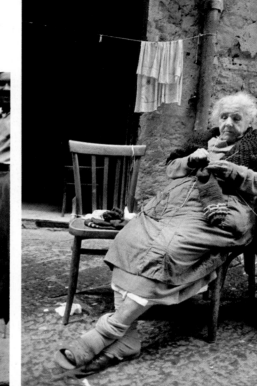

ITALY

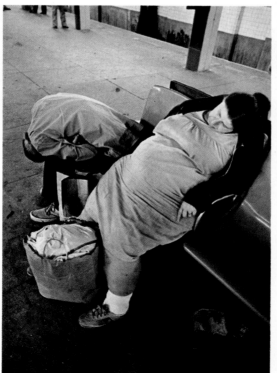

U.S.A.

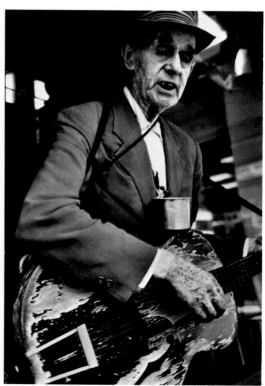

U.S.A.

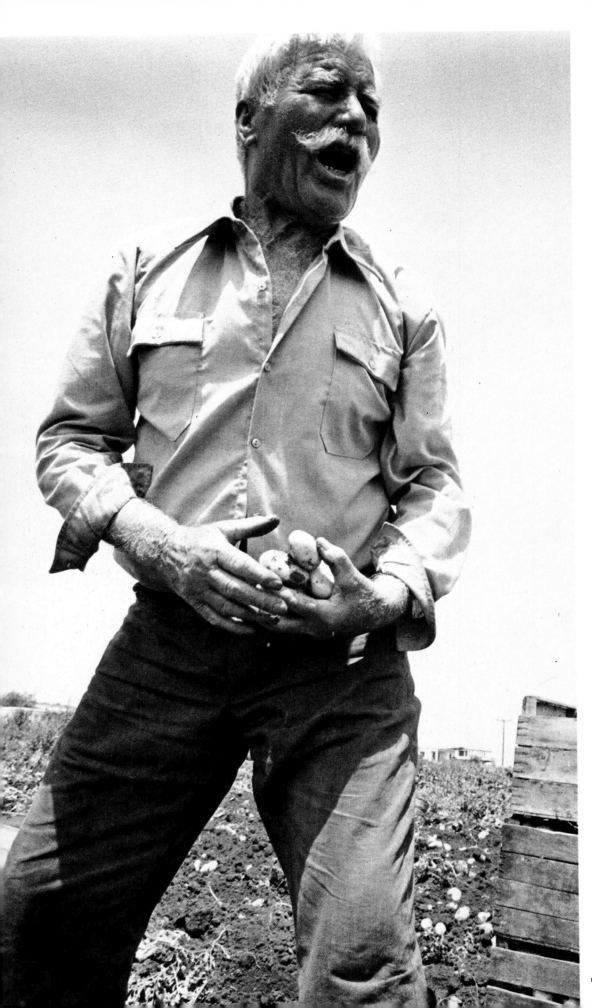

Already I have shed the leaves of youth,
Stripped by the wind of time down to the truth
Of winter branches. Linear and alone
I stand. Anne Morrow Lindbergh

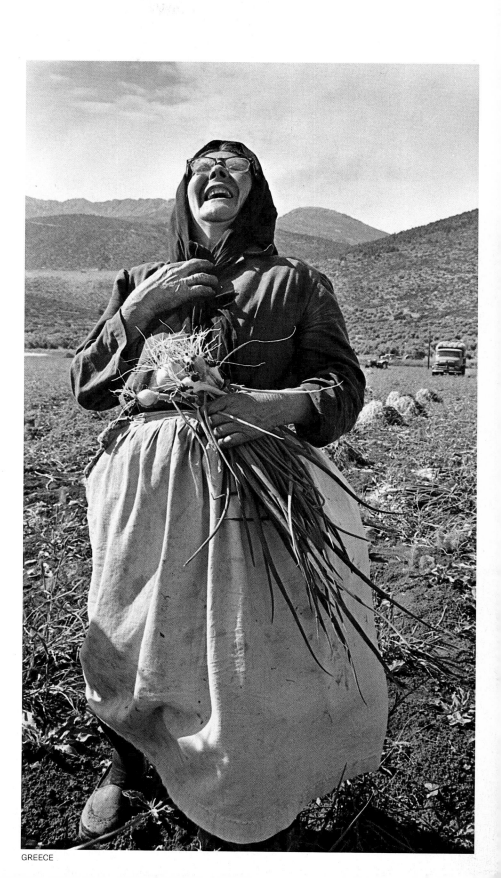

GREECE

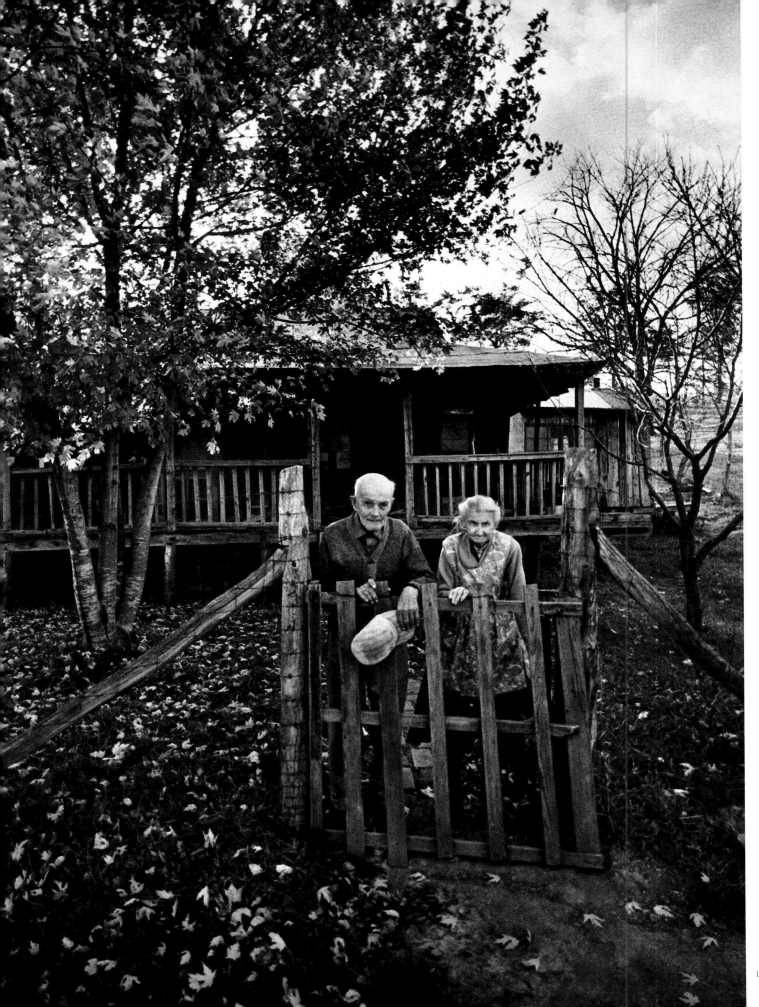

So we'll go no more a-roving
So late into the night
Though the heart be still as loving,
And the moon be still as bright.

George Gordon, Lord Byron

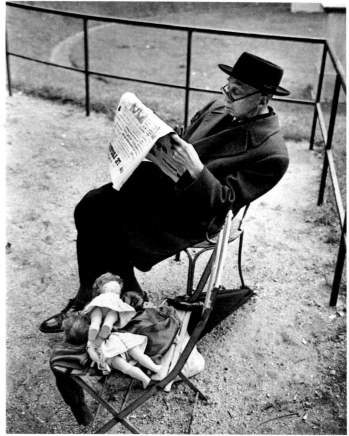

FRANCE

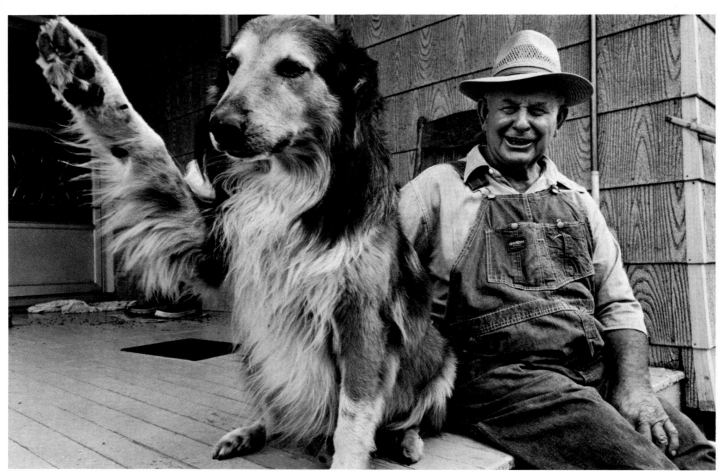

U.S.A.

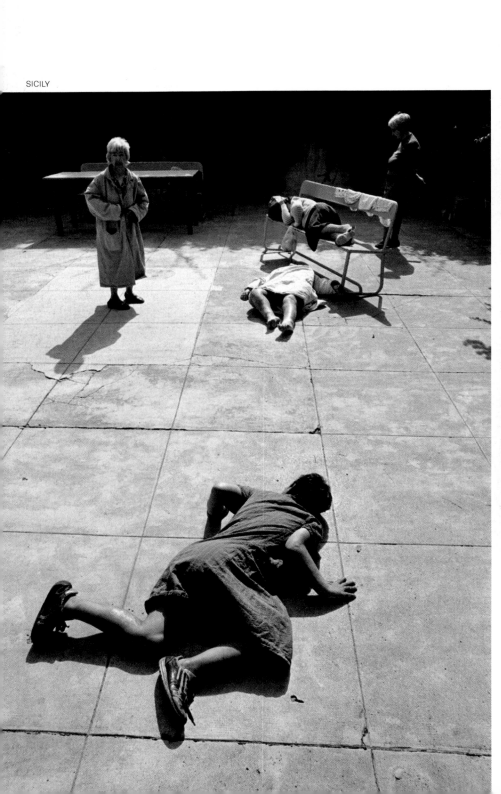

SICILY

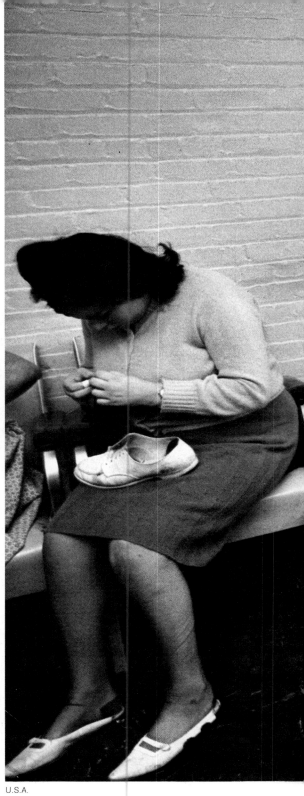

U.S.A.

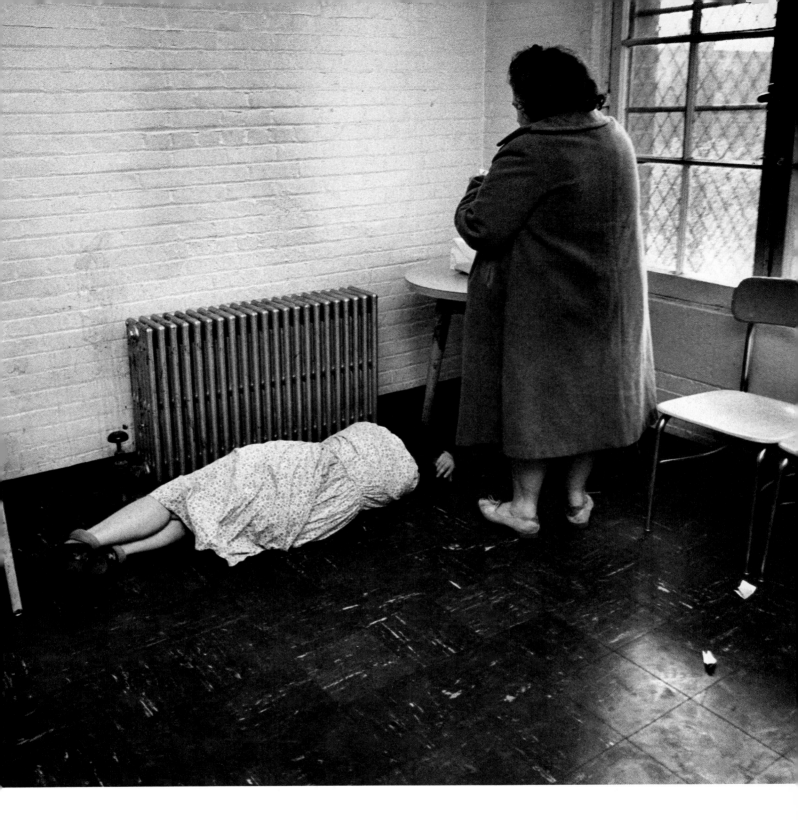

I have gone into the waste lonely places
Behind the eye. Theodore Roethke

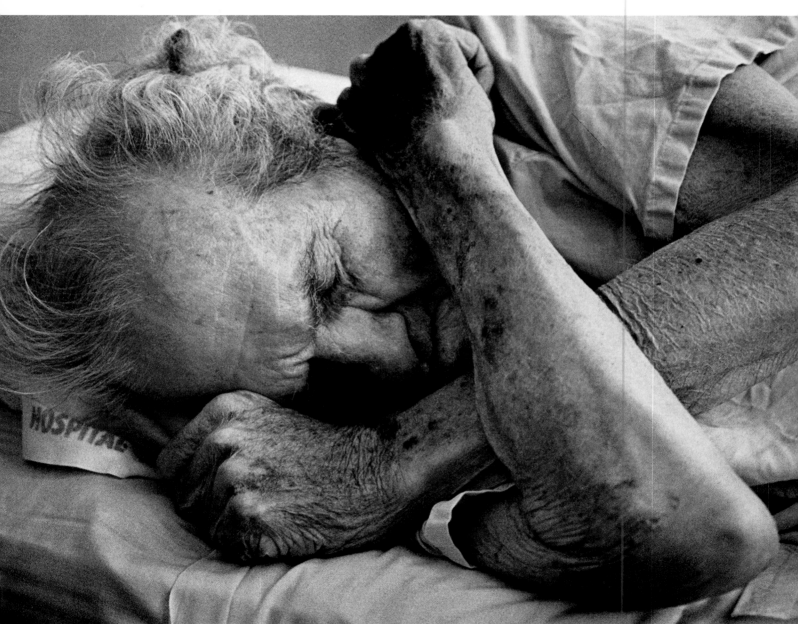

U.S.A.

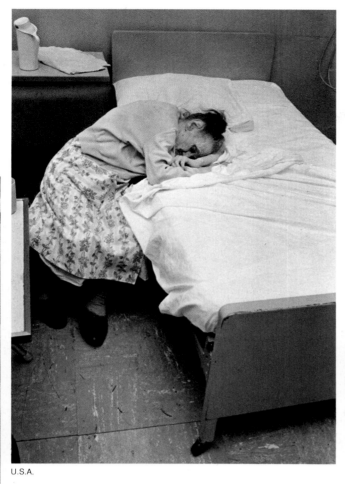

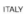
ITALY

U.S.A.

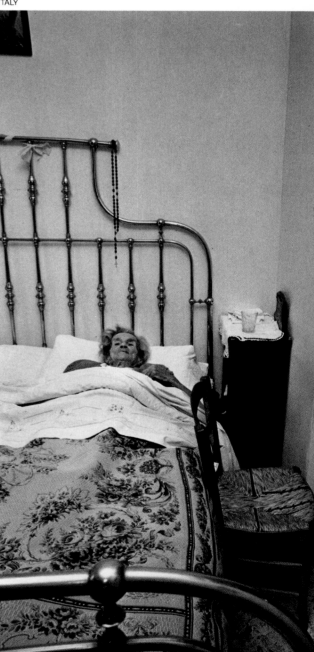

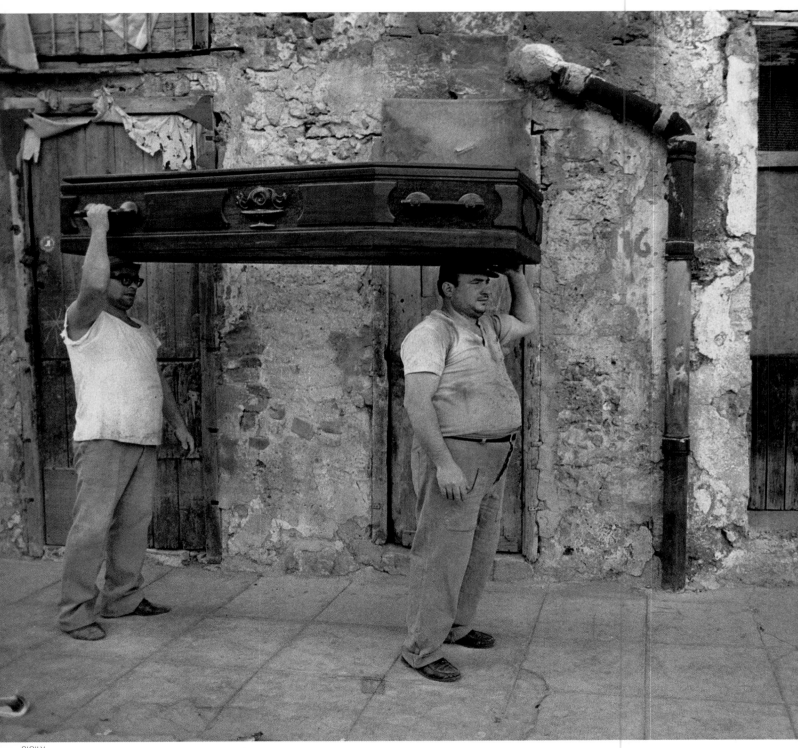

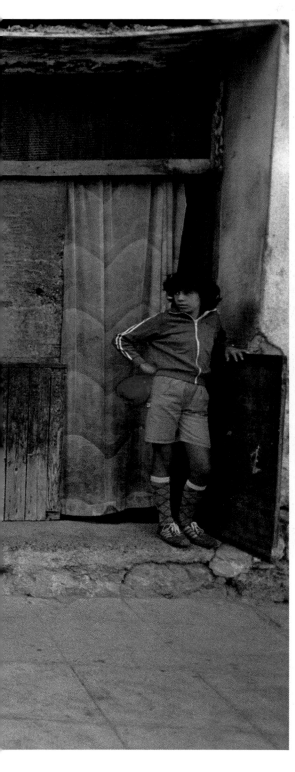

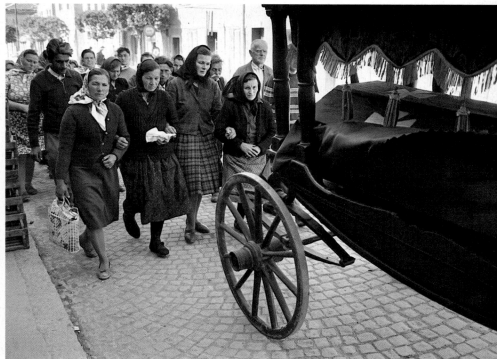

YUGOSLAVIA

The day we die
the wind comes down
to take away
our footprints Kabari poem

163

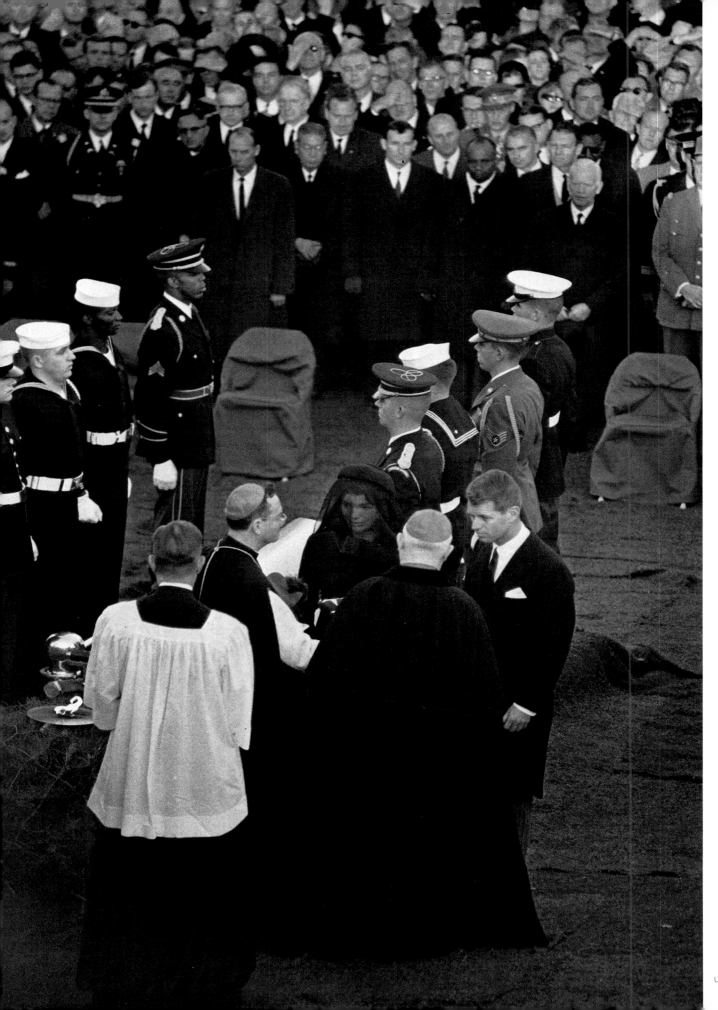

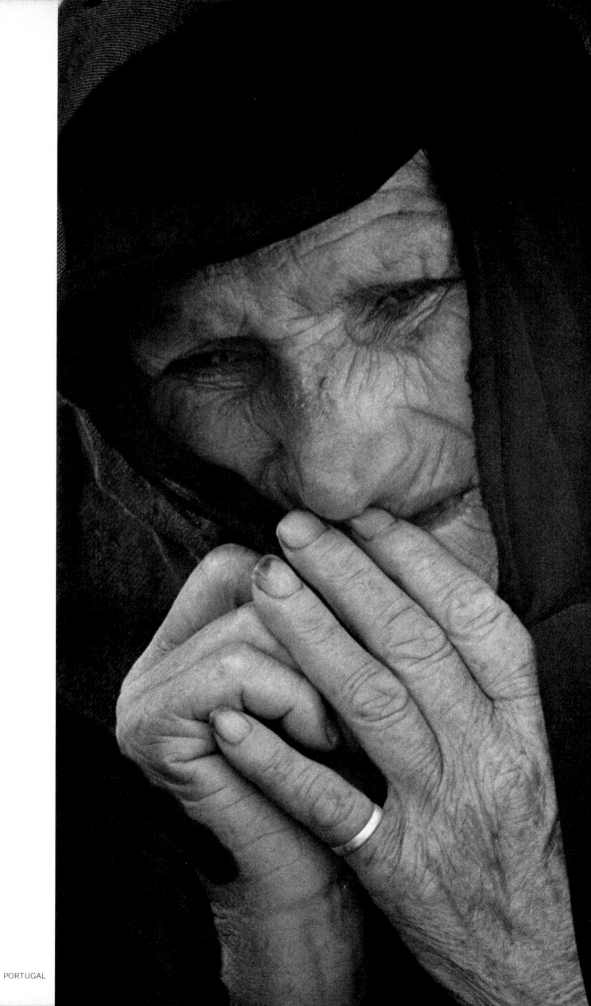

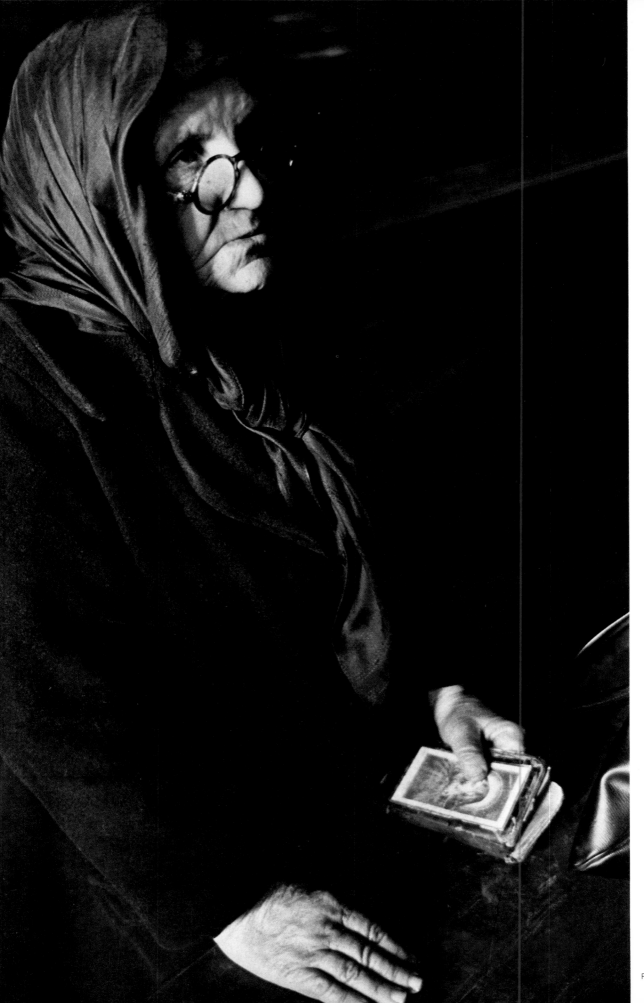

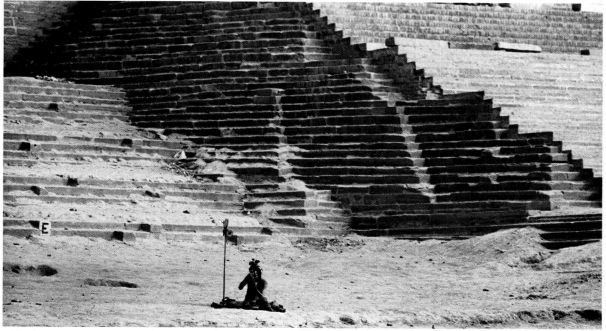

INDIA

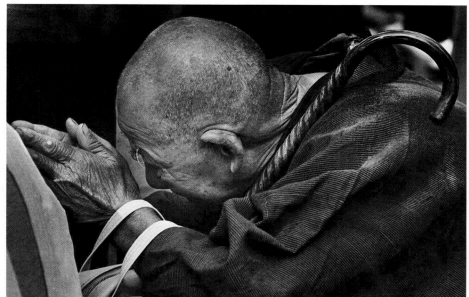

JAPAN

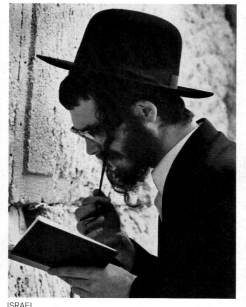

ISRAEL

O world invisible, we view thee,
O world intangible, we touch thee,
O world unknowable, we know thee,
Inapprehensible, we clutch thee!

Francis Thompson

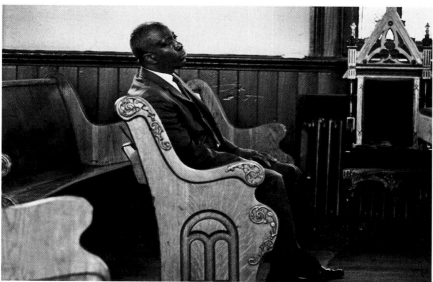

U.S.A.

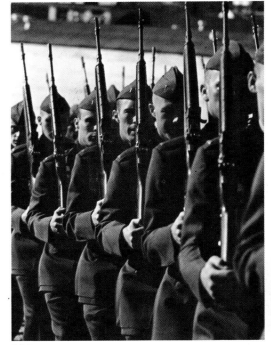

U.S.A.

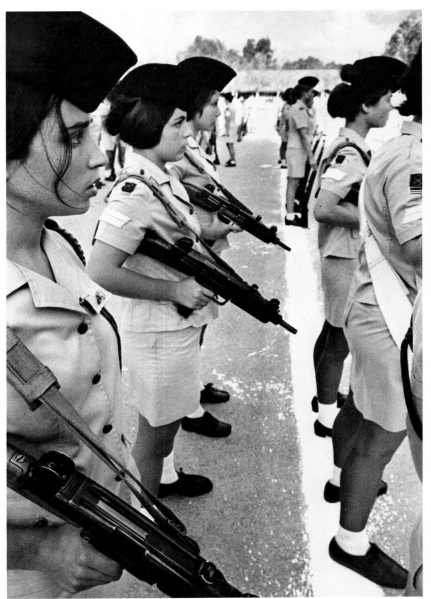

ISRAEL

U.S.A.

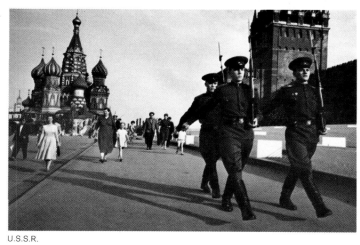

U.S.S.R.

My subject is War, and the pity of War,
The Poetry is in the pity. Wilfred Owen

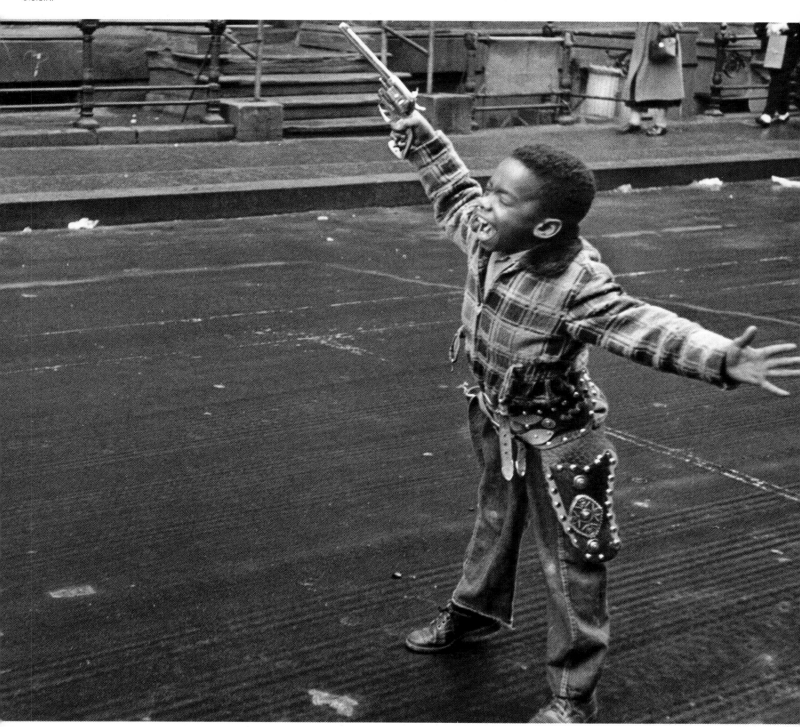

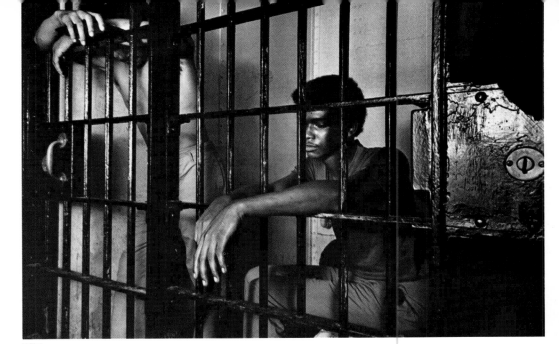

U.S.A.

MEXICO

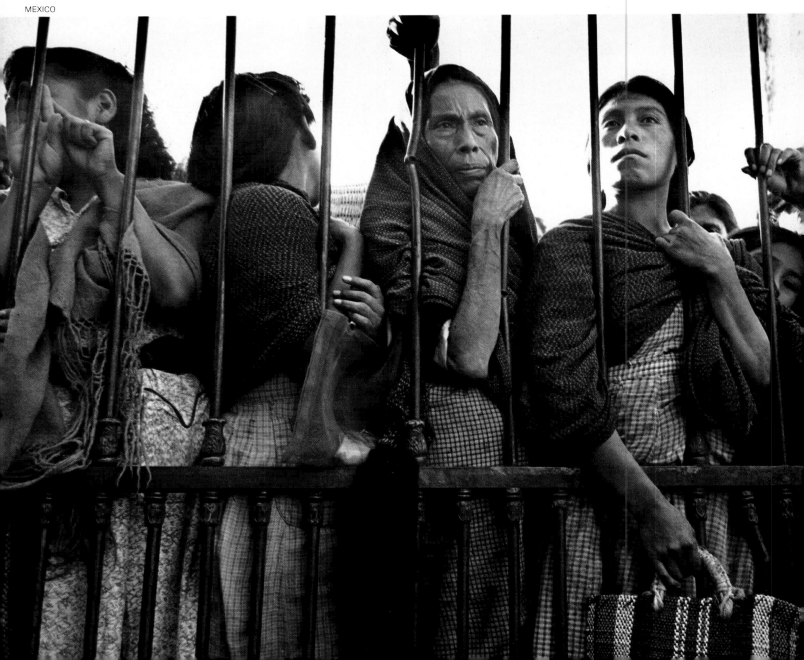

Is it nothing to you, all ye that pass by? Jeremiah

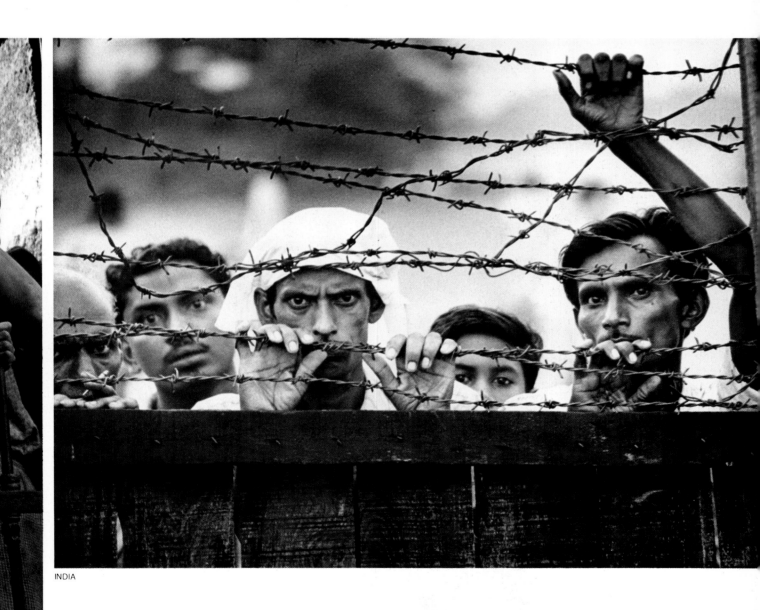

INDIA

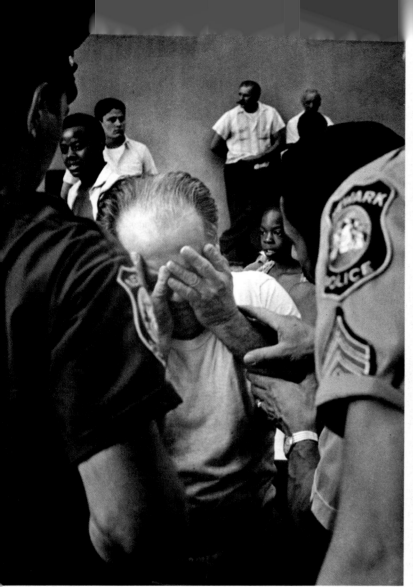

U.S.A.

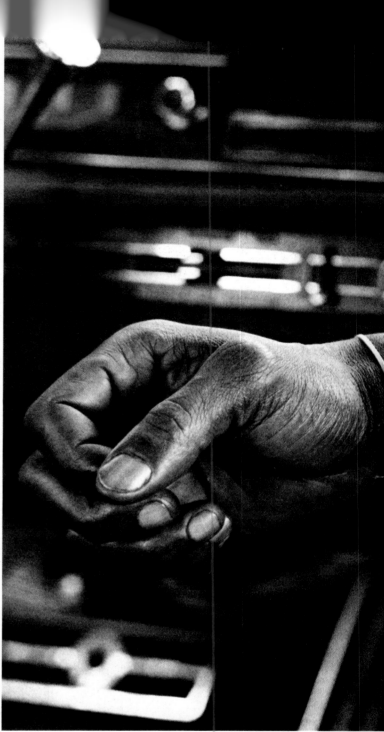

U.S.A.

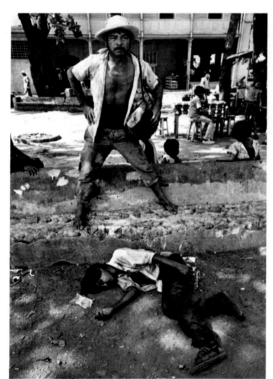

EL SALVADOR

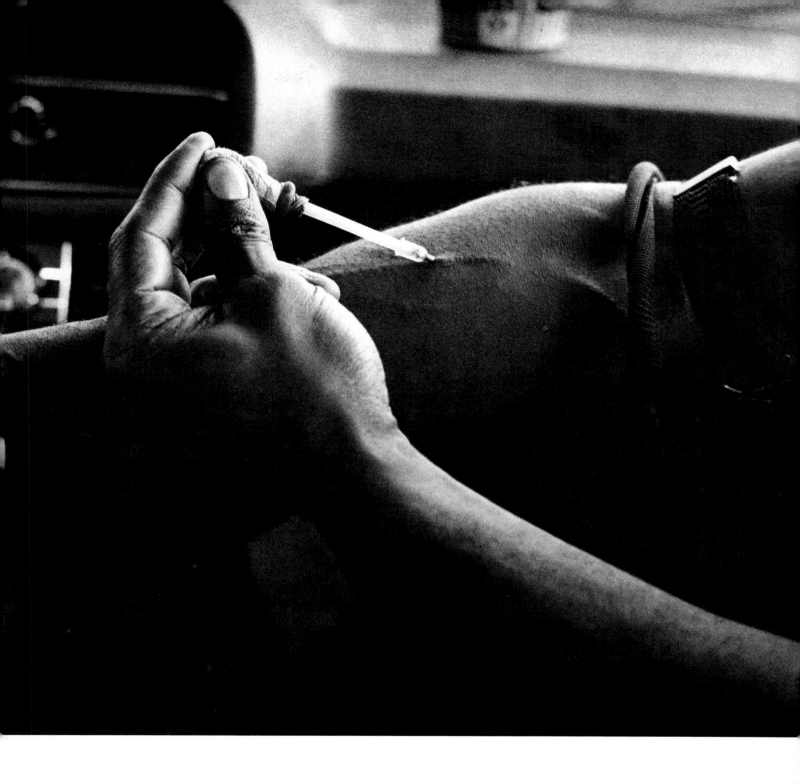

Is man no more than this? William Shakespeare

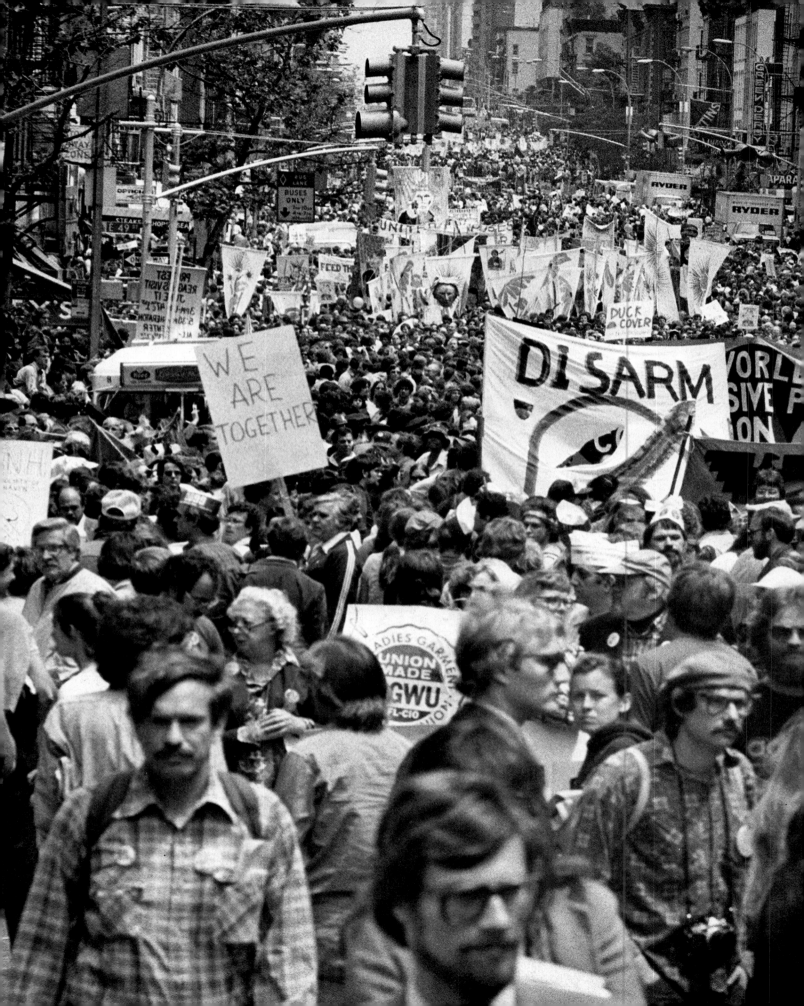

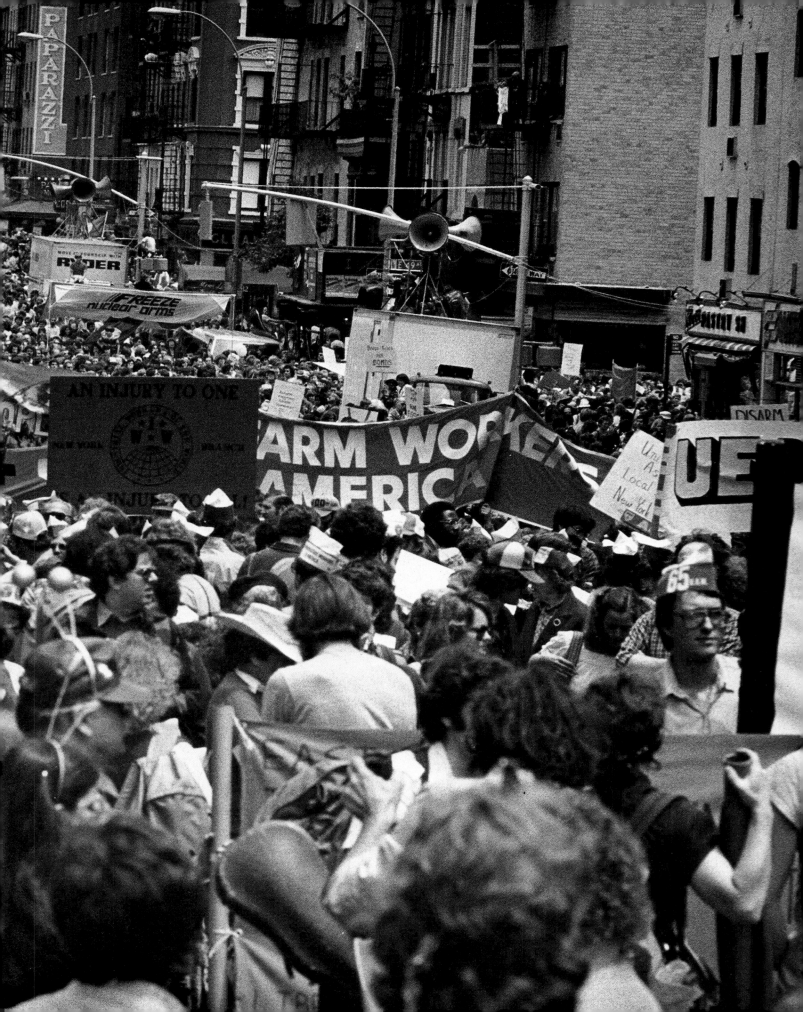

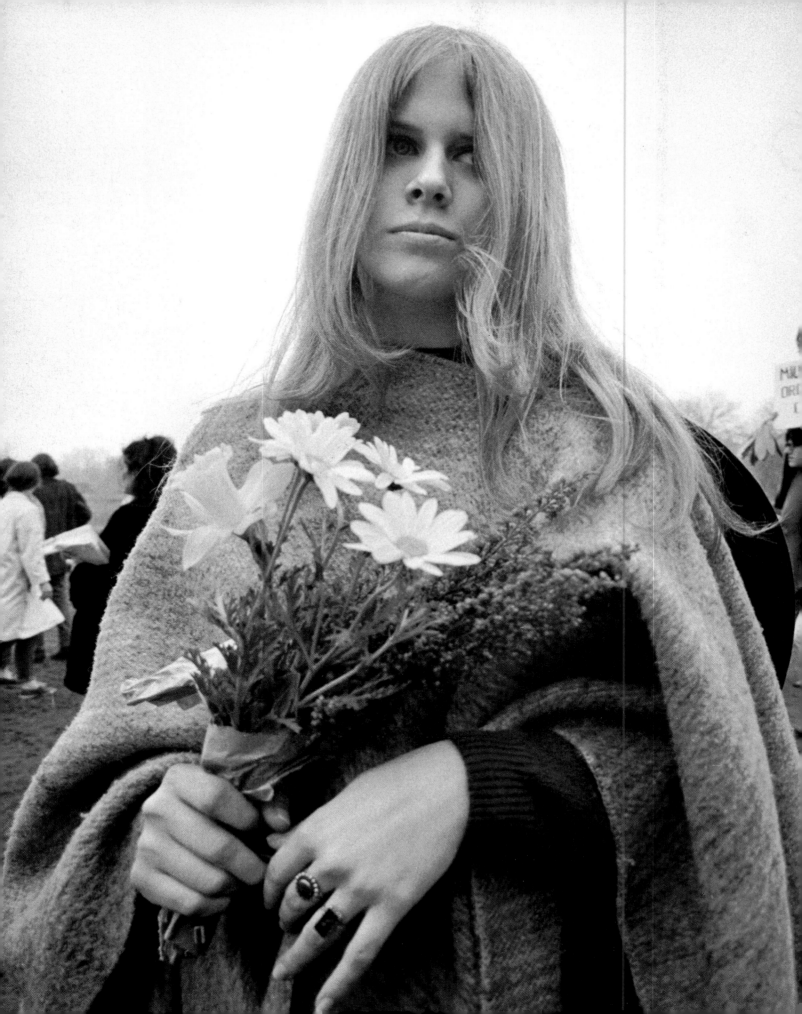

Behold, I dream a dream of good. Alfred Lord Tennyson

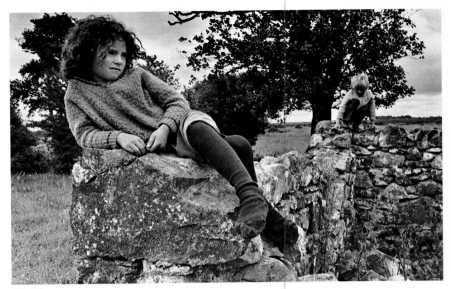

IRELAND

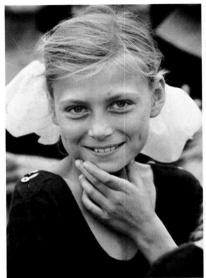

U.S.S.R.

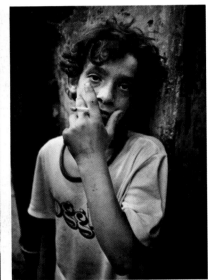

ITALY

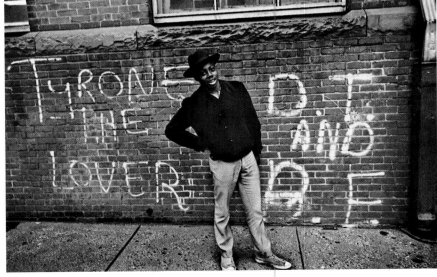

U.S.A.

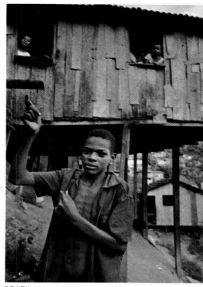

BRAZIL

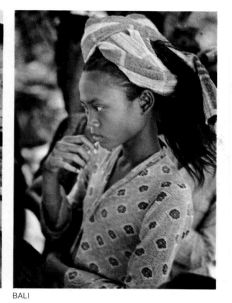

BALI

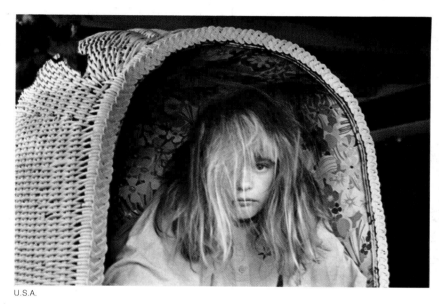

U.S.A.

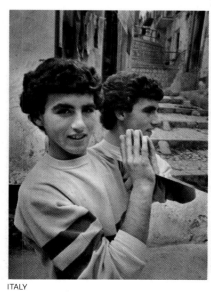

ITALY

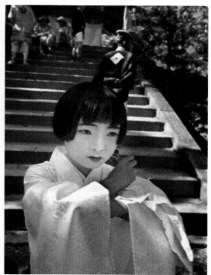

JAPAN

179

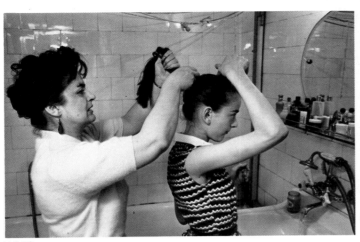

U.S.S.R.

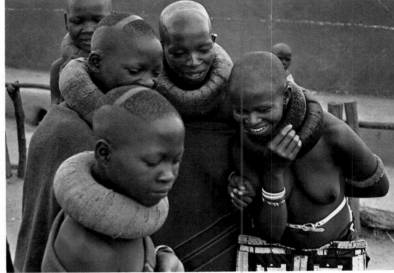

SOUTH AFRICA

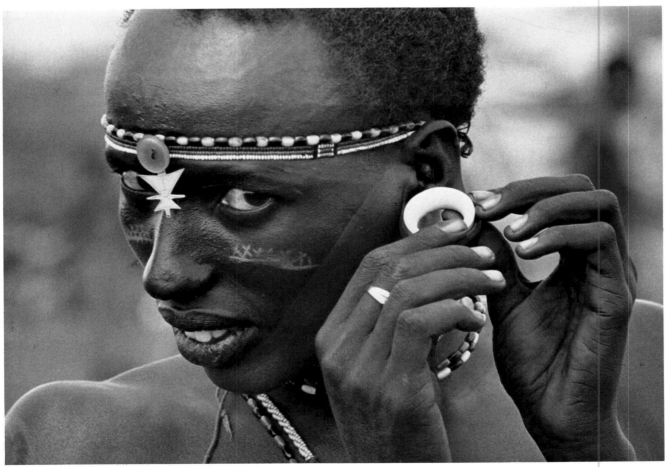

KENYA

U.S.A.

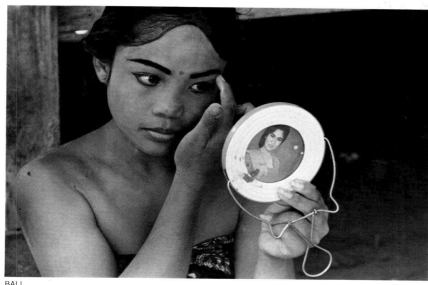
BALI

Throughout the world
Who is there like me?
Who is like me? Winnebago song

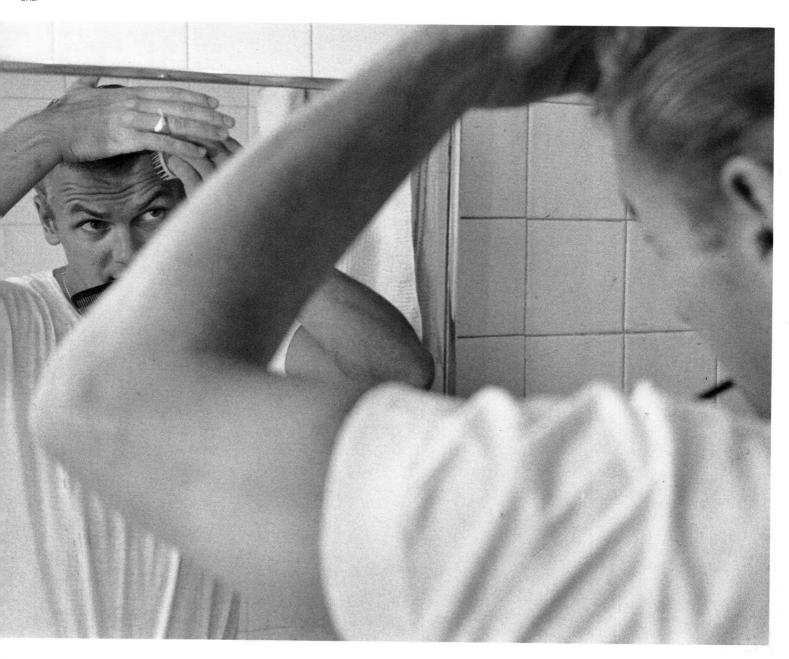

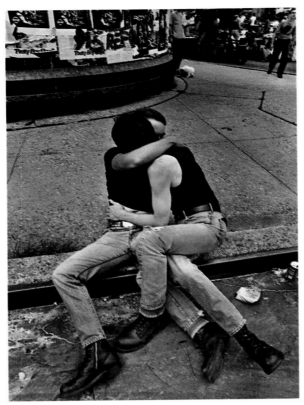

U.S.A.

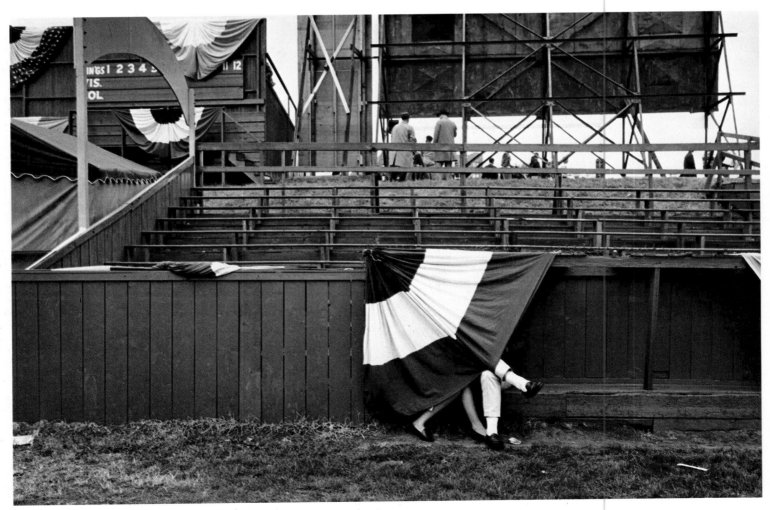

U.S.A.

For love...
makes a little room, an everywhere. John Donne

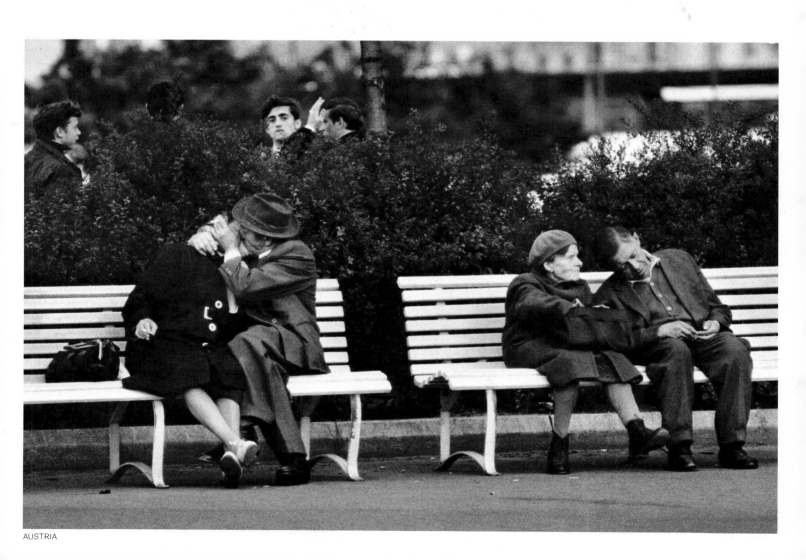

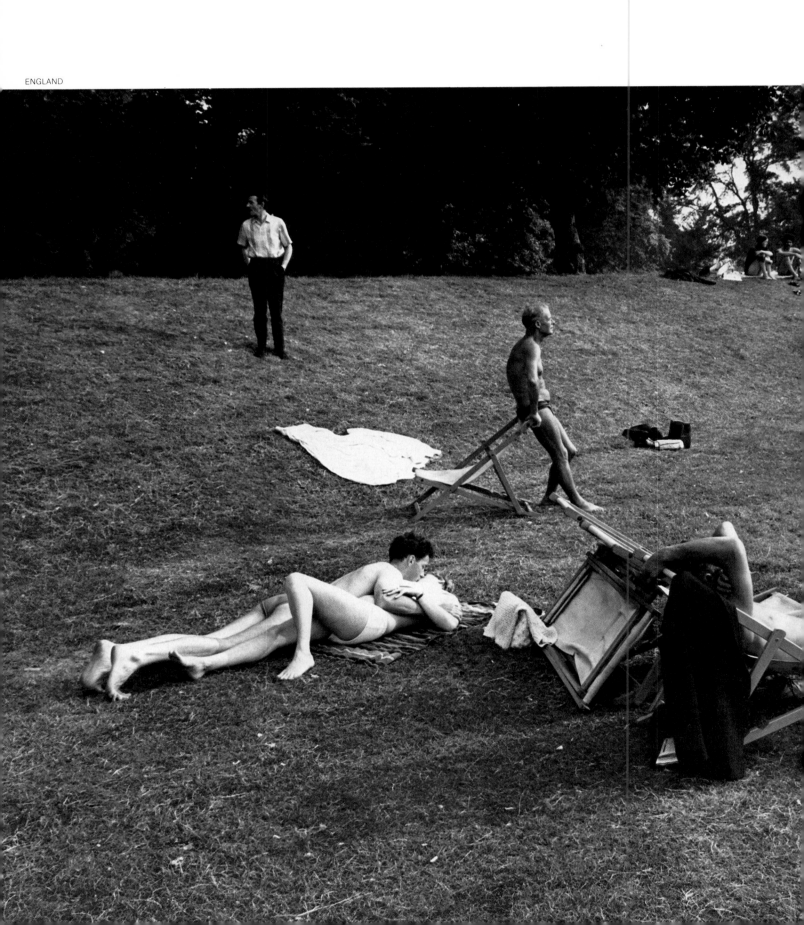

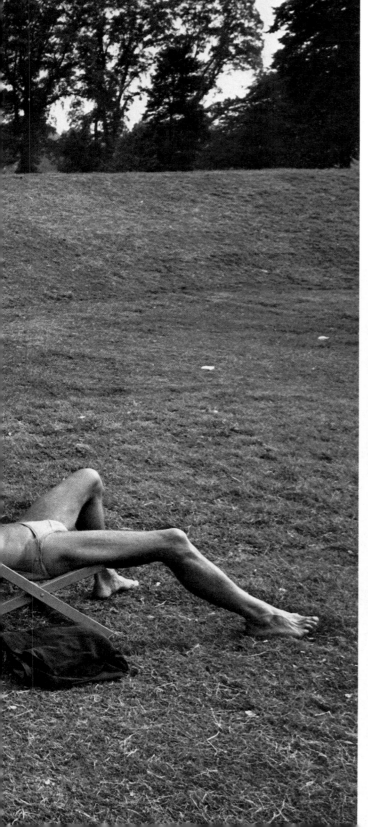

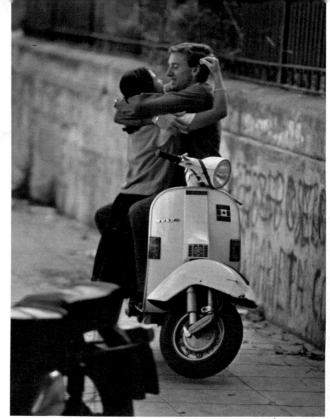

ITALY

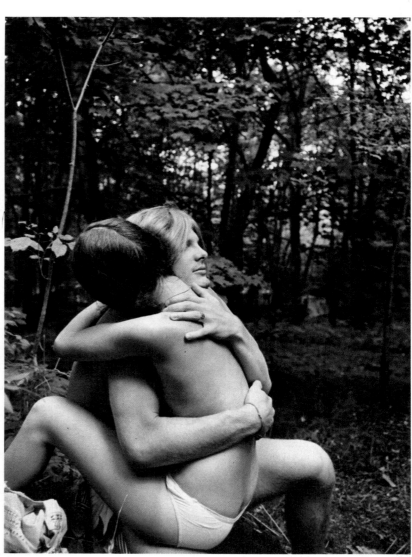

U.S.A.

And in his heart my heart is locked,

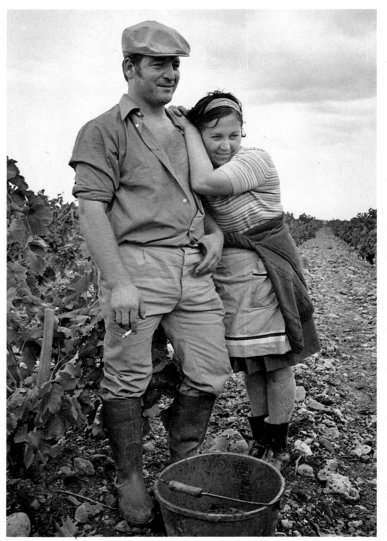

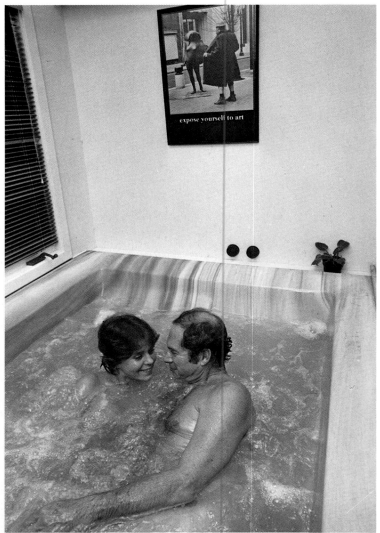

FRANCE

U.S.A.

And in his life my life. Christina Rossetti

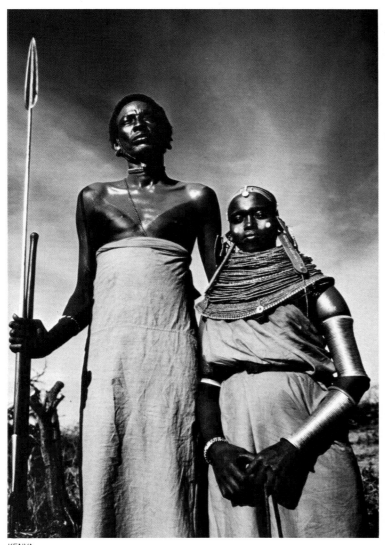

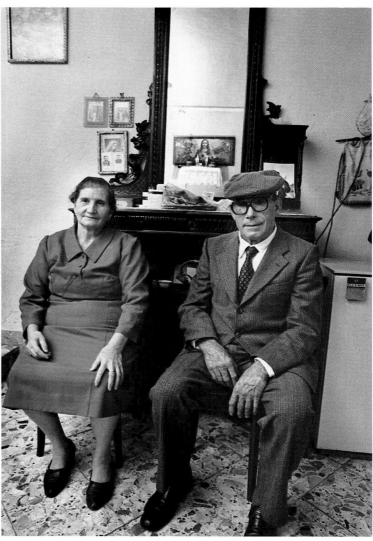

KENYA ITALY

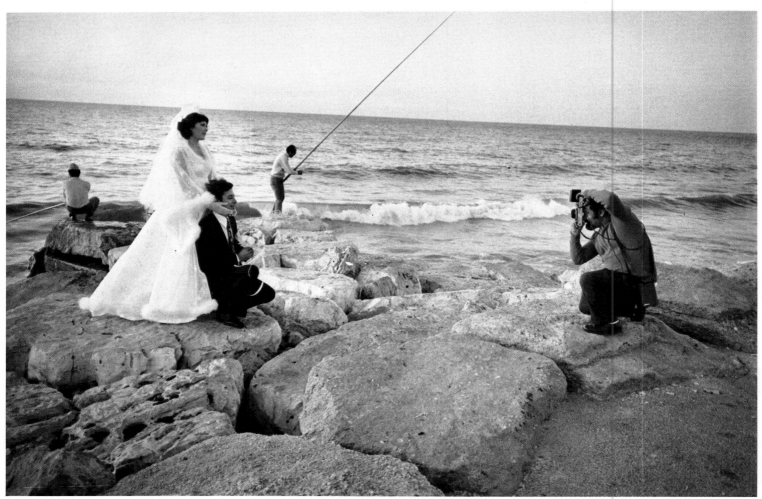

ISRAEL

How but in custom and in ceremony
Are innocence and beauty born? William Butler Yeats

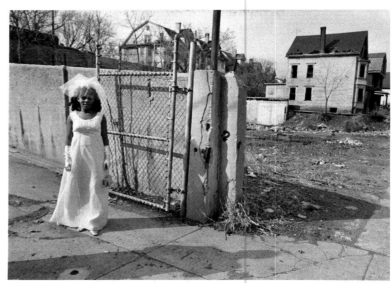

U.S.A.

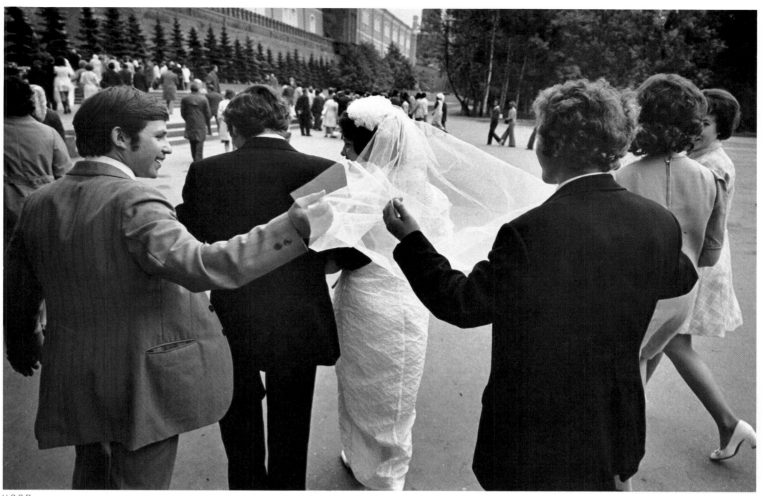

U.S.S.R.

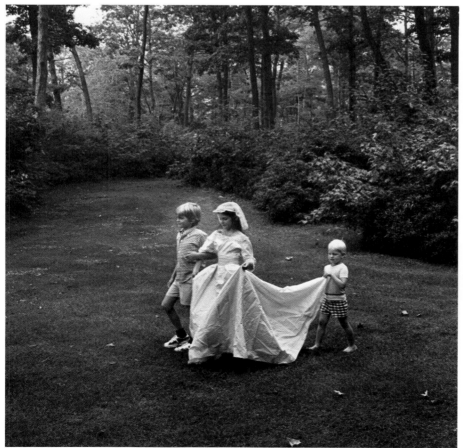

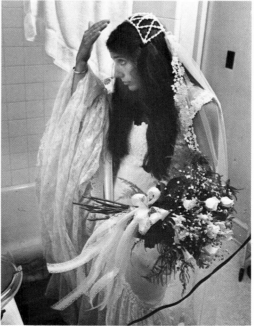

U.S.A.

U.S.A.

189

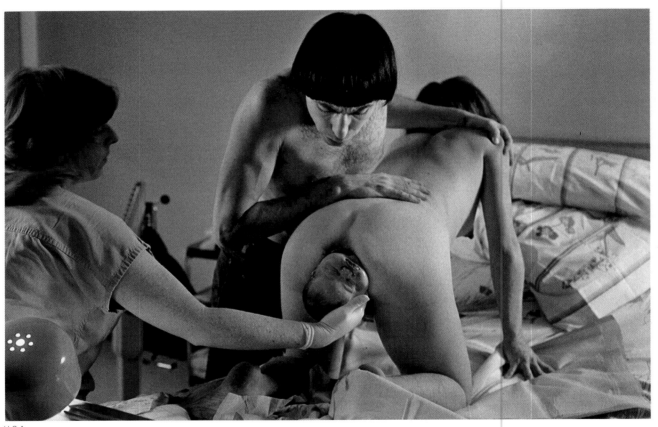

U.S.A.

Unto us a child is born
And his name shall be called Wonderful. Isaiah

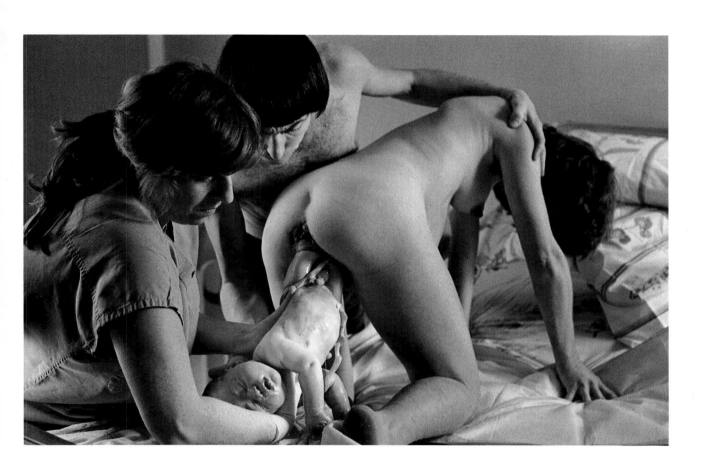

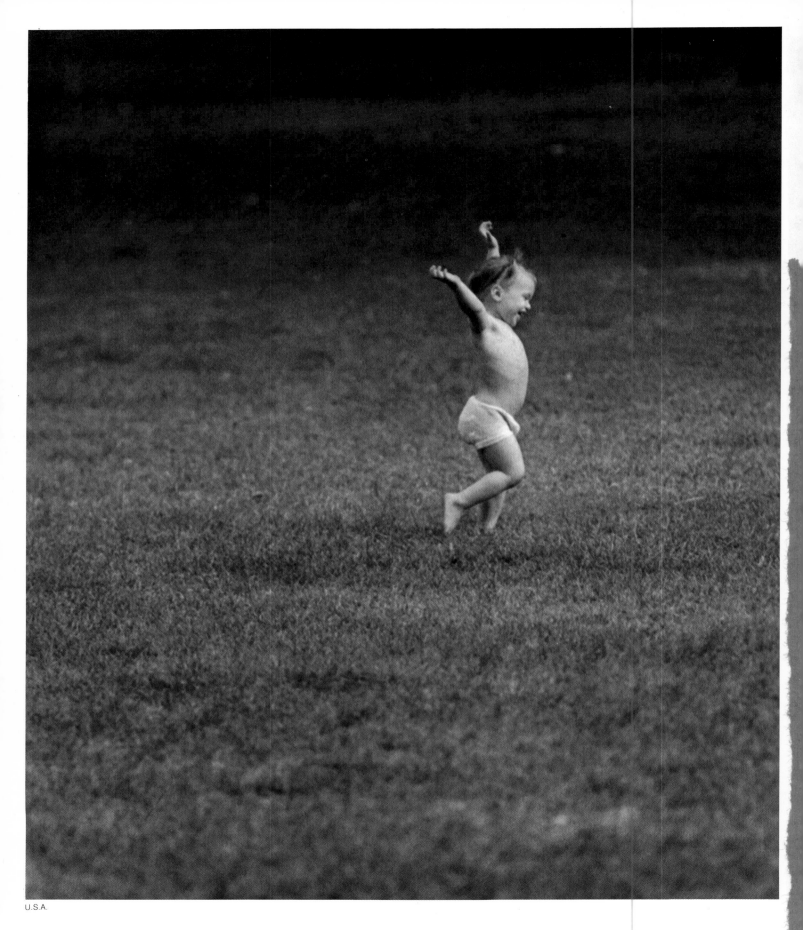

U.S.A.

Praised be the fathomless universe
For life and joy! Walt Whitman